Lindsay Taylor
Embroidered Art

Dedication

To Peter and Wendy Taylor

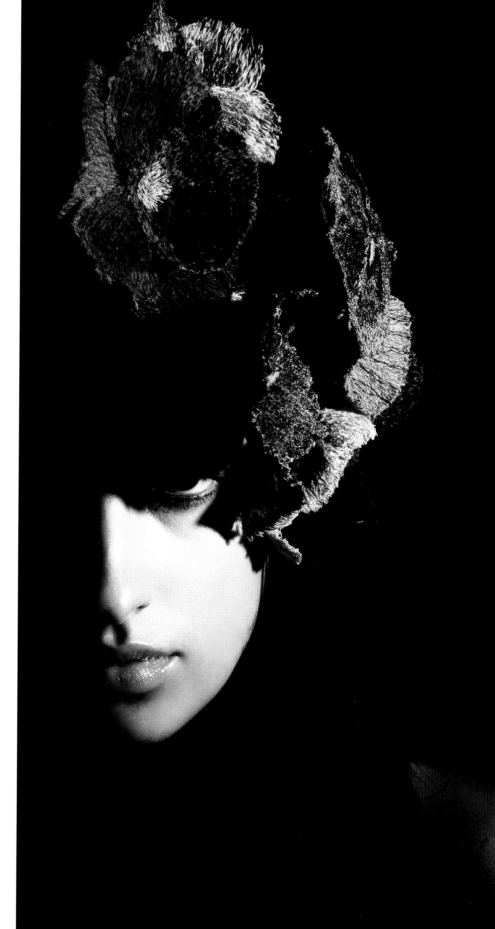

Lindsay Taylor
Embroidered Art

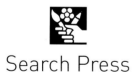

Search Press

First published in Great Britain 2013

Search Press Limited
Wellwood, North Farm Road,
Tunbridge Wells, Kent TN2 3DR

Text copyright © Lindsay Taylor 2013

Photographs by David Paul Betts, Paul Cotton, David Shih and Julie Yeo
Photographs and design copyright © Search Press Ltd. 2013

ISBN: 978-1-84448-778-3

Acknowledgements

To Roz Dace, who had the vision to ask me to write a book; if it were not for Roz this book would still be a dream; Katie French, who worked tirelessly with me. Katie has the patience of a saint. To Juan Hayward for his finishing touches, that made my book look so special.

To my photographers, who I have worked with over the years. Thank you for all your beautiful images. David Paul Betts, who worked with me during my period in the bridal business, for his romantic, fairytale images; Paul Cotton, for his beautiful, sensual studio shots; David Shih, whose arresting photographs just had to be included; and Julie Yeo. Julie's photographic style enriches my work, and her close-up images never cease to excite me.

To Kerry O'Reilly, whose friendship might have been pushed to the limit, for working on my rambling words and terrible spelling.

To my beautiful models, Bianca and Chanel Baker, my daughters, who had no choice in the matter; Charmaine Randall; Sarah Neil; Jasmine Wheeler and Shay Smith.

To Janice Blackburn, for her kind words in the foreword.

To my parents, partner, daughters and friends, for their support during my bumpy journey to success.

Printed in China

contents

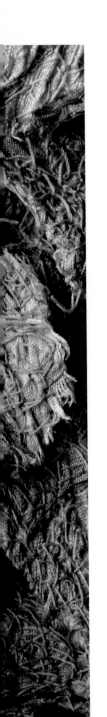

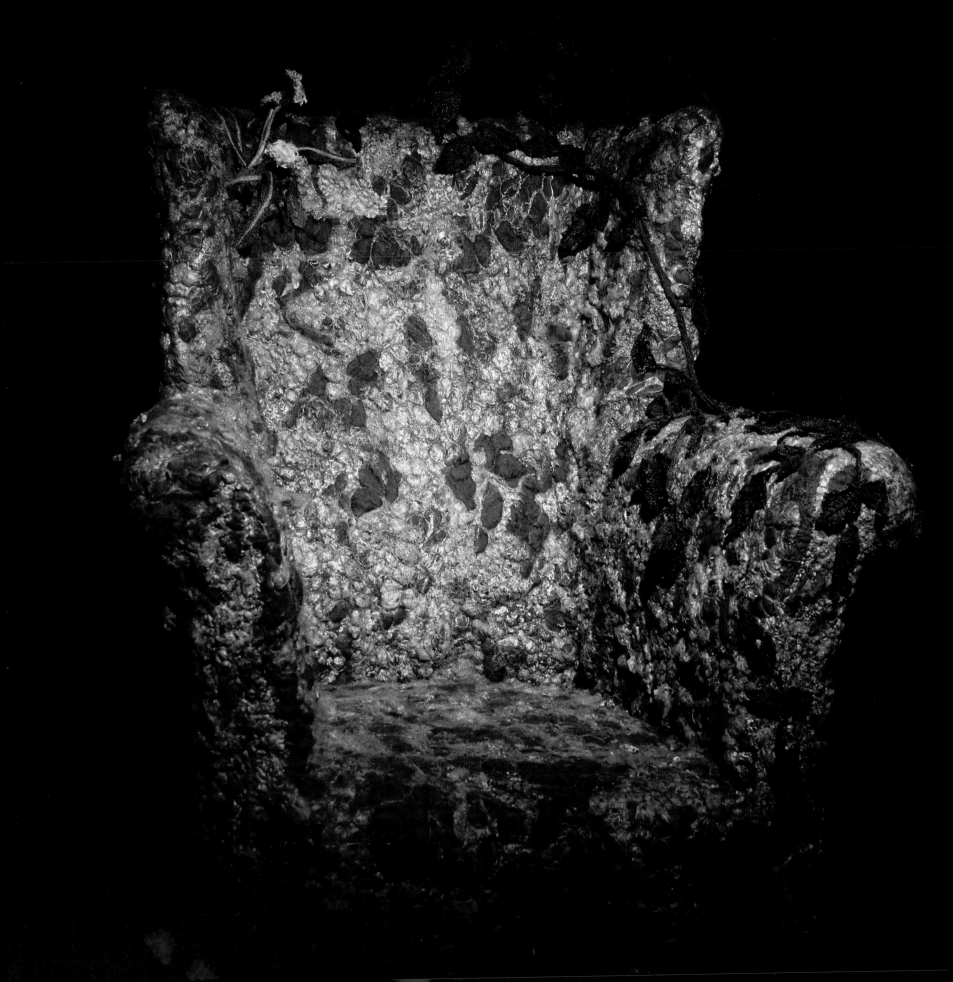

foreword

IT IS HARD TO REALLY CATEGORISE what is so special about Lindsay Taylor because, in truth, there are so many special features to her extraordinary work. First of all, her craftsmanship is simply exquisite. The originality of the embroidery, her hand stitching and her amazing imagination are all remarkable.

Lindsay takes her inspiration from the forest where she lives on the Isle of Wight and it seems as if nature – the woodland flowers and leaves – are simply transposed into bags and evening slippers fit for a princess in a fairytale.

I selected Lindsay for two exhibitions I curated at Sotheby's in Bond Street, London as I so admired her work. In the first exhibition, during the winter of 2010, there was a severe blizzard and Lindsay was completely cut off, but she boldly refused to be daunted and in spite of terrible snow and ice managed to arrive with her work in time and was rewarded by an enthusiastic response. On the second occasion she exhibited in one of my 'small show, huge talent' exhibitions and she produced a most beautiful embroidered chair and lamp (*see page 135*).

I was asked to curate a Royal Wedding Memorabilia exhibition for the iconic stationer Smythson and immediately contacted Lindsay who made an embroidered dress that took pride of place in Smythson's window, attracting much attention (*see page 63*).

In a world of mass production, a talent like Lindsay's stands out. She has been rewarded by opportunities to show her work both in the UK (for example in the Project Space at the craft fair Collect at the Saatchi Gallery, London) and abroad. She has a rare and remarkable talent, as this book demonstrates.

Janice Blackburn OBE

Detail of a shoe housed in a terrarium.
Photographer: Julie Yeo, 2010

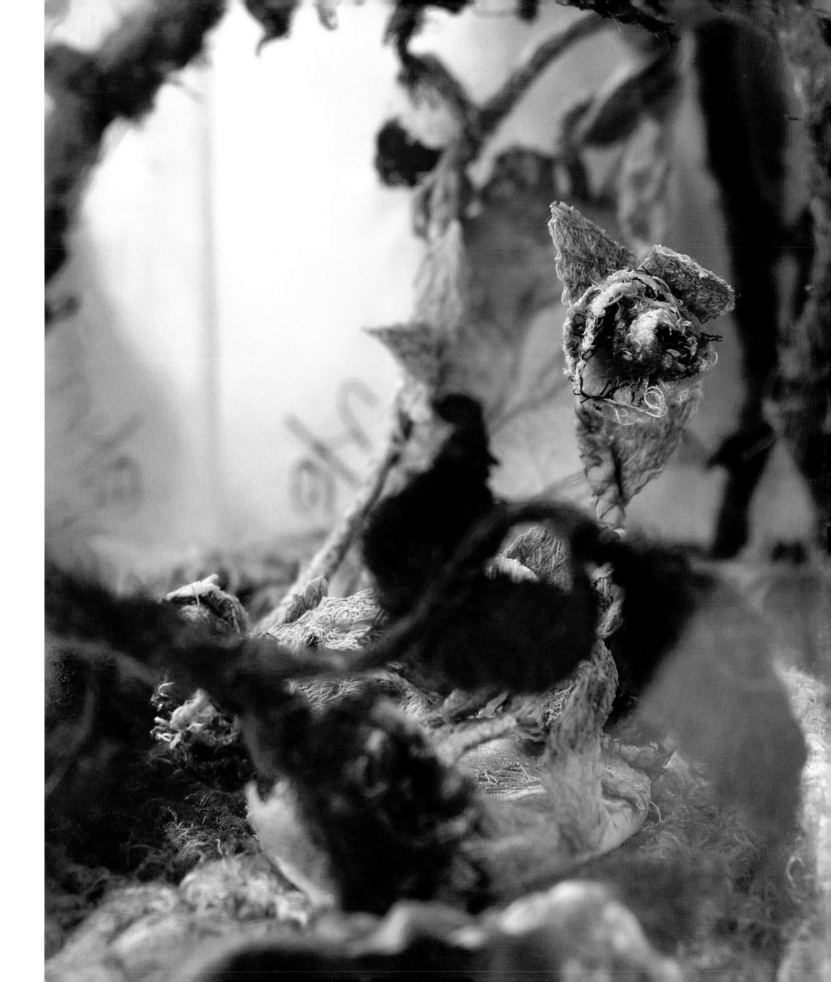

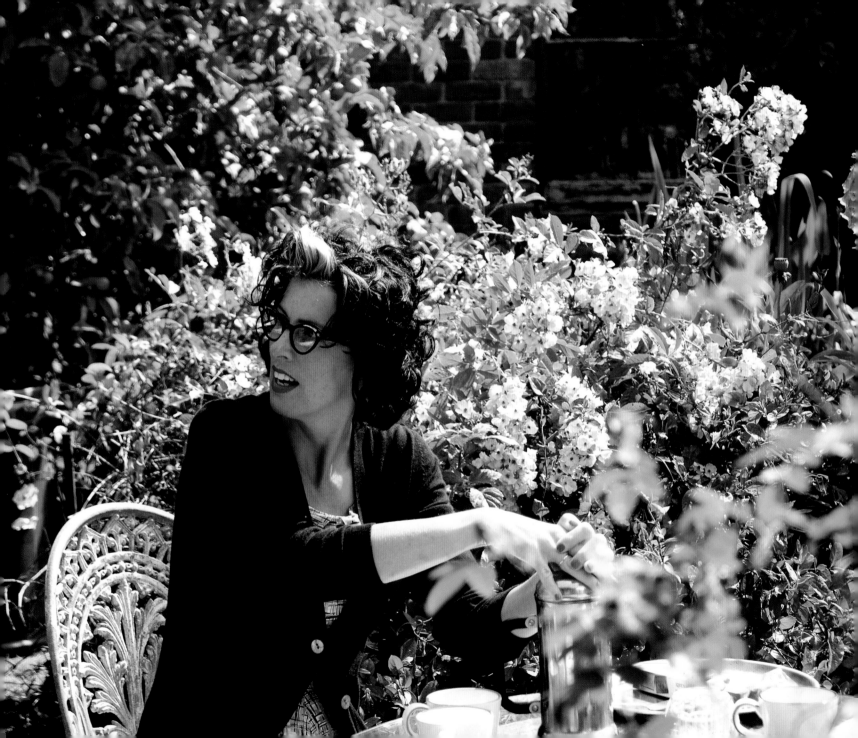

my story

What madness it is to embark on a career such as embroidered art. I sit in the designer-maker arena, being someone who both designs and hand-makes craft pieces on a small scale. It was unknown to me at the beginning how interesting the journey to the present would be and what an amazing roller-coaster ride I was about to take myself on, with fabulous highs and lows. My story starts just over a decade ago.

Childhood dreaming

I have always been a dreamer, with my head in the clouds; I do not care much for reality. Since I was a small child, I have loved breathing life into things and creating something from nothing. I was not a tomboy like my sister; I did not care for horse riding and grooming those large, smelly creatures with a will of their own. Instead I would sit for hours playing with odds-and-ends of fabric in the scrap bag my mother used to keep. At first I made dolls' clothes and progressed on to halterneck tops that consisted of one rectangle and four ties, two for the neck and two for the torso. (Sadly, and probably rightfully, my mother forbade me to wear my creations in public!) I stitched by hand until the arrival of my late-grandmother's foot treadle Singer sewing machine. Watching my mother making a pair of trousers for me to wear in just a couple of hours was amazing. Transfixed, I watched her every move.

Probably the first memory of my entrepreneurial skills came when, at around the age of ten, I had an idea to make money. I would design some outfits for my sister's Sindy doll. I made a little catalogue from which she could choose an outfit, then I drew the design in pencil and later made it up in fabric. For this creation I charged my sister a week's pocket money.

As you can imagine, she very quickly decided not to place a second order. But the desire to create something and be rewarded for it had gripped me and, deep down, I still want to earn a living from what I make.

I don't know why or where my creativity comes from. My father was a carpenter and a highly skilled problem solver; if you could not buy it he would make it. My mother is the creative one and now makes the most wonderful cakes. I have experimented in just about every known area of textiles: knitting, crochet, bobbin lace, quilting, smocking, tapestry and dressmaking, and then on to decoupage and painting skills such as rag rolling, stippling, marbling, stencilling and native American painting.

It was my mother who recognised my creativity and decided that hairdressing would be the perfect way of expressing it. I, as always, did not know what I wanted to do in life and was happy to go along with her suggestion. She managed to get me an interview with her hairdresser and I started work at the age of thirteen working every Saturday. When I left school I started my apprenticeship and worked at the salon for seven years until I left to start my own mobile hairdressing business.

Life changes

Marriage was followed by the birth of my first child, and I moved from the comfort of the Isle of Wight, the place where I had been born and bred, to an exciting new life in Arundel, Sussex. My husband had spent a lot of time in this area and wanted to return. For me, it was an adventure. However, with no family, no friends, a new baby and a husband who was often away, it turned out not to be such a great start after all.

A new shop opened in the town and the proprietor was a gentle lady with beautiful ringlets who made all kinds of pretty things with found objects, a hot-glue gun and some dried flowers. Stepping into her shop was like stepping into a flower garden. She was the first person I had ever met who, like me, was buying old, discarded furniture, stripping it back to its bare form and then adding paint effects. When she told me she could not paint the pieces fast enough, I decided to have a go. I started experimenting with a new product, medium-density fibreboard, and there was no end to what I could make with a fretsaw and a little MDF! I cut out flowers and, with a splash of paint and a terracotta flowerpot, hey presto, a little piece of art was born. I started decorating furniture with hand-painted roses and bows (all very fashionable at the time) and sold it in the shop.

Life has a way of producing its own full stops, and mine came as an enormous blow. The sudden, accidental death of my husband and then the realisation of being pregnant with my second child brought my bleakest time. I knew I needed the support of my family so I moved back to the Isle of Wight. It was the late 1980s and the property market had slumped. We had bought our house at the height of its value and I had to sell it at a loss. I moved back to the comfort and safety of the Island and into my parents' home.

Fresh challenges

Not far from my parents' house stands a forest and I would often take walks there. It is quiet there, and one can be alone with one's thoughts. I remember spotting a little house opposite the forest, obviously neglected, unoccupied and desperate for some love and attention. There was a hole in the roof due to the hurricane of 1987, a tree grew in the kitchen and branches poked out through the wall. I took a look around the garden and fell in love. The property was going through probate due to the owner becoming ill and moving to a nursing home; her family had now taken over the house.

There is a romance about an empty property: who were the past occupiers, and what did they look like? It took about six months before it was mine and two years before we could move in. Apart from an electrician and plumber, it was I who worked on the house. I pulled down walls, put up plasterboard, replaced windows and added new floors. I even learned how to render and plaster. This was my biggest project to date and I loved it. Every now and then reality dawned on me – what on earth was I thinking, taking on such a house? A woman on her own

My studio, viewed from my garden.
Photographer: Julie Yeo, 2011

with two small children and virtually no money. Each evening when the children were in bed, I would go down to the house and work until eleven o'clock. It was hard, in the depth of winter, to pull one's self from a warm house into what could only be described as a dimly lit fridge. I scoured car-boot sales looking for things to fill my new home. Lighting was expensive, especially for a whole house, but if I could buy a brass chandelier for a couple of pounds, paint it and distress it, if it did not work out I had not wasted too much money. I found old doors in skips and a wonderful old beam, now in place in my lounge. My father is a hoarder, much to the disgust of my mother, but to me his collection of junk was a delight and came in extremely handy, as did his tools and skills.

An old ceramic butler sink from a nearby field now sits proudly in my kitchen. The idea of items having a new purpose in life, especially not the one they were designed for, really appeals to me, so old peg tiles now sit on my kitchen floor; lace tablecloths and patchwork quilts hang as curtains. I can still be found most Sunday mornings at the local car-boot sale, and still get a buzz at the prospect of a new find. With a keen eye, a little imagination and always staying one step ahead of the latest must-have product, I have been able to make my house a home.

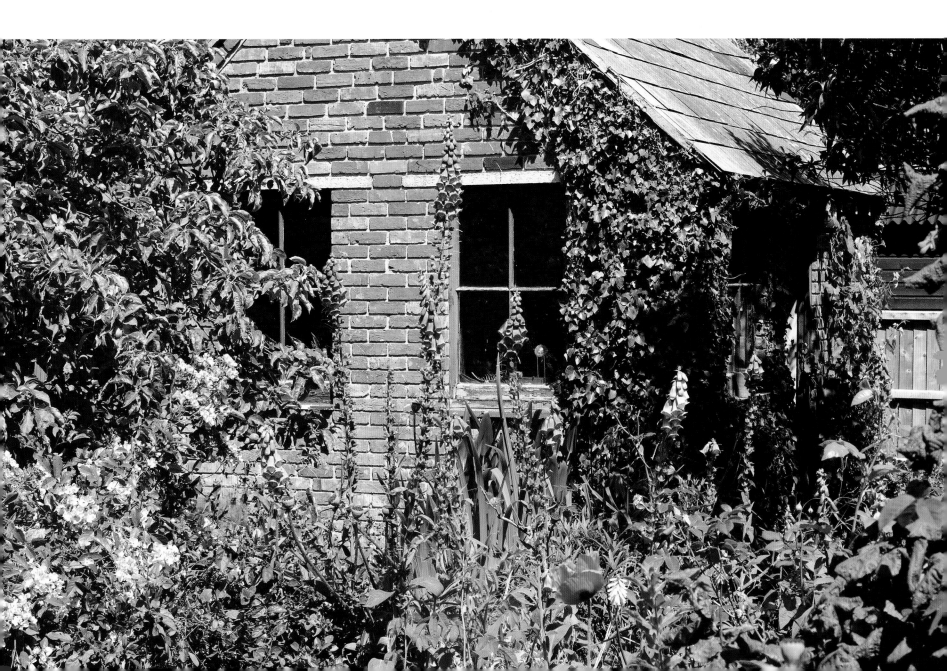

Wedding gowns

With my home complete and my children older I needed fresh challenges. I did not want to return to hairdressing, and painting furniture was now a thing of the past. It had been suggested that I start making children's clothes as my children were often seen in one of my creations and by now I'd honed my skills so that these were now garments any parent would be proud to let their children be seen out in.

However it was while attending a close-friend's wedding that I had my light-bulb moment. Why not make bridal gowns? I had the skill to make a gown as I had been dressmaking most of my life; I had taught myself how to embroider; and I could command a reasonable price. I had made and refined many patterns for my own use over the years, but this was an area in which I needed to improve if I were to do it professionally. I enrolled in a pattern-cutting class for two years, taught by a highly skilled woman who was a perfectionist. I decided that my bridal gowns would have to have the 'wow' factor; I did not want to make plain gowns as there were plenty of companies doing that already. My first collection was elaborate by any standard, and my favourite to date. A long-standing friend who also happened to be a great photographer shot it in the forest opposite my home, using the daughters of my friends as my models.

Having finished the pattern-cutting course, I was bitten by the learning bug. What next? I had taught myself many traditional embroidery techniques and had seen a book about the French embroidery school Ecole Lesage, which creates embroidery for the couture fashion houses, and I knew it would be good to have professional skills in this area.

I found an embroidery course, and will never forget the first day that I enrolled. I had no idea what awaited me and what a journey I was about to embark on. Our tutor, Judith Bell, showed us some of the previous year's work. I was transfixed; I had never seen anything like it. Freehand machine embroidery – what was that? For the next four years Judith's class was the highlight of my week. I was hungry for her knowledge and skills in so many areas that I knew nothing about. Judith was truly inspiring to the whole class and we excelled. Here we learned the art of dyeing, appliqué, slashing, burning, batik, screen printing, the list goes on. But my greatest pleasure was learning the art of freehand machine embroidery. Using water-soluble fabric, stitching into the fleece and making shapes such as leaves and petals, this was a technique I could use on my bridal gowns. Judith was a little unorthodox in her approach to teaching, but with her guidance we all blossomed. We produced huge amounts of embroidery but very little paperwork – none of us had time for that. An idea would form in our minds and we were off. How Judith must have despaired of us! To this day I rarely produce any pre-drawings of my work. It is all planned out in my head before I start. I can see the piece as clear as day; I work out how I will achieve it, any problem areas, and the final outcome. Only with a commission will I produce a drawing and samples of the embroidery.

For five years I worked on my bridal business, but I noticed that each collection was becoming a little plainer than the one before, in my attempt to entice the Island bride. In the end, there were very few gowns that I actually enjoyed making. The commissions I received were often uninspiring to me, and it is inspiration which fuels my passion for creation. What most brides wanted was a strapless gown, with no or very little decoration. Ivory was, and still is, the most popular colour by far, so this left very little scope to be creative.

I had made some bags as alternatives to bridal bouquets for a catwalk show at a bridal fair. These were well received and often commented on. So the roller-coaster dip of the safe, ivory, strapless dress was left behind with the birth of my vibrant and tactile bags.

Photographer: David Paul Betts, 2003
Model: Jasmine Wheeler

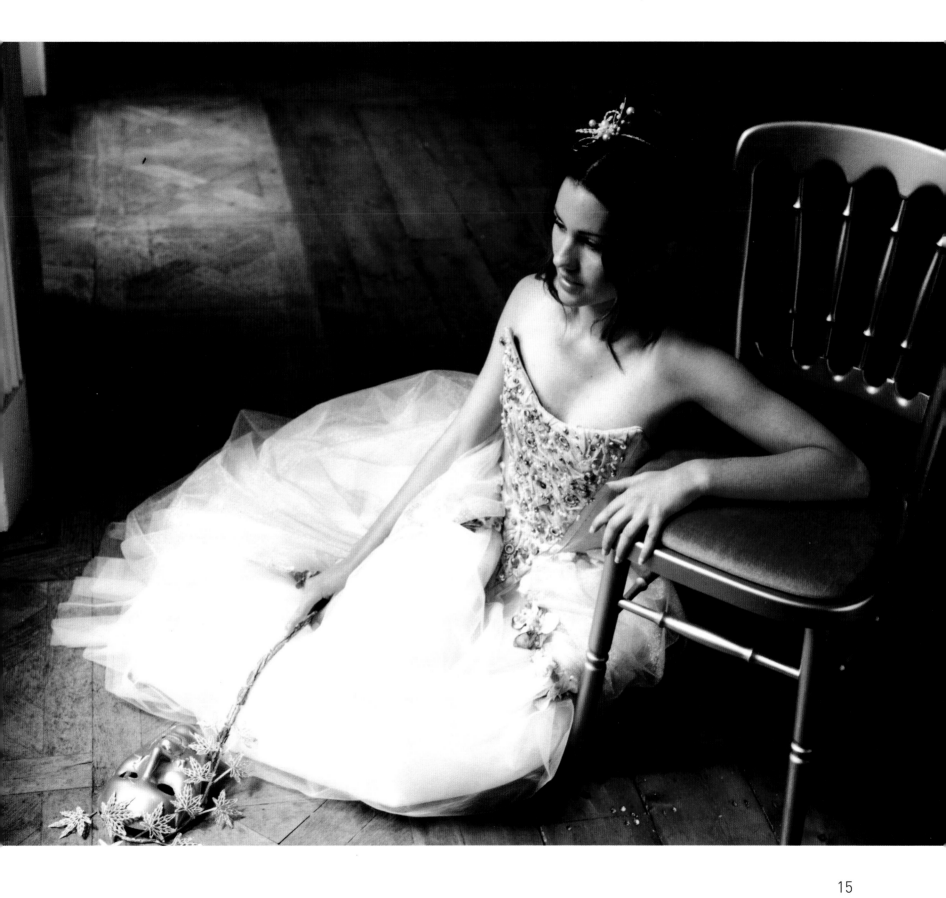

Bags

Bags, it seemed, had taken over from shoes. Open any magazine in the 1990s and there were pages of celebrities with designer handbags dangling from their arms. That was it; I decided to make bags with scarves to match. My handbags would be works of art; unique; in beautiful, luscious colours. I hoped my bags would be cherished and passed down through generations, hung in a frame not put away in a drawer. I had taught myself how to devoré silk velvet, so this and felt would be the base on which I would embroider.

With a new collection and the help of my close friend Kerry, we decided to try 'cold calling' boutiques in Oxford, Henley and Marlow. We set off early on a beautiful summer morning in 2005 with enthusiasm, excitement, apprehension, a suitcase containing my samples and some handmade booklets. Our first point of call, a boutique with a brash and colourful Italian owner, offered a positive, "Molto Bella, Bella!", but then whipped it away with a harsh, "But no darlings, not for me!" Slightly disheartened but undeterred we plodded on. By the end of the day I had my first commission. A boutique in Marlow wished to take both bags and scarves in three colourways. Success – or so I thought. The work was made and sent out on time, but it struggled to sell. The first problem was that I was an unknown. The customer wanted to purchase an item with a designer name, a name they knew, a brand. Eventually, reality dawned. I was selling in the wrong place; I needed to be stocked in a gallery, not a boutique. This was a world I had rarely experienced, and it was a daunting prospect. One enters a gallery expecting to see something unique, something beautiful, and with the expectation of paying a little more. With a few local galleries stocking my work and some sales, I felt I was at last on the right track.

Valentine bag
Photographer: David Paul Betts, 2006
Model: Sarah Neil

16

Teacups and cabbages

It was at this time that I started playing with three-dimensional pieces. This was mainly for my own enjoyment, challenging my skills and pushing my abilities in new directions. First came the idea of an embroidered teacup. The inspiration came from a cutting I had of a china cup in the shape of a poppy. Could I possibly re-create it in embroidery? I could, and following that success came a shoe. I had in the past covered a standard shoe with hand embroidery and beads to complement a gown. This time I decided to make a cabbage shoe. I can't remember why I chose a cabbage, but it was a success. Inspired, I started producing three-dimensional jewellery pieces too.

To balance my new-found euphoria, a reality check was lurking just around the corner. I was selling, but again not enough to make a living, and I needed to. My children were now teenagers and found it hard to understand why their mother kept producing stuff that only very few wanted to buy. It must have been difficult for my parents too, but they remained quietly concerned and let me get on.

There is always a light at the end of a tunnel, if only one can find it. My light came in the shape of Portsmouth University. It had acquired enough funding to set up help for artists in a particular area and chose the Isle of Wight and Chichester. Artists in both these locations had the same problems: lack of opportunities, lack of marketing and lack of motivation. The one thing I did not lack was motivation, though most artists seemed to struggle in this area, and it soon dawned on me that this was my main achievement to date.

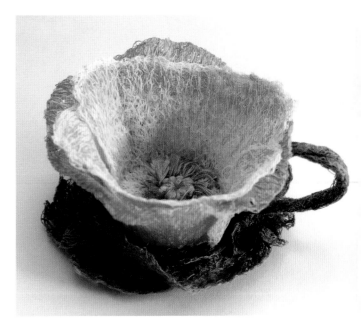

Teacup and saucer
Photographer: David Paul Betts, 2009

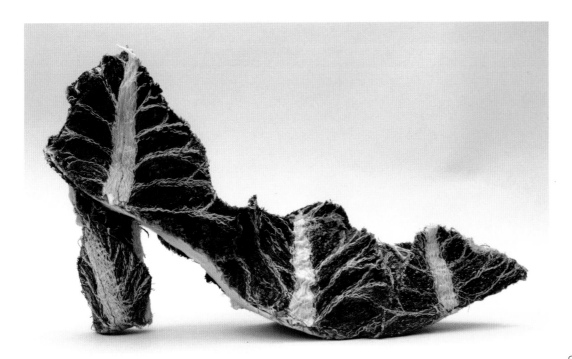

Cabbage shoe
Photographer: Paul Cotton, 2008

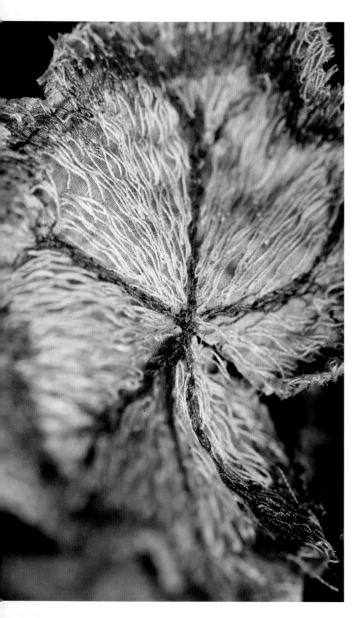

Pelargonium leaf (detail)
Photographer: Julie Yeo, 2011

Moving forward

I had heard about the Crafts Council and decided to attend their craft fair 'Origin' at Somerset House. A one-to-one mentoring session was arranged at a local gallery with Beatrice Mayfield – an angel if ever there was one. Beatrice worked for the Crafts Council and was able to see clearly why I had failed and what I could do to rectify it. After I had shown her a selection of my work she fell silent, and I could almost hear the cogs moving in her brain. I listened intensely to her every word, now embedded in my brain: "It is your three-dimensional pieces that excite me." I could not believe my ears. I had only dabbled in three-dimensional pieces for my own benefit and loved doing it, and this was to be my way forward!

I had already booked a place at a trade fair in April and it was now halfway through January. If I was to change direction I needed to do it in a hurry. I had six weeks in which to make a cohesive collection worthy of being exhibited at the prestigious Crafts Council fair. Much work had to be done. I worked day and night producing flower shoes, teacups and saucers, floral bags and jewellery.

By now I had decided that my shoes needed to be displayed differently and, in search of something new, I discovered Victorian terrariums, used originally to display indoor plants. The Victorians produced intricate designs for these glass cases, but I wished to make a simpler, modern version. With the help of my father's skills, we devised a Perspex-fronted box with a distressed mirrored back and, with my painting skills acquired in the 1980s, I painted algae on the walls. The shoes came to life, and later, after adding extra extra foliage, they had finally arrived.

Opening doors

Slowly doors started to open. I was elected to membership of the Society of Designer Craftsmen, an organisation previously known as the Arts and Crafts Exhibition Society and founded in 1888 by Walter Crane and William Morris. I exhibited at the Mall Galleries and SDC Gallery, and still do so on a regular basis.

I now am well established as a designer-maker, producing three-dimensional embroidery. I exhibit my work on a regular basis at contemporary craft fairs and in galleries nationally and internationally. My work has led me down roads I never expected to go. When I think back to the days of those halterneck tops, I could never have envisaged that teaching my skills to small groups of people and giving lectures on my specialism would become part of my future life.

Making a living as a practising artist is not easy; passion and determination have been the keys to my success so far. My work is a never-ending project; not knowing what is around the corner is the exciting bit. I am constantly looking to new horizons, new inspiration, and more boundaries to push. I am very lucky: I do something I love.

Right: ivy shoe in a terrarium.
Photographer: David Paul Betts, 2010

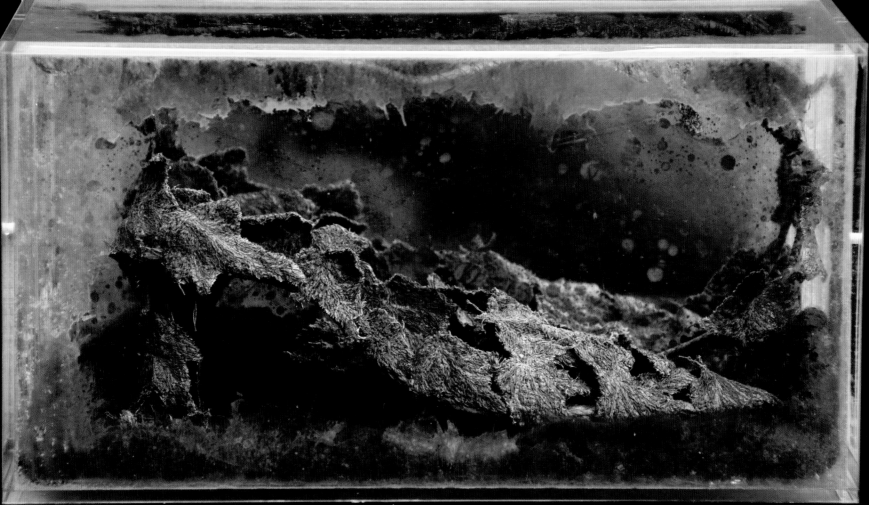

inspiration

I am often asked what inspires me, and the answer is simple: inspiration sparks when I stop and take time to look around me.

Island living

There is something very special about living on an island, especially the Isle of Wight, and it has often been said there is a magical light here. My home is on the edge of a forest, which is the perfect environment for my love of flora and fauna. When I have time, I enjoy gardening and walking. I love the architecture of plants and working with colour, and I gain a huge amount of inspiration from these.

The seasons bring a constant supply of ever-changing interest. From the first signs of a bud in spring, the full blooms of summer (when gardens are at their best), autumn's death and decay and the sleep of the winter. (As I am writing this, on a beautiful day at the end of March, I am sitting at my garden table. Only a few feet away, a little bird is busy making its nest in the rotten fascia board of my home. If he was not making so much noise I would be unaware of his presence.)

Being an artist has always been a difficult profession and lifestyle. Looking back at any of the great painters, we are only too aware of their pain and financial struggle, and it is no different in the twenty-first century. Artists constantly judge their practice and have to contend with diminishing galleries, which is sadly an all-too-common occurrence. With austerity measures in place, many artists have evolved or turned to recycling and upcycling. For me, this is just part of the spiral of my art's journey, and during the past twenty years I have been a keen visitor to local car-boot sales and charity shops. I am always on the look-out for something interesting. Beads, fabric, ceramics – you name it. If it sparks inspiration, I will buy it. My house almost groans at the thought of more stuff. This latest financial low of the nation means that I will have to get to the car-boot sales that little bit earlier than in wealthier times!

Talking of the more decadent financial times of the past provokes me to think of the other things that stimulate my creativity. We are bombarded on a daily basis with imagery: newspapers, magazines, the internet, social media and television, and they all play a part in this. Throughout my life I have had a love of fashion, and for a long time I looked to John Galliano's outrageous designs for Dior as inspiration. He has never ceased to rouse me with his beautifully embroidered gowns; I love also Christian Lacroix's use of colour and bejewelled embellishment. I later discovered and was thrilled by Alexander McQueen's glorious, avant-garde designs.

Growing up in the 1980s I was inspired by the colour palette and pattern of Kaffe Fassett; the use of culture fusions and colour variations by designer Kenzo Takada for Kenzo; the paint effects of Jocasta Innes; and the must-have fabrics of Tricia Guild for Designers Guild. Inspired by the past, Victoriana was the taste of the decade – William Morris was hugely influential, as was the intense detail of the Pre-Raphaelite painters with their romantic vision of Victorian life. This was my early foundation. Always on the look-out for new inspiration, my interests turned to interior designers like Tord Boontje with his highly sought-after products and the embroiderers of our time: Jan Beaney, Jean Littlejohn, Diane Bates and Richard Box to name but a few. I have bought their books and seen their work displayed and been enthused by both.

Photographer: Julie Yeo, 2012

20

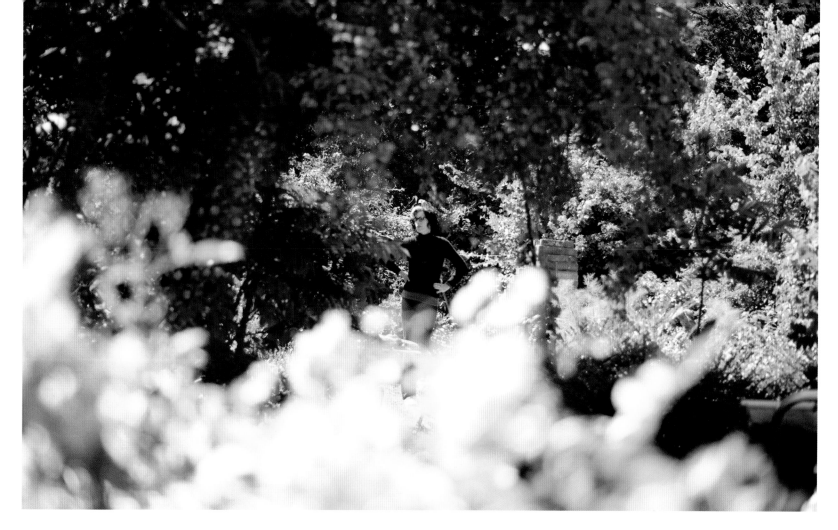

This is where I love to be – at home, in my garden, in the summertime.
Photographer: Julie Yeo, 2011

Another noteworthy area for inspiration is the people I have encountered on my journey: the friends that I have met on the courses I have been on, my contemporaries at exhibitions, and the people within the clubs and organisations I belong to. We have learned from each other and enriched our creativity by sharing the special skills we each possess.

While studying embroidery I met Caroline Bell, who produces amazing hand embroidery; Cath Von Carlhousen, who mixes paper with textiles and produces fairy illustrations and textile dolls; Gill Drew, who became interested in felt in a big way and produces the most detailed wallhangings of native birds; and Gail Radcliff, whose skill lies in three-dimensional pieces inspired by nature. We meet from time to time, inspiring and supporting each other both emotionally and professionally.

I also belong to a professional craft group based on the Island, the Quaycrafts. The group has been meeting for almost twenty-five years. It is a mixed crafts group, exhibiting crafts from calligraphy, print, ceramics, glass, jewellery, basketry and, of course, textiles. Here too we encourage, support and critique our work and exhibit on an annual basis. Belonging to a group of like-minded people is so important; as artists we are isolated in our practice, living inside our own little world.

Whilst living on an island has many positive points, it also has drawbacks. The cost of leaving the Island is expensive and time consuming. A need to visit museums, galleries and art exhibitions is often on my agenda. Soaking up the atmosphere of our great cities, the fast pace of life, architecture and shops proves to be a good investment time after time.

materials

Some might label me a hoarder; however, I rather consider myself a great collector of stuff.

I can't help myself. I have collected over many years from far and wide, gathering things from holidays abroad but mainly locally from charity shops and car-boot sales. I have been hooked since attending my first car-boot sale at the end of the 1980s. At that time I had very little money and was bringing up two small children on my own. I went along intending to pick up a few bargains, and came away with a life-long obsession for collecting.

Over the years I have amassed a large collection of vintage china, plants, fabrics and sundries such as hotel cotton sheeting, jewellery (for the beads), clothing (for the fabric), lace, buttons and lampshade bases. The old adage that one man's junk is another man's treasure certainly resonates with me! I have furnished and decorated my whole house from these sources and almost nothing is new.

Fabrics

When working on an art piece, I put much thought into the fabrics needed. Though I work mainly with natural fabrics, I occasionally use synthetics – they can't be dyed easily but they do burn beautifully. If stitched into with a cotton backing then heated with a paint-stripping tool, they will distort and shrink, giving the appearance of smocking; holes will form and, if 'zapped' for longer, the piece will start to disintegrate, creating the effect of decay.

Cotton and silk fabric take dye beautifully. I rarely use commercially dyed fabric, preferring to dye the material with cold water Procion MX dyes in my chosen shade with subtle colour variation. For a heritage feel, tea and coffee work wonders and are pretty colourfast.

Inside my studio.
Photographer: Julie Yeo, 2011

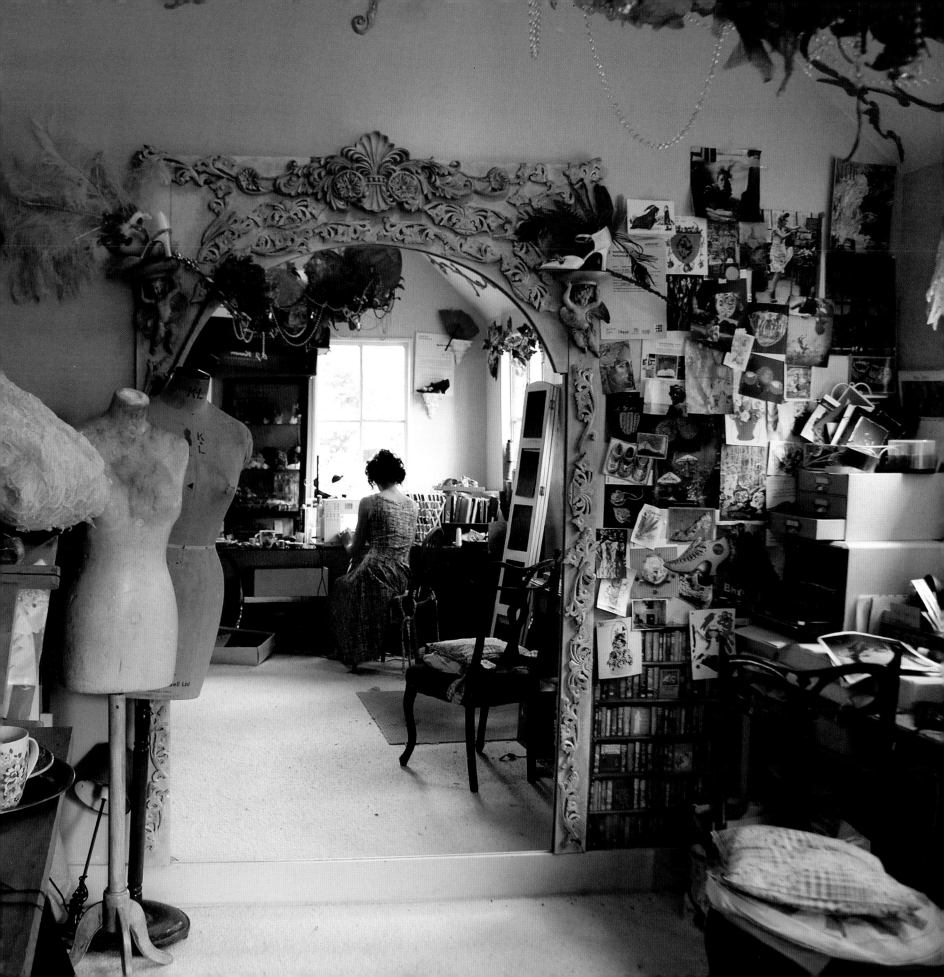

Dyeing fabric could not be easier. I wash the fabric in washing soda but do not rinse it and make up a small solution of dye with water. I then place the fabric in a plastic bowl and paint or distribute the dye using a spoon. Several colours might be used and, with the fabric wet, the dyes bleed into each other causing a very naturalistic effect.

Large works require heavier fabrics like old Egyptian cotton sheeting or silk velvet. For smaller pieces I use a lighter fabric; silk dupion and sheers of silk habotai, organza and chiffon are my materials of choice.

When felting is required I will always use merino tops. Sometimes I use commercially dyed tops but most of the time I dye the wool myself using acid dyes. First, I place the wool hank in a metal dye bath and immerse it in enough water to submerge it. I then heat the metal dye bath slowly, bring the water to the boil, then turn the heat off. I then sprinkle the grains of dye over the surface of the water and allow the dye to slowly penetrate the fibres. After 45–60 minutes, I rinse the wool carefully.

The material I just could not live without is Solufleece by Vilene. I really should have shares in the company – I get through so much of it. I have found it to be the strongest water-soluble fabric (dissolvable fleece) around. It looks much like Vilene's rip-and-tear interfacing, but when the water hits it, it dissolves more or less instantly.

Threads

Lots of stitching requires lots of thread, and throughout any single component of a piece, I will use many different thread colours. I have no particular preference for any brand of thread; often the cheapest will do, though metallic threads are the exception to this rule. When possible, I buy large cones of thread that hang behind my standard domestic sewing machine. I have made a contraption incorporating a pole with a base, to which a coat hanger is suspended. The thread passes from the cone up through the coat hanger and back down into my machine.

Photographer: Julie Yeo, 2012

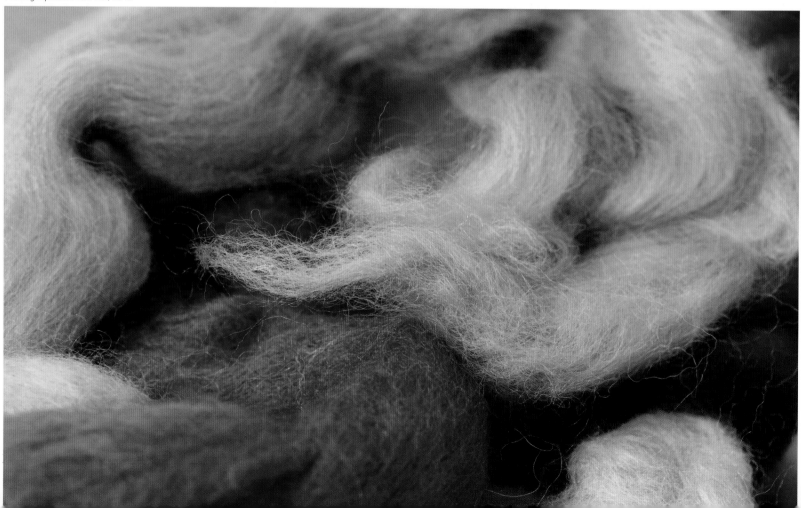

Photographer: Julie Yeo, 2012

I use metallic threads for their rich and decadent appearance – they can be a struggle to work with, but the end result makes it all worth it. It is best to invest some money in a quality brand. I have spent so many hours screaming with frustration while endeavouring to use cheap Indian threads – the threads tend to break and unravel, leaving me with only a few inches of work after several hours of sewing!

techniques

It is hard to put my style of embroidery into words. Throughout my career I have experimented with many styles, but working three-dimensionally comes easily to me. I think this is partly due to my past experience with pattern cutting, moulding and sculpting. A pattern designed to fit a body is not as dissimilar to moulding a flower as you would imagine.

My techniques have been tried and tested hundreds and thousands of times. Some regularly, some occasionally, and some I will never attempt again! Either it took too long and I have found a better solution, or I did not like the finished results. Whenever I come up against a problem, usually the solution is only discovered while I am relaxing in the bath or drifting off to sleep. Time out can often be a great problem solver.

The design process

First and foremost, I need to decide what I am going to make. I then study my chosen subject closely. As a child growing up, I used to collect wild flowers while out on family walks. These were then taken home, pressed between sheets of newspaper and placed in books or under the carpet. I did this during most walks, amassing a large collection of flowers to be made into pictures. This was my first foray into studying natural forms.

Having the actual plant in front of me allows me to look closely at its shape from all angles. I like to draw upon the imperfections and colour variations, and study these closely as well as the details of the plant. I count how many petals make up the flower head, and consider how many flower heads might be needed and how the leaves are shaped. A rose leaf, for example, is made up of a feather-like arrangement of about seven leaflets on a single leaf stem, a Virginia creeper has five leaflets and no flowers, and a fern leaf consists of a pattern of growth repeating over and over, decreasing in scale towards the tip. The pattern of the veining is important, and I ponder whether the veins are lighter or darker than the actual leaf. I also look at other plant parts, such as the seed heads and hips, which have an architectural appeal of their own.

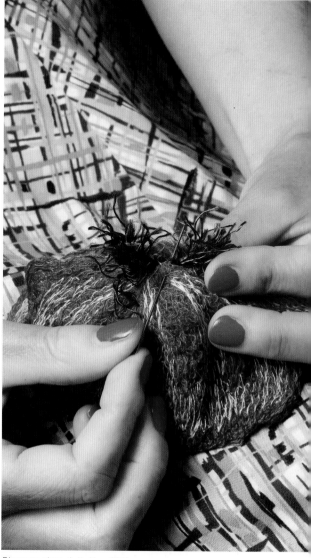

Photographer: Julie Yeo, 2011

Timing is key: a plant at the beginning of its season will look very different from that at the end. I also look for any evidence of insects nibbling at the plant. How beautiful it is to embroider a hosta leaf after the slugs and snails have had a meal from it! The laced leaf takes on a very different feel from one that is still intact. Frost and drought also take their toll – a stunning display can be formed from decay.

Books are my weakness. I can live without a pair of shoes, but if I see a book I want, I have to buy it. Books are an invaluable source of information. Over the years I have amassed an excellent library and seem unable to stop it from growing. I also have a collection of images torn out of magazines that I have built up over the years. I store them in ring binders, arranged according to topic. The Internet too has a rich supply of stock images. What a delight it was when I first discovered Google images! With all my images spread around me, at the side of my machine and on the floor, the plan is hatched and only then can I start work.

Photographer: Julie Yeo, 2011

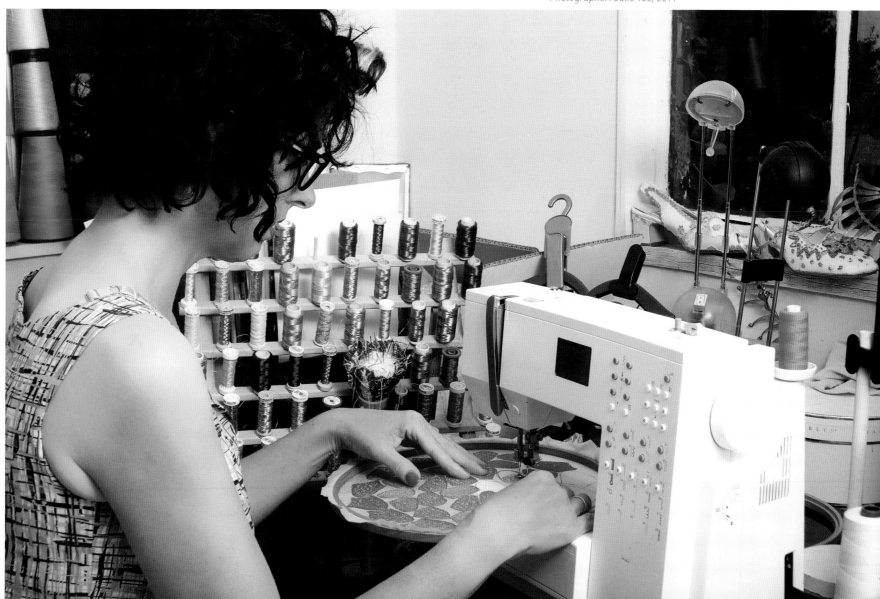

As a new project evolves in my head, each problem is thought about, often for days. Unusual as it might be, I do not make sketches – I don't feel I need to. I have the ability to visualise my finished piece as clear as day, in my head, in the same way as people might walk into a new house and visualise their furniture *in situ*. Only when working with a client to a commission will I need to make sketches.

My art can evolve and develop while I am working on a piece – it is only when I start building up the layers of the piece that it will assume a life of its own and new ideas will flow; a leaf here, a butterfly there – often it is only when things go wrong that new ideas arise. While hand stitching into velvet many years ago, the work looked truly terrible and almost ended up in the bin, but along came a brainwave. Out came the sewing machine and the lovingly hand-stitched work became covered in freehand machine embroidery. Hey presto! I had found a new technique.

Planning

Having decided what I am going to make, I have many options to consider. I think about the colour and feel of the piece. Do I want the overall look to be light with a spring-like appearance, or do I want it to be edgy, dark and with a sinister feel? If I am making a piece for a particular exhibition or working to a title, there may be rules and limitations to adhere to. If it is a commission for a wedding or special event, I will need to consider the needs and preferences of the client.

I then need to consider the specifics of the piece: how many components will be needed, and the shape and size required. The size and number of the component parts depend on the piece, but it is always better to make too many than too few. A piece of jewellery will usually have smaller parts than, say, a hat, and smaller parts still than a chandelier.

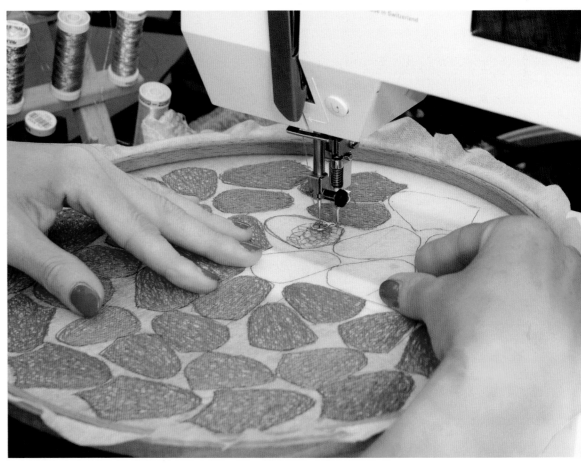

Photographer: Julie Yeo, 2011

Stitching

I use two stitching techniques depending on the size of the component. Both involve a water-soluble fabric (dissolvable fleece) stretched over a wooden embroidery hoop. For small to medium pieces I use a technique for which I have coined the term 'just stitch', and for larger pieces I use 'the fabric sandwich'.

Just stitch

With this method, either I draw the shape I require using a soft pencil then use the sewing machine to redraw over the pencil lines in thread, or I draw directly on to the fabric using free machine embroidery. I then fill in the spaces using an up-and-down then side-to-side motion to create a grid of numerous interlinked stitches. I then fill in the area completely with stitching worked in a small, circular motion. This forms a new, solid fabric. Finally, I change the thread colour and add any veining or other detailing on top using a running stitch.

The fabric sandwich

This method is the same as 'just stitch' but with the addition of a base fabric, for example hand-dyed silk, underneath the water-soluble fabric (dissolvable fleece) to add strength. My choice of base fabric depends on the shade and weight of my intended creation – the smaller the component, the lighter the fabric. I cut out all the necessary components from the base fabric, place on the water-soluble fabric as before, then use the sewing machine to fill in the fabric areas and draw on the veining using different coloured threads.

Throughout any single component, I will use many different colours of thread. The edges of my leaves are kept frayed (nature is not perfect), and every leaf or petal will be slightly different. When I am satisfied with the finished piece, the fleece is loosened and the work put under warm running water. This is when the magic happens. The fleece dissolves completely leaving behind the embroidery.

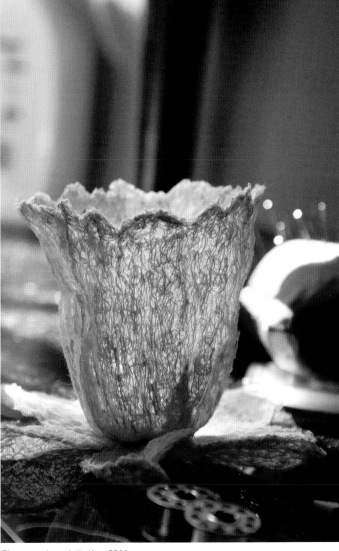

Photographer: Julie Yeo, 2011

Moulding

Moulding the components into shape calls for some ingenious constructions. I consider the desired shape and architecture when dry. If it is a leaf or a petal, some movement might be needed; if it is a large art piece it will probably need to be stiff; if it is to be worn next to the skin, it will need to be soft.

To make the work stiff, I use a range of techniques that includes not rinsing out all the water-soluble fabric (dissolvable fleece) so that the piece automatically dries stiff; applying a little laundry spray starch; or hand stitching wire into place.

However, if the work needs to be soft, I ensure I rinse it really well and finish it off with a bath of fabric conditioner.

I mould the piece by pinning it on to a mat, a pincushion or around a cup, bowl or any handy items sourced from around my home. I then either leave it to dry naturally or, alternatively, give it a quick blast with some warm heat from a domestic hairdryer, stretching the component into shape as it dries.

Making three-dimensional art has its challenges and sometimes I need a piece to be strong and rigid. In this case I will incorporate wood wrapped in fabric. This is where the buddleia bush (also known as a butterfly bush) growing in my garden comes in useful. It grows like a weed with branches of various thicknesses, some very straight and some with a slight curve. The fabric used to wrap the wood is first covered with stitch and then hand stitched into place.

Construction

The construction is the most exciting stage, and is when the initial planning comes together for the first time. It is also the stage at which I discover whether or not my piece of work has been successful. I begin by spreading out all the components in front of me, then slowly and carefully I choose the ones I need and pin them in place. If I am making a piece of jewellery, the components are pinned straight on to a mannequin, allowing me to decide upon the length and desired shape of the finished piece.

I take great care to ensure that every component is secure and neatly finished off. After that, the piece is ready for hand stitching.

Finishing touches

It is just as easy to overwork a piece of art as it is to not quite finish it; the secret is to know exactly when to stop. The final stages are very important and can make or break a piece.

Stamens

Stamens add a realistic touch to a flower. I use three different methods for achieving them. The first involves taking a length of cotton twist, anchoring it in the desired place and cutting it to the required length. This process is repeated to build up the required number of stamens.

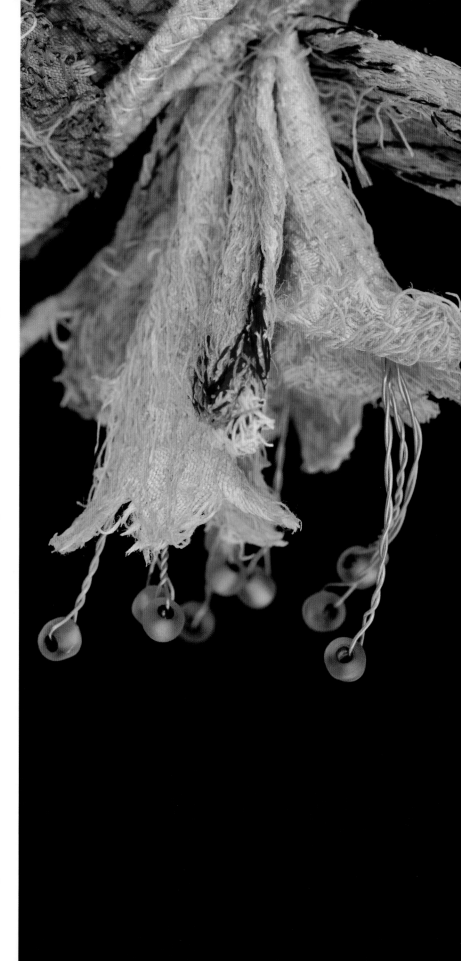

Photographer: Julie Yeo, 2011

The second method involves using craft wire. Wired stamens can be bent and sculpted into shape. Craft wire comes in many colours and thicknesses; the larger the piece of work, the thicker the wire that I tend to use. I cut the wire to a length of around half a metre (or 18 inches), then attach one bead and twist it to the desired length. This process is repeated until I have made sufficient stamens to achieve the desired effect. Taking care to conceal the ends of the stamens in the fabric, I then anchor them in place.

Machine stitching is the third method I use for making stamens. I use a small running stitch worked on to water-soluble fabric (dissolvable fleece). I start in the centre of the flower and work outwards in a fan shape, stitching up and down the desired lengths several times. This technique results in something that resembles a dandelion clock, with the stamens all splaying out from the centre point.

Burning

I love leaves in early autumn, now crisp and ruffled at the edges and partly eaten by insects. The frost, too, has started to take its toll as the injured tips turn from green to yellow and on to brown.

By melting my fabric with a soldering iron, I am able to produce little holes and create an effect reminiscent of autumn leaves. This technique works beautifully to give an aged and distressed look. 'Zapping' synthetic fabric and papers such as Tyvek (archival paper) with an electric paint stripper also produces some wonderful results, causing the fabric to distort and shrink. Layers of sheer synthetic fabrics on a natural base fabric, embellished with stitch then zapped with a heat tool produce the most delicate, disintegrated effect. But care should be taken when burning fabric, as it gives off harmful gases – this is especially true of silk. I usually extend a lead out into the garden and do my burning out there.

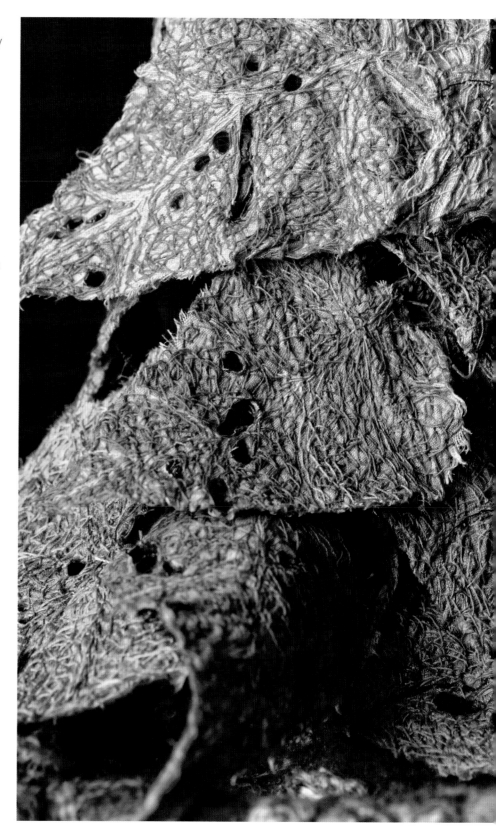

Photographer: Julie Yeo, 2011

31

Felt

Felt is often incorporated into my work. This wonderful, natural product with endless possibilities is one of the oldest textiles known to man. Its soft, cushion-like feel is perfect as a moss effect. I incorporate hand-rolled, wet felt as a base for my embroidery, chosen for its strength and desired effect. Merino wool tops are one of the easiest fibres to felt, having been cleaned, carded and dyed prior to being sold. I make it up as required, embedding silk fibres and sheer fabrics into it prior to felting, then stitching into it with the sewing machine to produce a rich texture.

Cords

I utilise cord ribbons as a closure fitting for a book cover or as handles for a bag. I select a variety of fibres or fabrics and cut them to a desired length. I set the sewing machine to a wide zig-zag stitch and sew along the fibres, twisting as I stitch up and down the length until the desired effect is achieved.

If movement is required, I twist the fibres around some wire. Craft or garden wire can be used depending on the thickness needed. This is probably my least favourite technique. The skill is to zig-zag across the wire, without allowing the needle to hit the wire. If this happens, either the needle will break or, worse, the wire is pulled under the plate and into the machine, thus causing serious damage.

Hand-dyed silk fabric was screen printed, appliquéd, quilted, smocked and beaded, then bespoke tassels finish off this scarf.
Photographer: Julie Yeo, 2010

Tassels

A tassel makes a nice finishing touch to a scarf or book. All sorts of things can be used to decorate a tassel such as shells, beads, buttons, lace and ribbons. Tassels can also be fun to make and I would usually start by dip-dyeing some cotton twist or knitting wool. I take a piece of card slightly longer than the tassel and wrap the yarn around the card to the desired thickness. I'll then pass a few strands under the wrapped yarn into the centre, tie it tightly, then cut through the loops of yarn at the bottom to release. I'll wrap more yarn around the top third of the tassel several times to produce a head before tying a knot and cutting it. I like to trim across the bottom of the tassel to produce a neat finish.

Beads

I love beads: they are the sweeties of life and I cannot resist them. I used to incorporate large beads into my work to make a real statement, but now prefer tiny seed beads as a more subtle addition. I might use beads as stamens threaded on to coloured wire and twisted into place, or to highlight a small area.

The tassels on the scarf opposite were embellished with a variety of vintage glass and seed beads, collected from car-boot sales over many years (detail).

Photographer: Julie Yeo, 2010

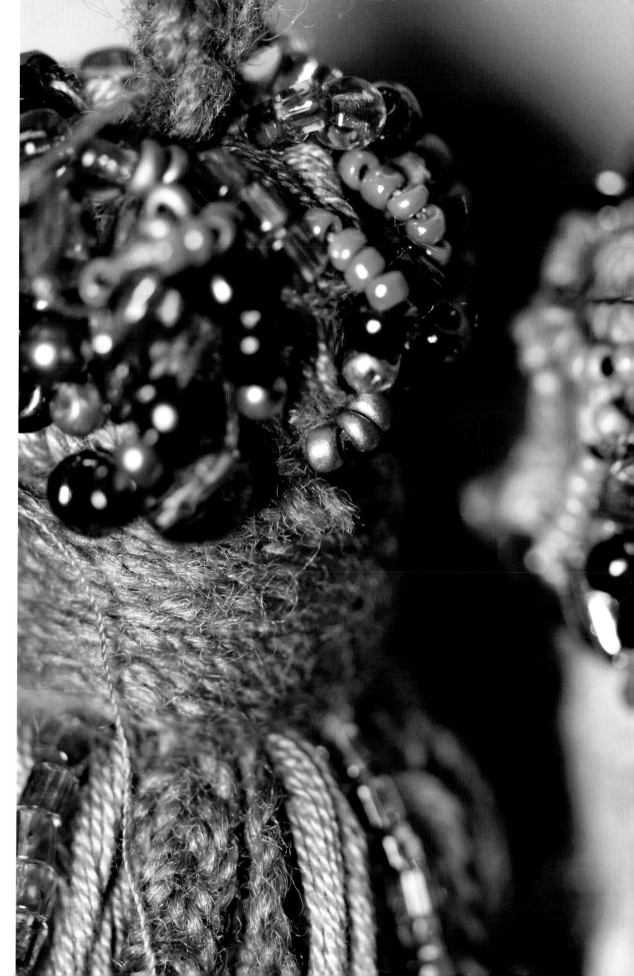

Gallery

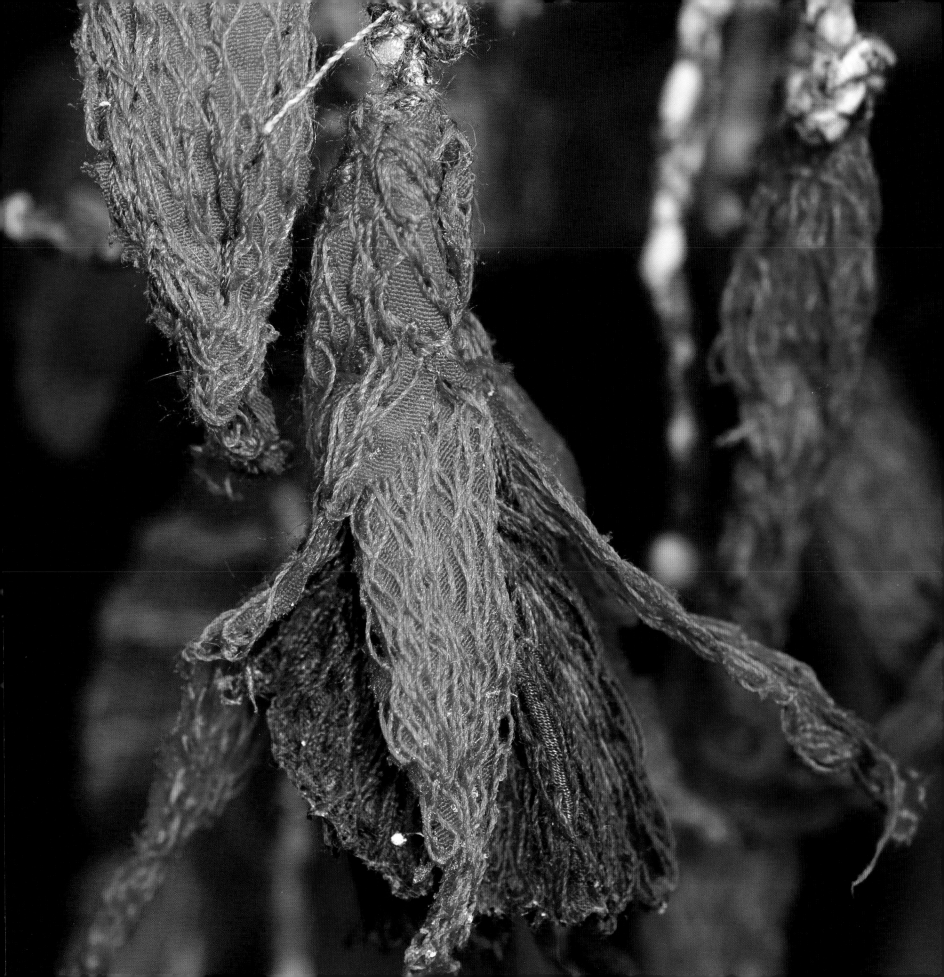

floral explorations

When I entered the classroom for the first time at the start of my adventure into embroidery, I should have guessed that flowers would be my main inspiration. My doodles were, and still are, always flowers of one sort or another. The homework I was given on that first day was to find some botanical images that could inspire my embroidery work over the following weeks. I chose an image of poppy seed heads. I still return to this subject time and time again.

Early embroidery work carried out while studying under the tutorship of Judith Bell in 2002, taking poppy seed heads as my inspiration. I learned so many fabulous techniques at that time – handmade paper from paper pulp mixed with dried leaves, tea and seeds; silk printing; lino printing; batik – to name just a few. Most of these methods I adopted in my later work. I was not afraid to experiment, and learned as much from my mistakes as I did from Judith and my classmates.

Photographer: David Paul Betts, 2002

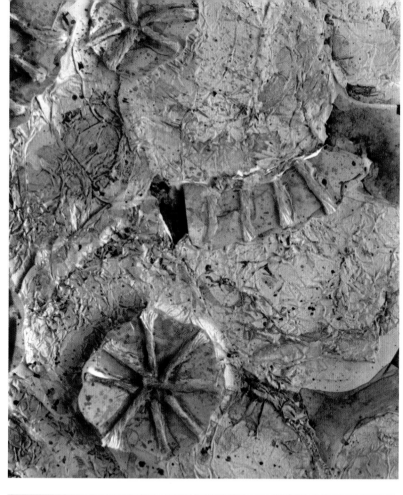
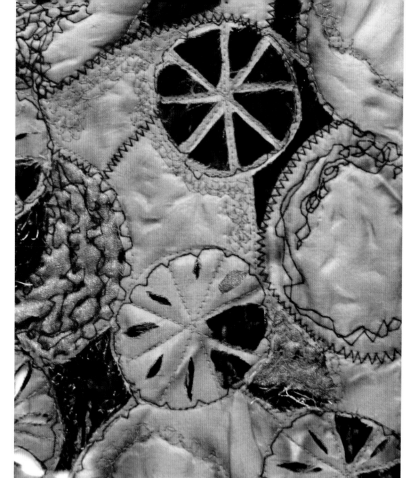
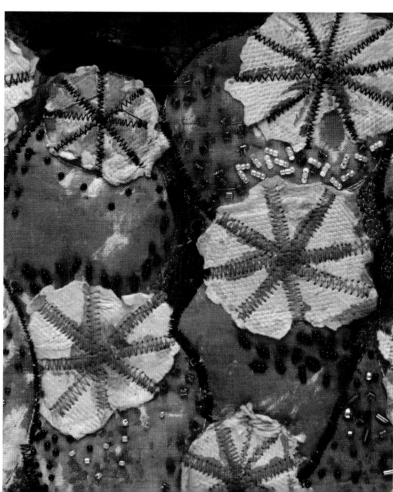
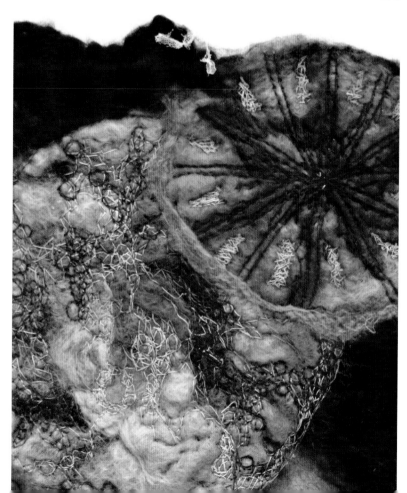

The rose. What is it about the rose? Why do I come back to this flower time and time again? My garden is full of roses. They are easy to grow and I love their deliciously heady scent. The leaves provide a pleasing background for the flower heads, and the seemingly endless variety of shapes, sizes and colours make them a constant source of inspiration. Here, various examples of artworks take roses as their central theme and are developed using a range of materials and techniques.

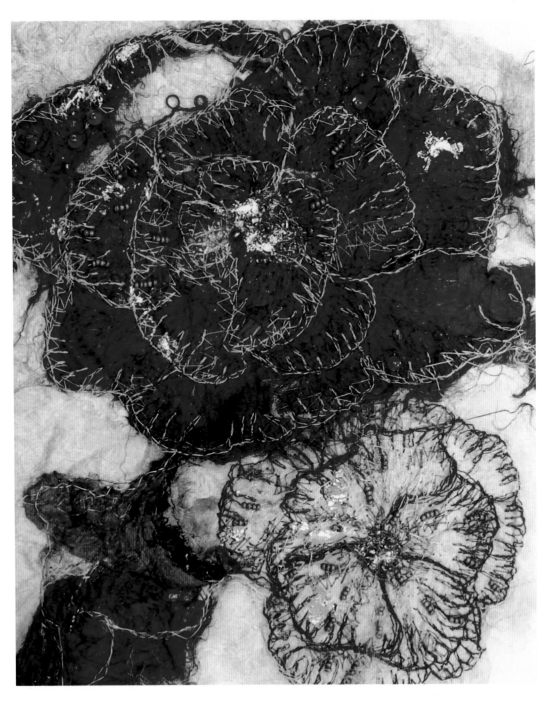

Right, clockwise from top left: tea rose, created using quilting, appliqué and freehand machine embroidery on to batik-dyed cotton sheeting; the Italian quilting technique of trapunto was worked on to devoré silk velvet that had initially been dyed to create a cabbage rose; hand-dyed silk paper made with silk fibres bonded together with wallpaper paste has been left to dry and embellished with beads to create a rosa mundi; wild roses made from felted merino fibres and embellished with machine stitching and glass seed beads.

Left: rosa mundi is a true old rose of early European origin that dates back to the sixteenth century. This piece was produced by machine stitching into handmade silk paper that had been previously dyed. Gold seed beads in the centre of each rose add a finishing touch.

Photographer: David Paul Betts, 2002

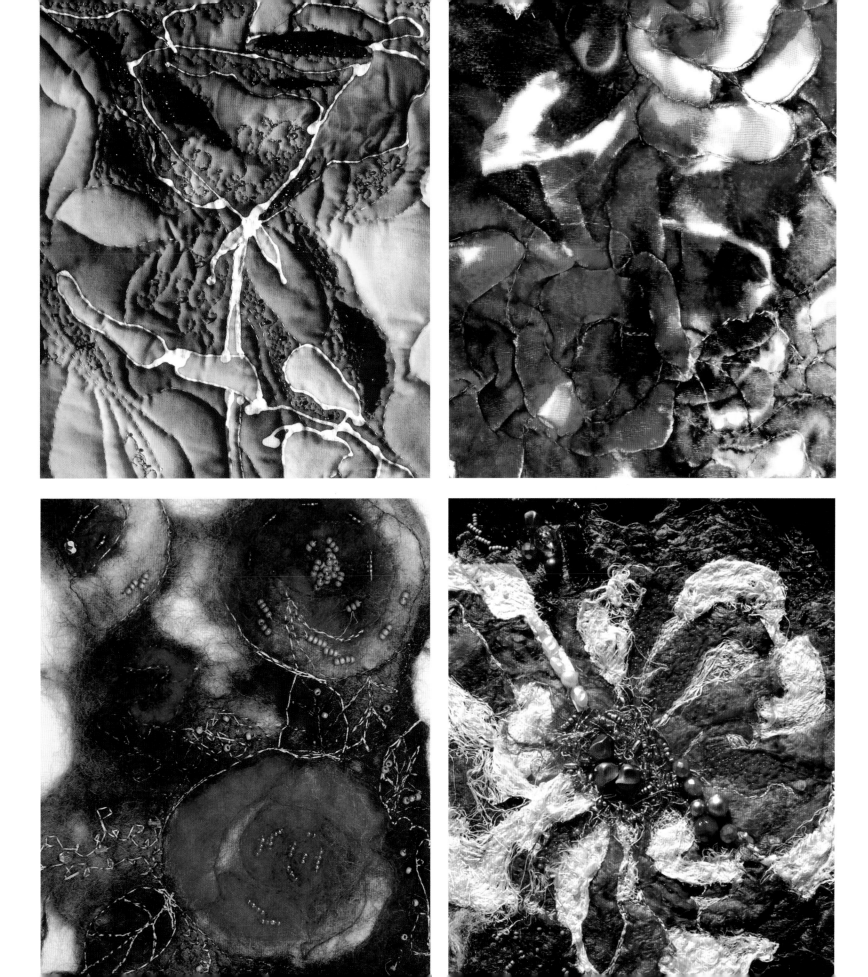

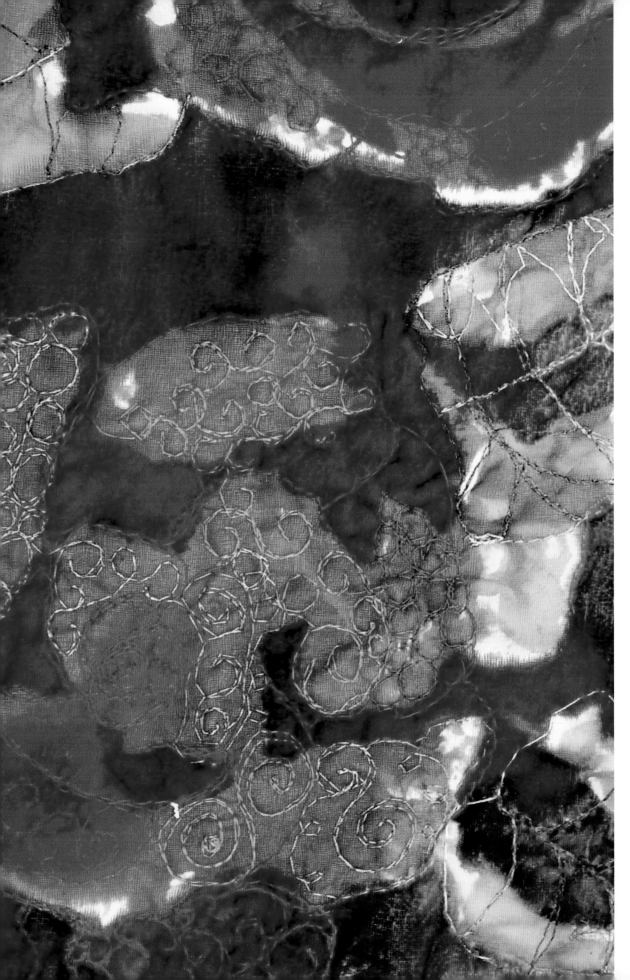

Right, clockwise from top left: layers of silk chiffon fabric have been Italian quilted and cut through, then hand-embroidered French knots added as detail; wool fibres have been sandwiched between layers of tulle and then felted; many layers of fabric have been Italian quilted, then some layers cut back to reveal what lies underneath and beads added as a final touch; felt has been used here, with appliqué and machine stitching.

Left: the space-dyed method was adopted to this piece of devoré silk velvet. Space dyeing is a method of dropping differing shades of dye on to wet material. The dyes merge together naturally producing a softly muted fabric. Machine-stitch work emphasises the leaves and highlights.

Photographer: David Paul Betts, 2002

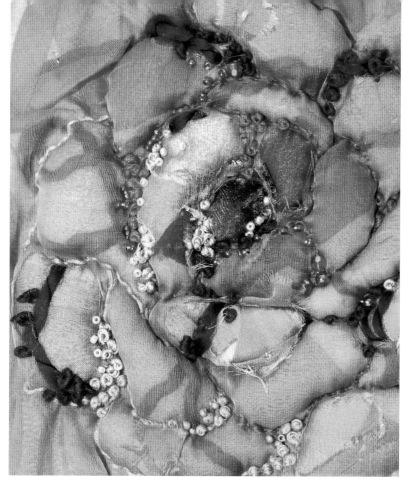
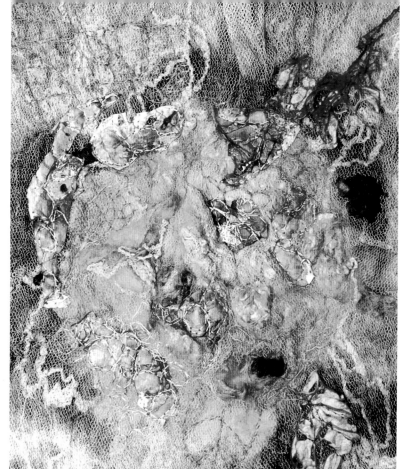
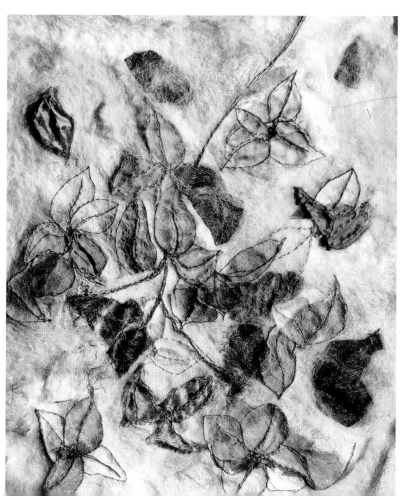
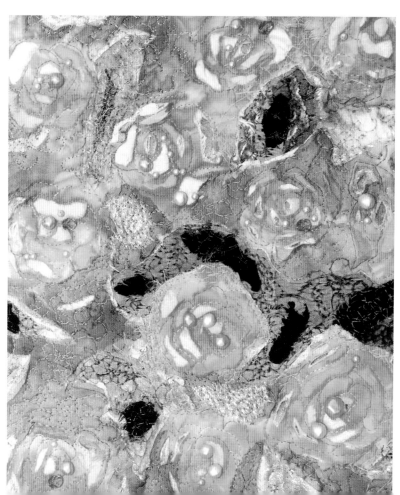

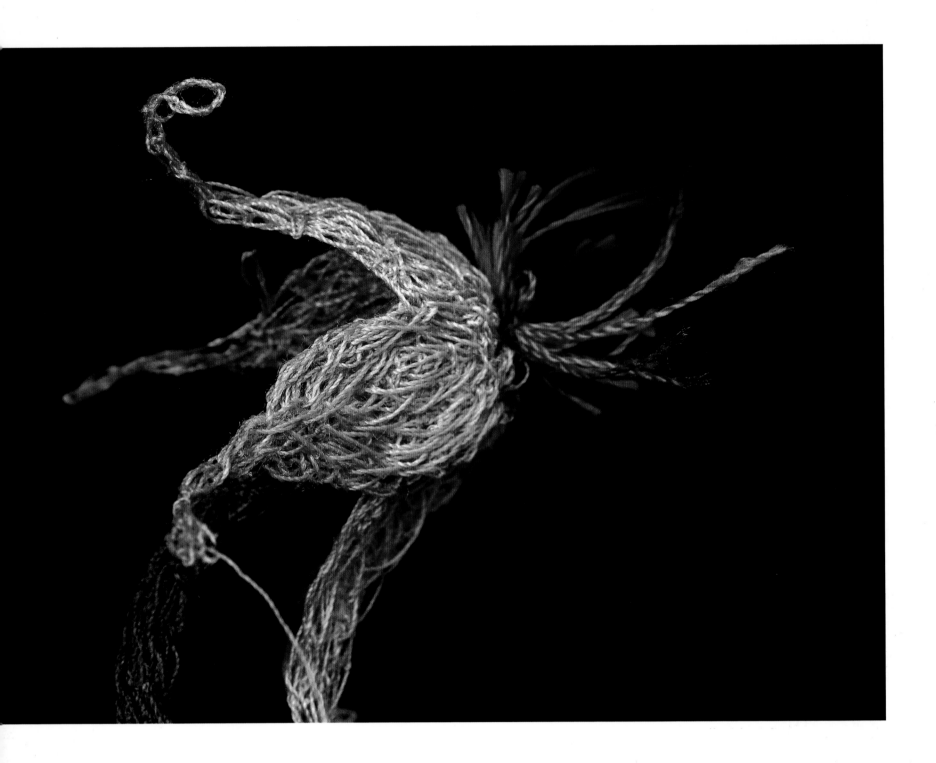

Moving my work on, I discovered a book entitled *Herbarium Amoris: Floral Romance* by Edvard Koinberg. Here, beautiful colour plates of plants are captured against a black background. The striking images fired my imagination, and I knew that I wanted to produce the same effect in my own work.

Right: rose hip plant, worked in thread, fabric and wire. 15 x 14cm (6 x 5½in).

Above: detail

Photographer: Julie Yeo, 2011

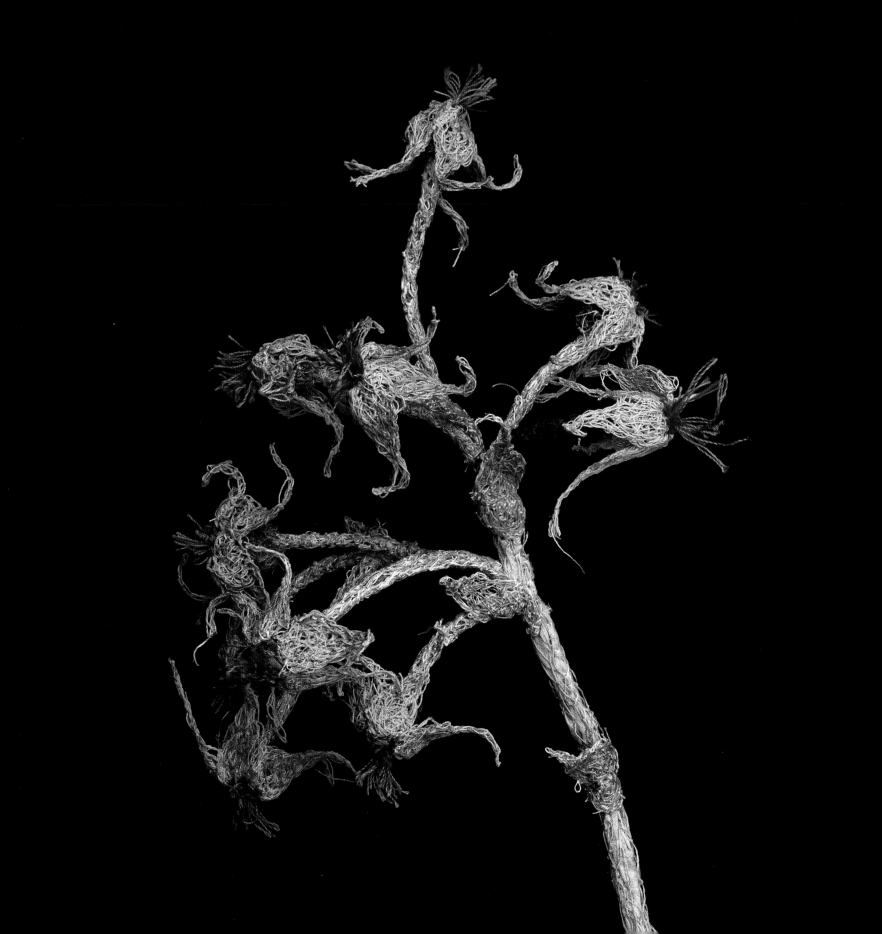

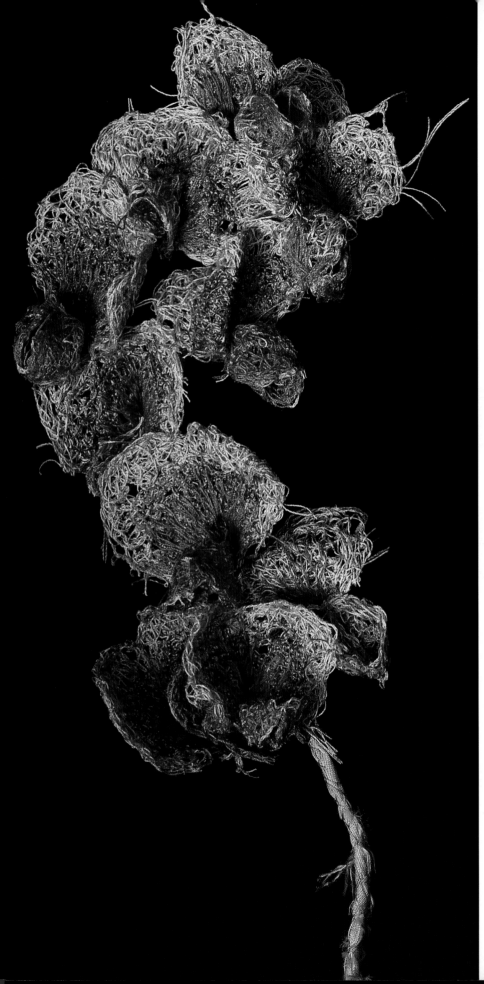

Right: I have nettles in my garden and I usually pull them out without giving them a second thought before they sting me. One morning however, while walking in the forest, the sunlight glistened on the dewy leaves of the common nettle and beauty emanated from this spiteful weed. I was so inspired, I decided to recreate it in my studio using thread, fabric, wire and beads. 40 x 18cm (15¾ x 7in).

Photographer: Julie Yeo, 2011

Left: the sweet pea, native to the Mediterranean, has been cultivated since the seventeenth century for its intense, heady fragrance. I was able to produce the colour graduation on the petals by using several differing shades of thread. 20 x 11cm (7¾ x 4¼in).

Photographer: Julie Yeo, 2011

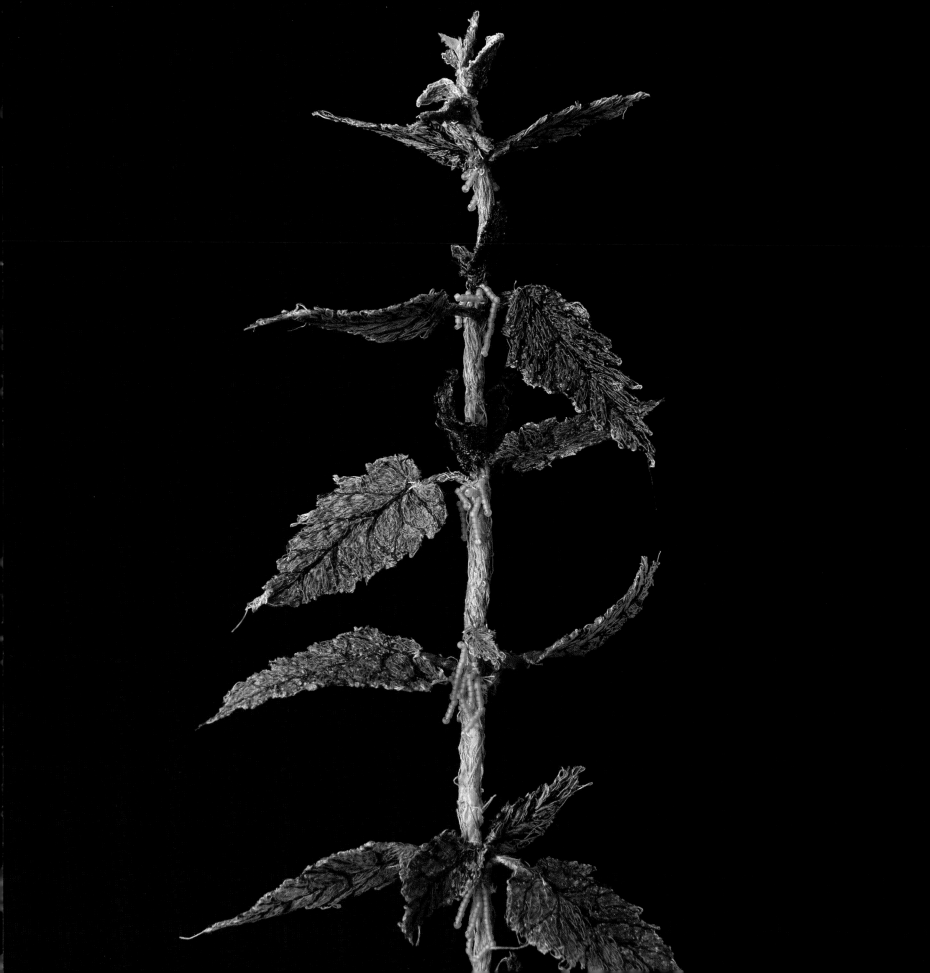

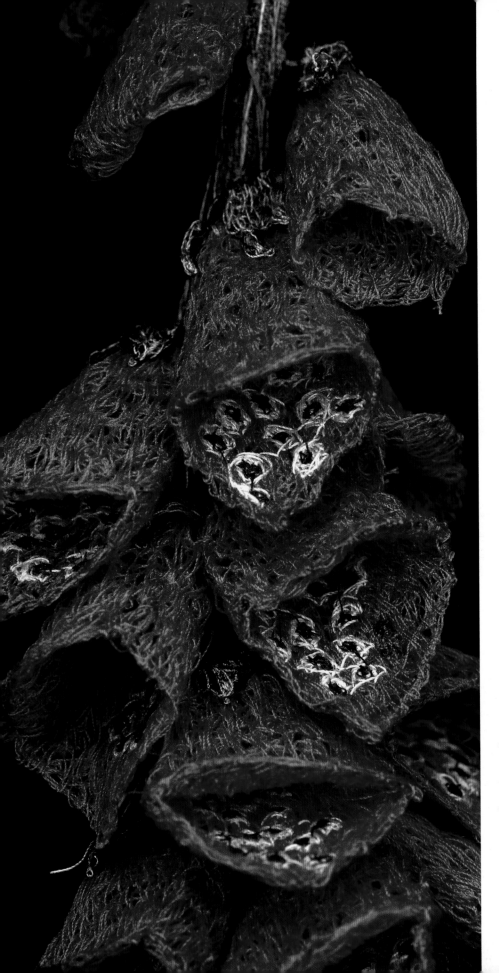

Right: in June my garden is at its best. My roses are in bloom and the spires of the tall foxgloves peep through the lush foliage of my flower beds. I have always felt that foxgloves would make an interesting project. It was not an easy task producing such a lifelike plant. Twenty-two flowers were machine stitched, manipulated into shape and sewn by hand on to the stem, which consisted of stitched silk wrapped around a wooden stick. 57 x 11cm (22½ x 4¼in).

Left: detail

Photographer: Julie Yeo, 2011

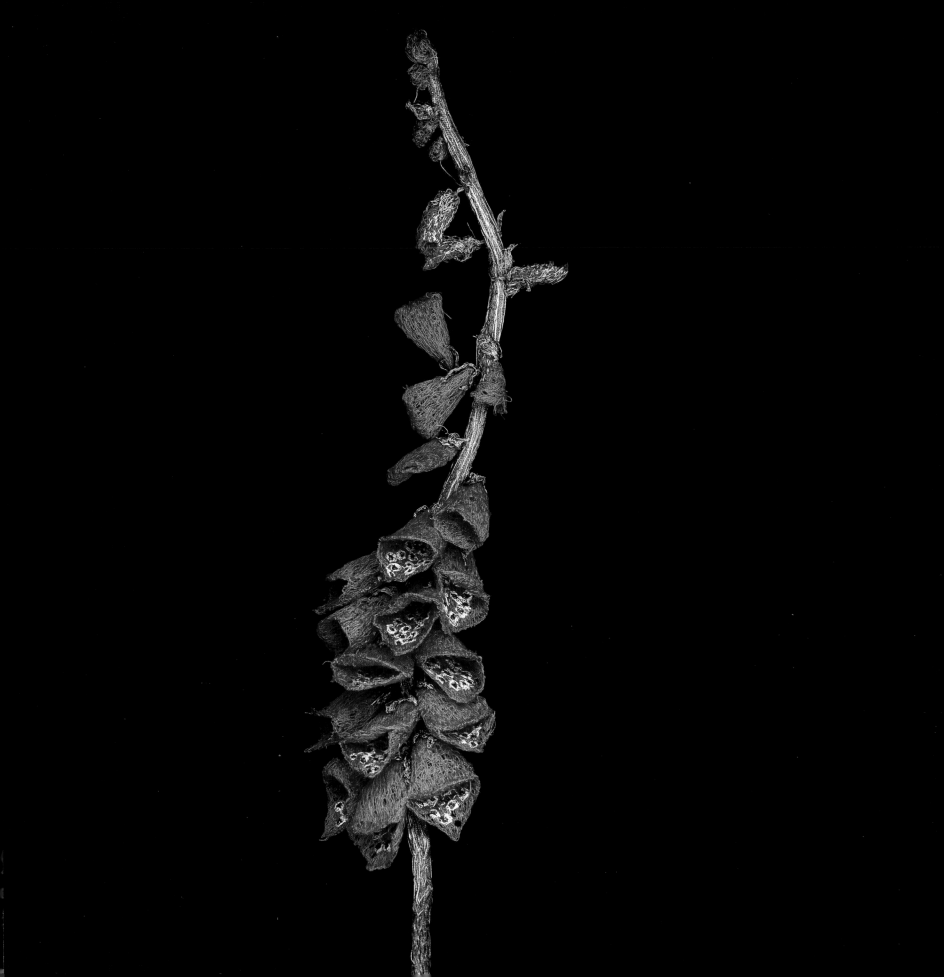

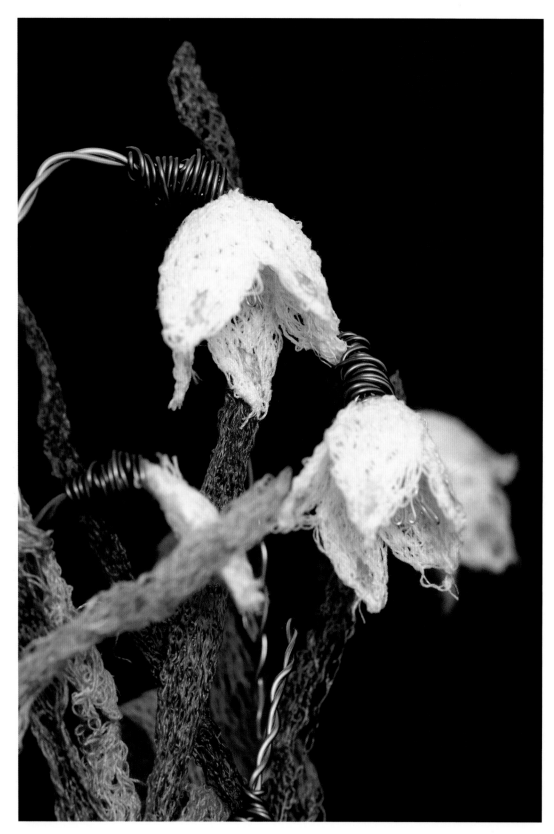

Right: bindweed created from lace, thread and wire. 10 x 10cm (4 x 4in).

Left: I made a snowdrop tiara for a bride to complement her gown. The bodice was enriched with hand-embroidered snowdrops, while the tiara had three-dimensional flowers and foliage. 19 x 15cm (7½ x 6in).

Photographer: Julie Yeo, 2011

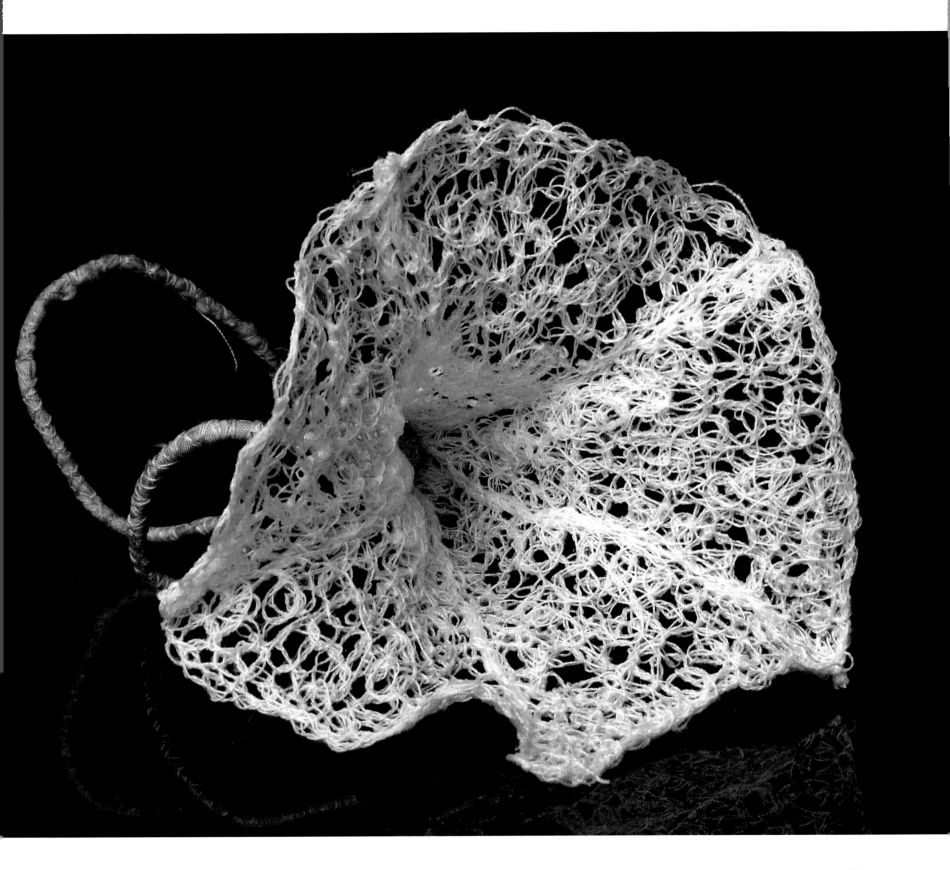

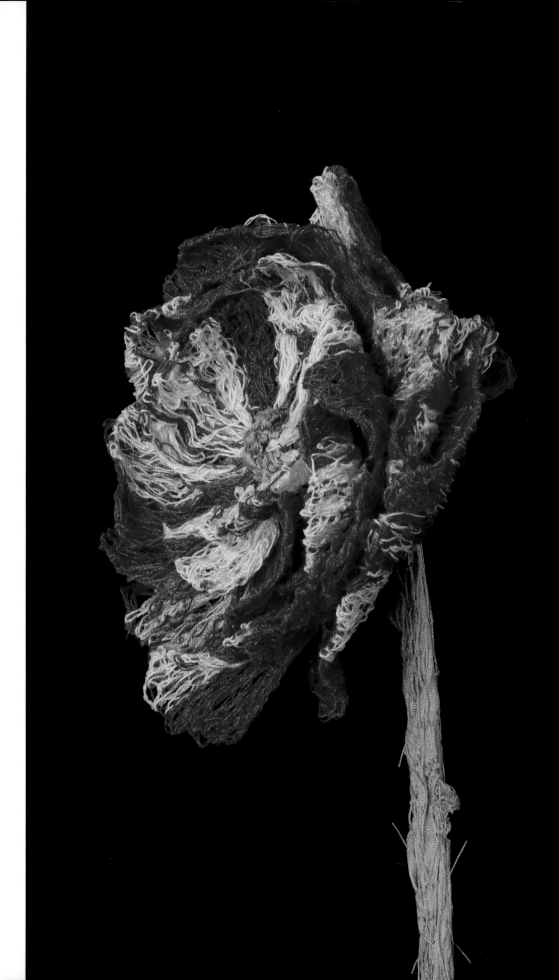

The rosa mundi is the oldest variety of rose in Britain, bearing crimson flowers striped with white. This version was created using thread, fabric and wire. French knots have been used to mimic stamens.

Photographer: Julie Yeo, 2011

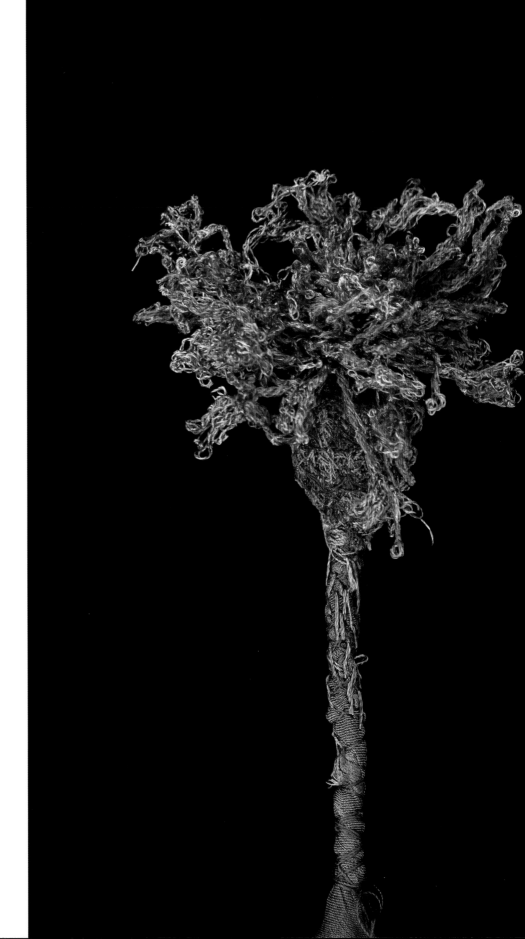

The thistle – the floral emblem of Scotland. While walking, I picked one to study at home, but by the time I got round to working with it, the flower head had completely dried out. This happy accident gave the specimen a new architectural interest. The head consists of linking machine stitching on water-soluble fleece; the trunk and stem is stitch work on fabric.

Photographer: Julie Yeo, 2011

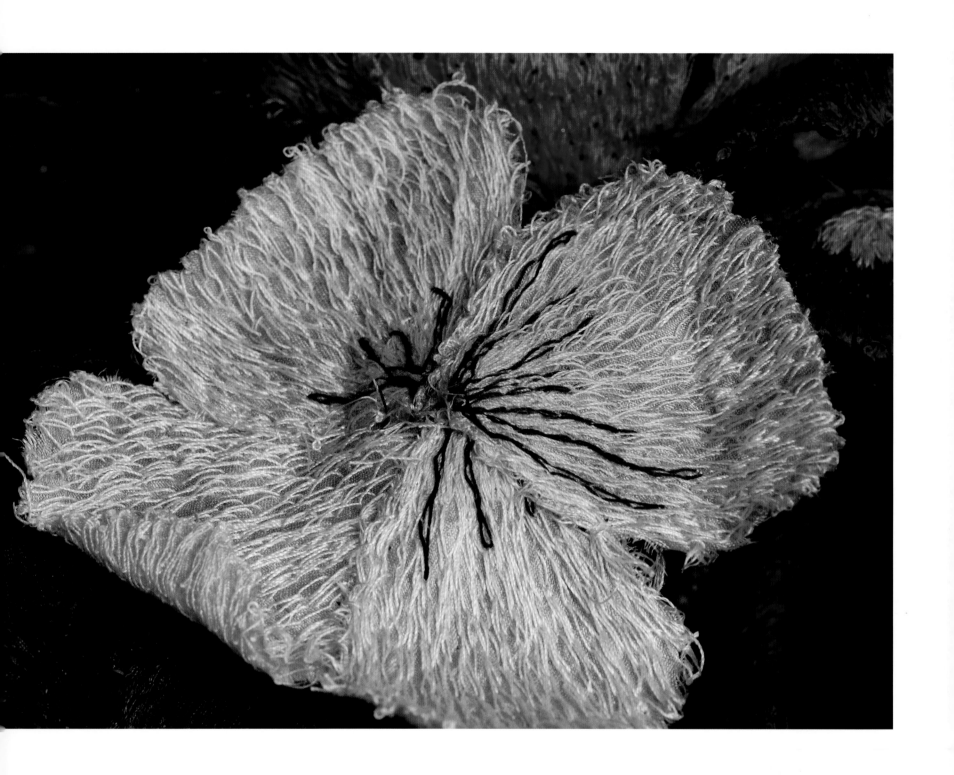

Right and left: details of the pansy hat shown on page 90.
Photographer: Julie Yeo, 2010

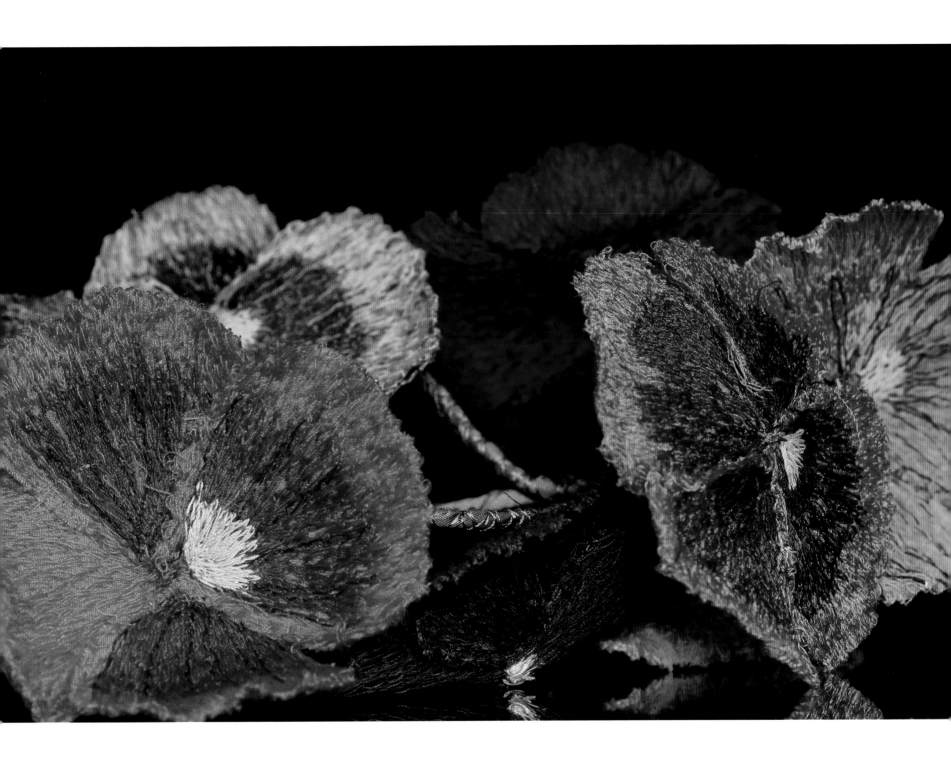

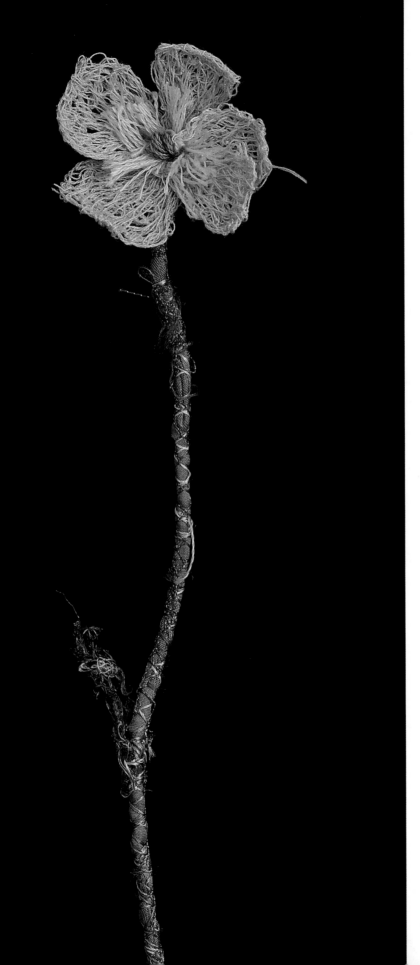

Right: primroses, first used on one of my little handbags, take on a new twist. The flower petals are free machine embroidered on to water-soluble fabric while the stems have silk as a base and wood as a support.

Left: a single, delicate buttercup. Free machine embroidery was used to create the petals with silk fabric-wrapped wire for the stem. 25 x 4cm (9¾ x 1½in).

Photographer: Julie Yeo, 2011

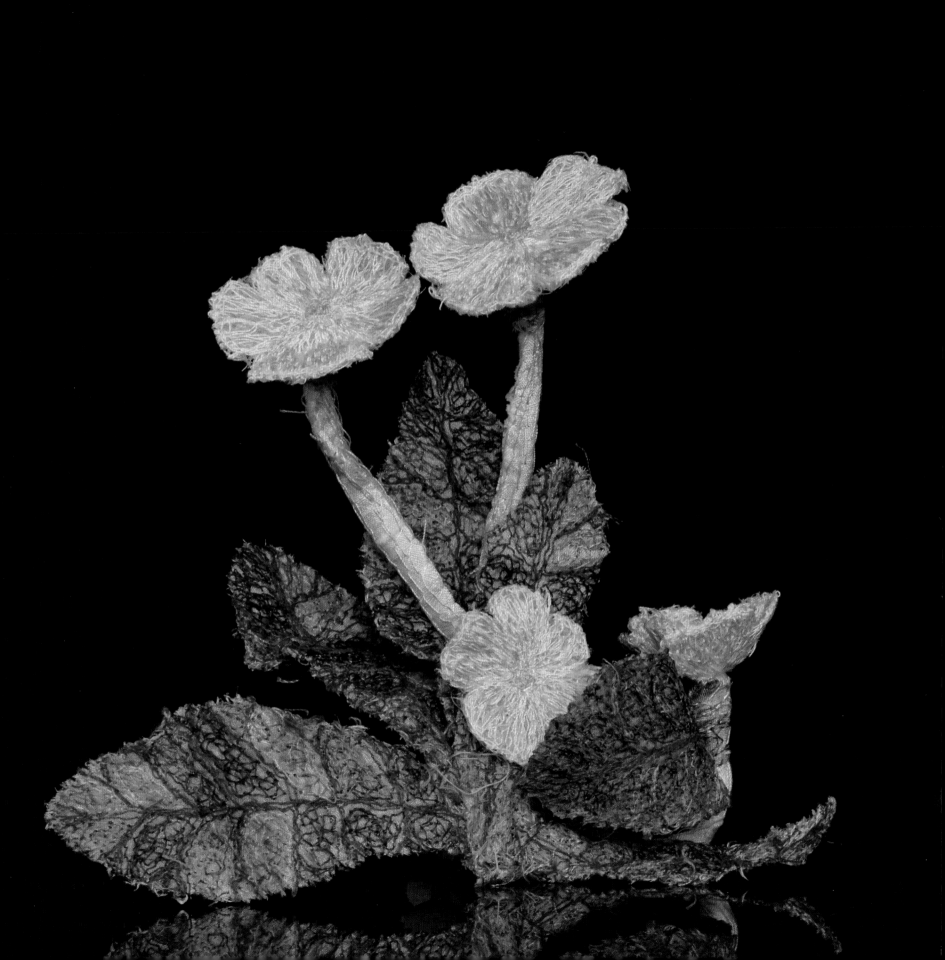

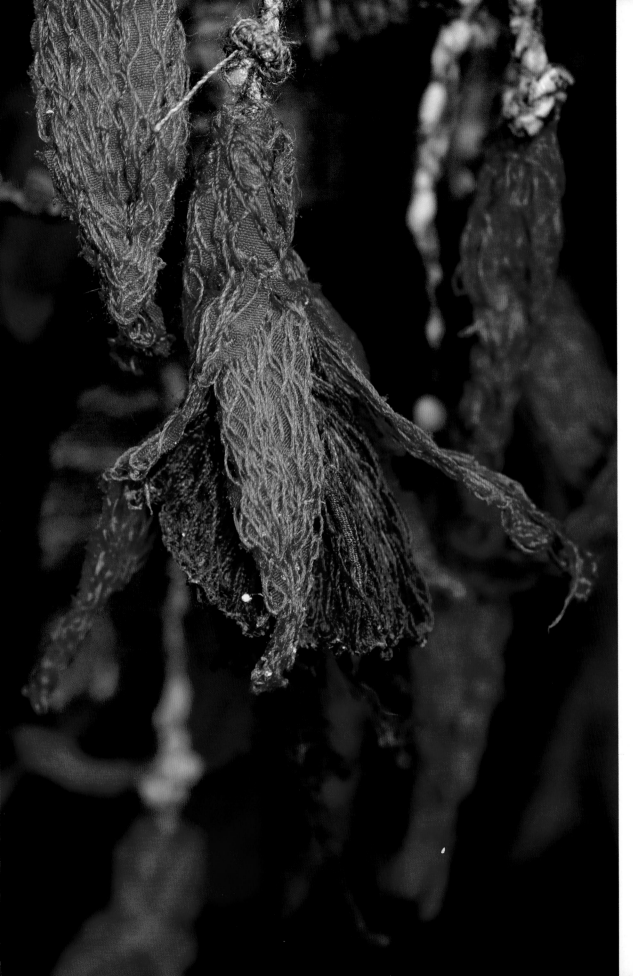

Right: the same techniques were used on this corn poppy as the bindweed piece on page 49. The seed capsule in the centre of the plant was created with a little felt wrapped with embroidery twist. The stamens are numerous looped embroidery threads, twisted and then cut. The threads unravel naturally and splay out.

Left: the fuchsia produces a splash of vibrant colour from summer right through to the cold winter months. The variety I have chosen to recreate in stitch has prima ballerina flowers borne in profusion on pendulous branches. Great enjoyment was had creating a little bag and hat from this amazing shrub.

Photographer: Julie Yeo, 2011

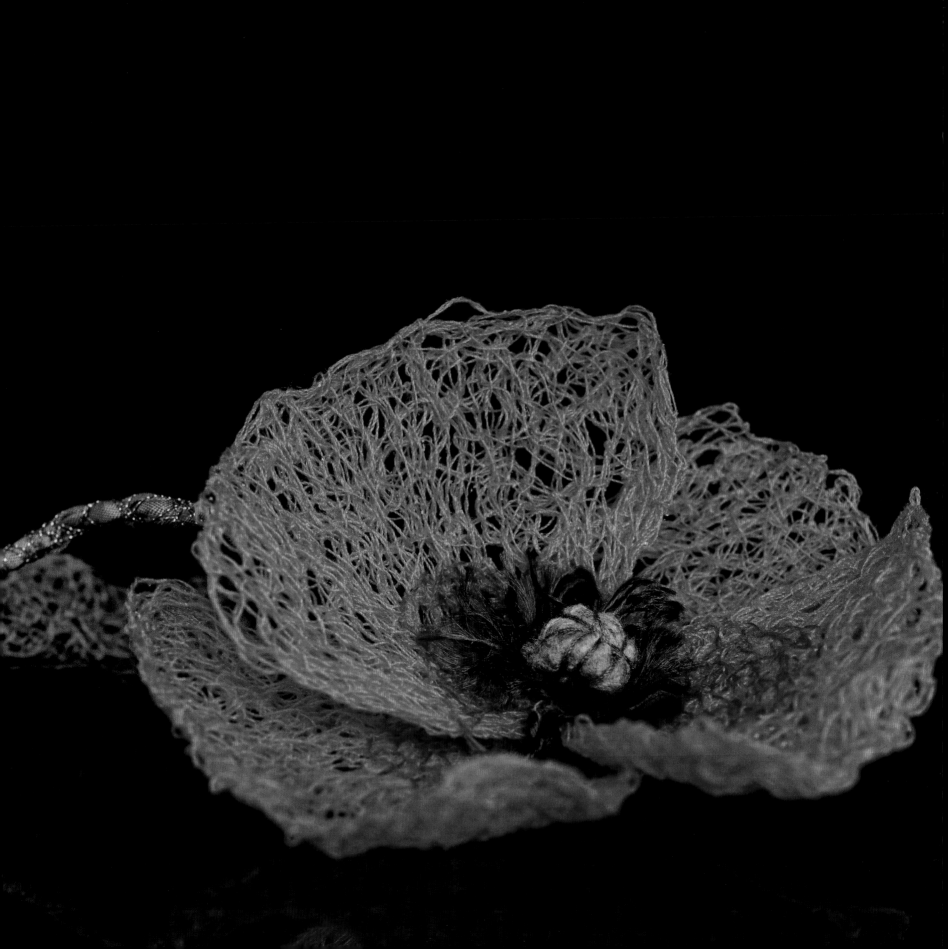

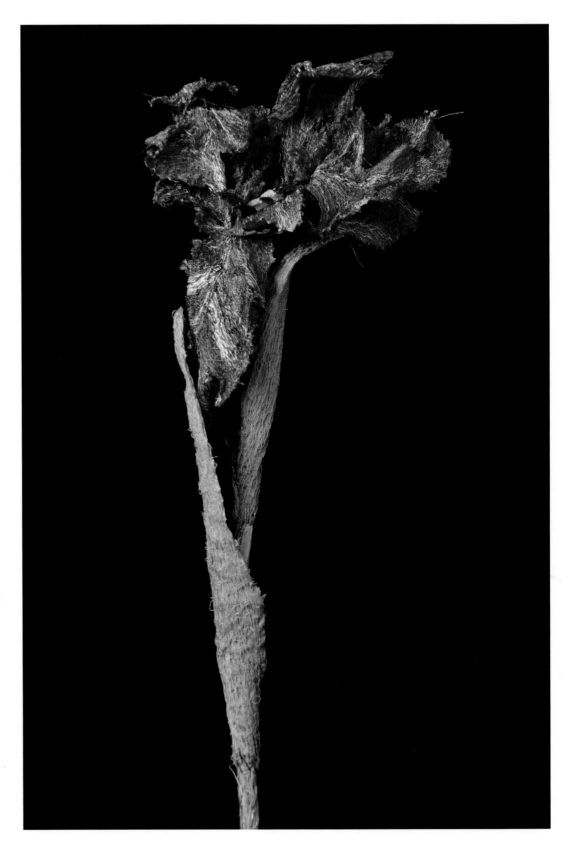

Right: tulip made with thread, fabric, wood and wire. The variegated varieties of parrot tulip – so admired by the Dutch masters during the seventeenth century – here take on a new life. A silk base fabric was used throughout this piece with wire embedded into the petals for movement and wood supporting the stem. 37 x 12cm (14½ x 4¾in).

Far right: hellebore made with thread, fabric and beads. These flowers have a fabric base for the stitch, the stamens are frayed embroidery twist, and lime green glass beads are used as nectaries in the flower centres. 11 x 11cm (4¼ x 4¼in).

Photographer: Julie Yeo, 2011

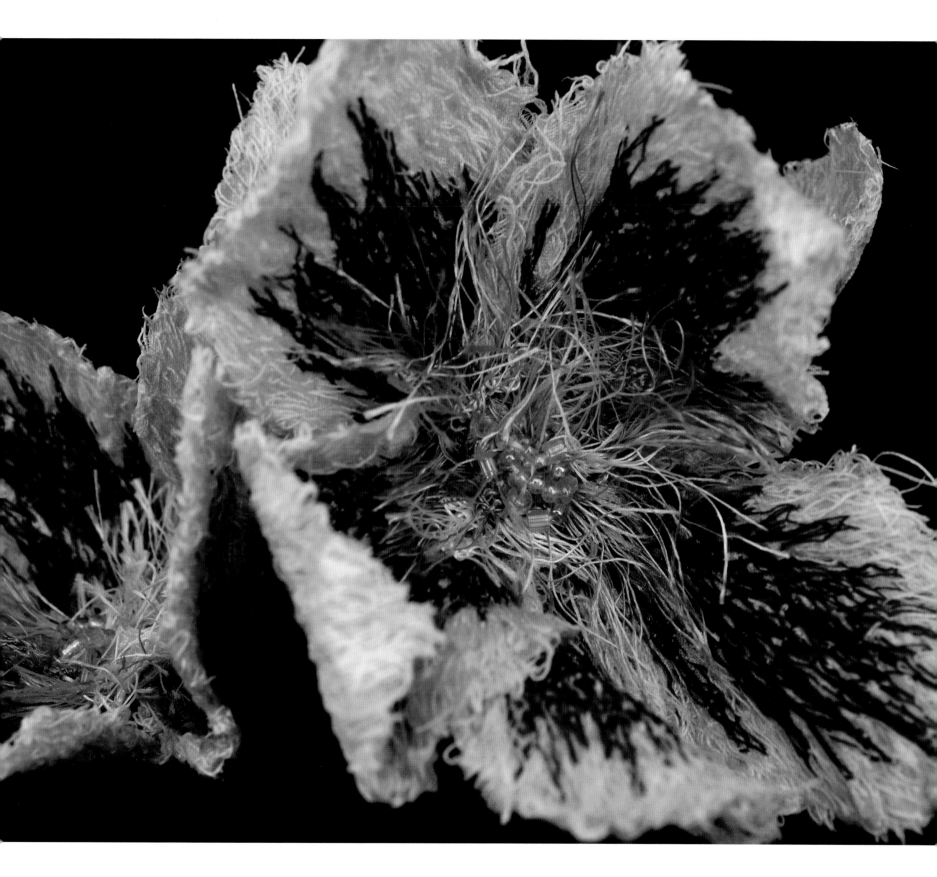

gowns

Making bridal gowns was a natural progression for me. I use embroidered embellishment to transform and give depth to the simplest gown, making it truly memorable. Embroidery is synonymous with luxury and elegance. It creates three-dimensionality and, in devising my collections, I took references and inspiration from the Renaissance and pre-Raphaelite painters.

Working with brides led to a natural progression into children's gowns. Here my inspiration came directly from the pages of the *Flower Fairies* books of Cicely Mary Baker, and my imagination could truly run wild.

If you go down to the woods today ...
Machine embroidered ivy leaves and flowers decorate the bodice of this handmade tulle gown, reminiscent of the ivy flower fairy. The tiara was made from vintage pearl beads and sculpted with wire.
Photographer: David Paul Betts, 2004
Model: Shay Smith

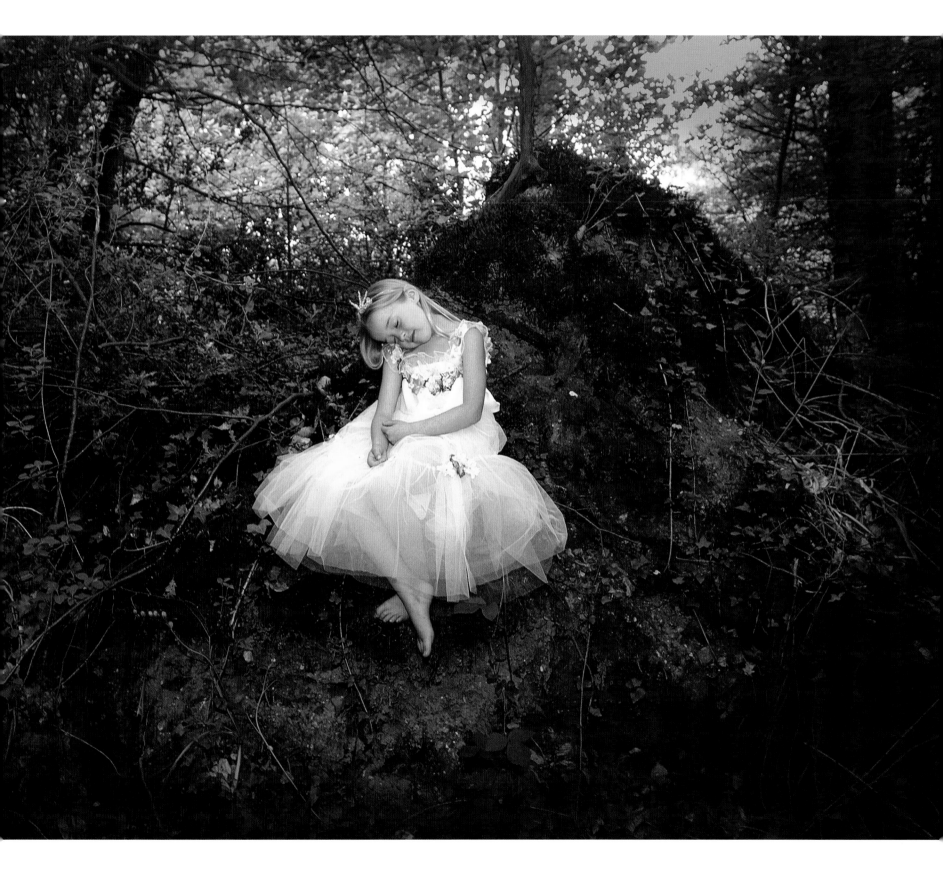

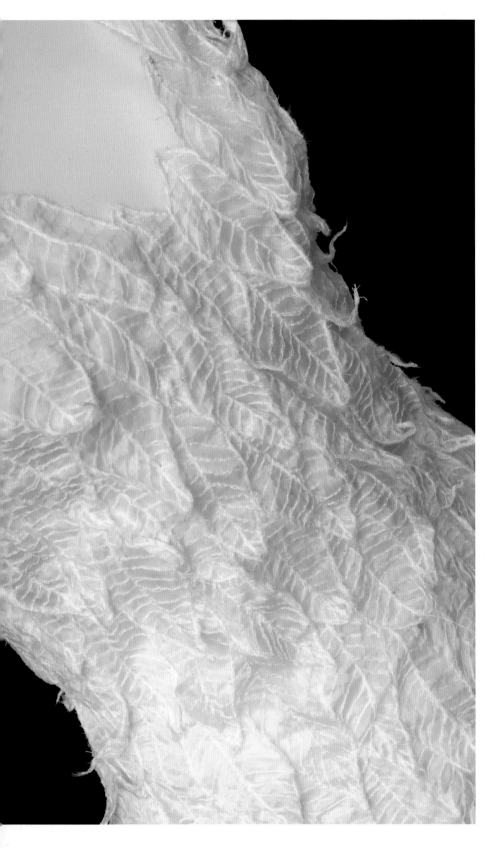

This bridal gown was commissioned by Smythson to be exhibited in their Bond Street window to commemorate the royal wedding of HRH Prince William to Katherine Middleton. Never in my wildest dreams would I have believed this opportunity could come my way. The gown consisted of many hundreds of silk organza leaves, each one made individually, pinned into place, then carefully hand stitched. I had used this technique before when I made the poppy-head shoe, shown on page 113, so I knew it would work well as a gown. The gown was dyed in a colour gradient, starting with white and progressing to ivory through to fudge. Tea was used to graduate the colour. This piece took three months of painstaking work, but the joy of the finished result made this a small sacrifice.

Right: Sospiri gown (*sospiri* is an Italian word meaning 'gown').

Left: detail

Photographer: Julie Yeo, 2011
Model: Chanel Baker

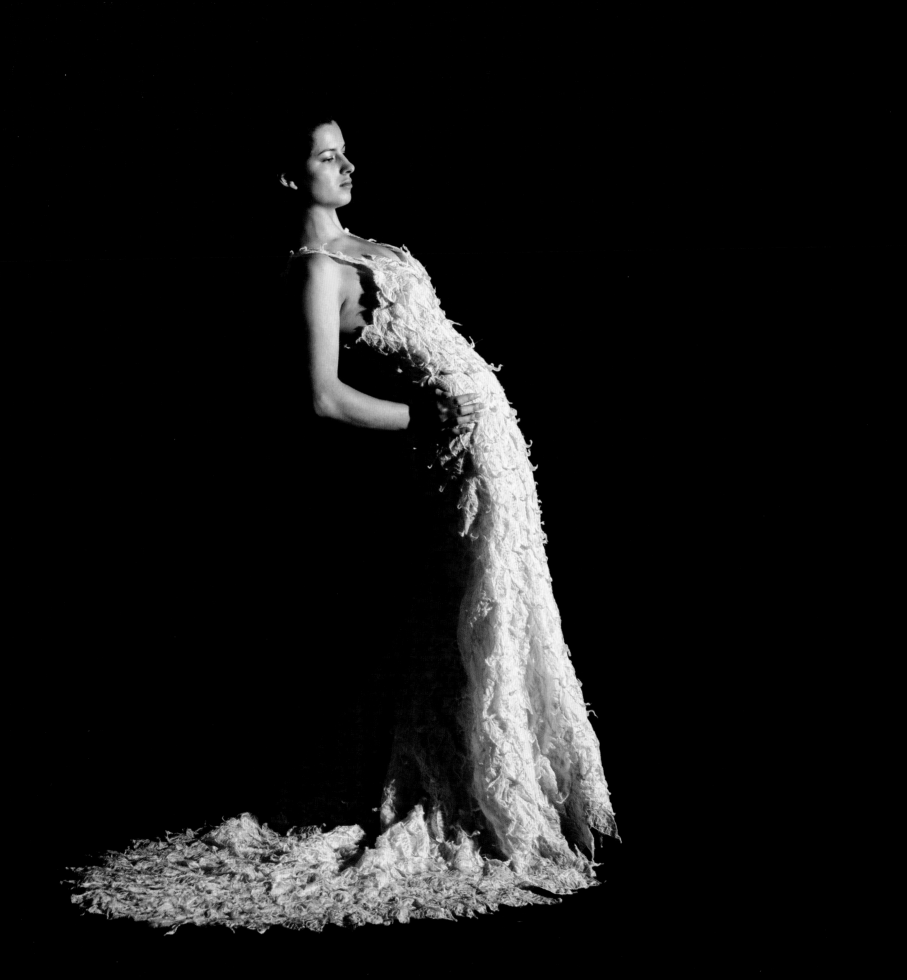

Above: the Sleeping Beauty gown was from my first collection and is my personal favourite. Lavish detail was applied to the bodice, as to all the gowns on this collection, my aim being to entice the brides away from high-street gowns. This collection was photographed and modelled by friends in the forest next to my home.

Photographer: David Paul Betts, 2001
Model: Charmaine Randall

Far right: the Cinderella gown was photographed at the Portsmouth Guildhall steps. Getting Charmaine into her gowns proved a problem, but luckily we found a quiet corner and I held up a large sheet to block the public's view. The bodice was inspired by the work of textile artist Richard Box.

Photographer: David Paul Betts, 2003
Model: Charmaine Randall

Right: Esmeralda gown. This two-piece silk velvet gown has a crushed velvet, Elizabethan-style boned corset encrusted with vintage beads and embroidery. The bias-cut skirt has a fluid drape and ends beautifully with a puddle train.

Photographer: David Paul Betts, 2003

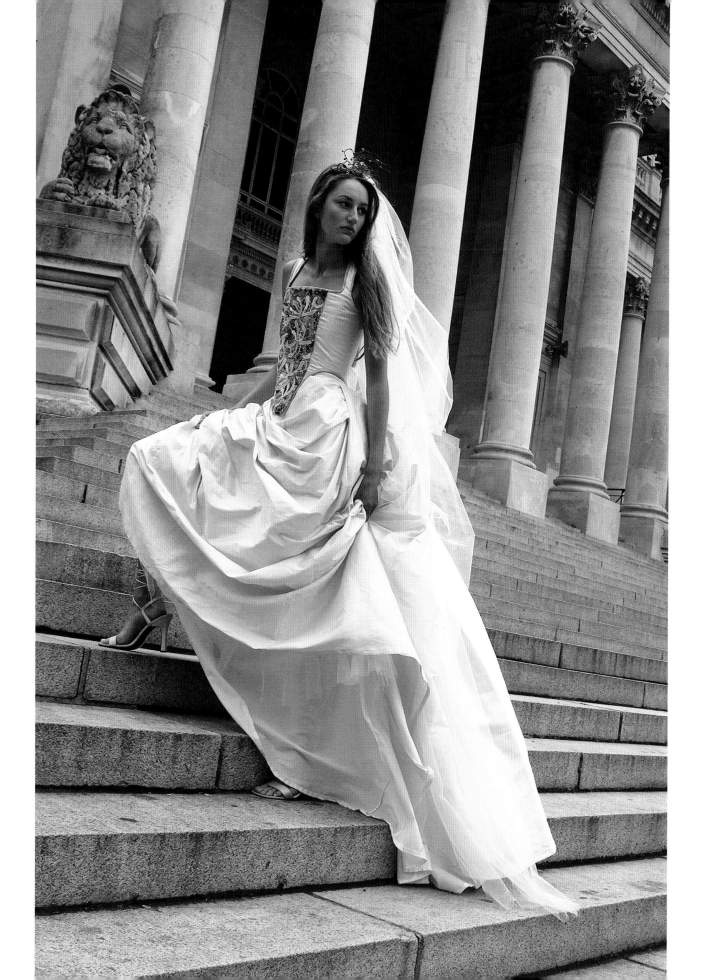

bags

Embroidered bags were a move away from the monotone colours of the bridal gowns I was used to working with. I had learned some fabulous techniques and now felt ready to move on, away from the bridal arena.

My thinking behind this range was to make useable art; pieces of embroidered art designed to be used, then hung on the wall. I wanted each bag to be as different as the person who bought it, which gave limitless possibilities for enhancing their unique appeal.

Each bag was made of felt or hand-dyed and devoréd silk velvet with a base of buckram for strength and stability. The bags were richly embellished with different forms of embroidery and a variety of materials and adorned with wire and glass-bead handles.

Photographer: David Paul Betts, 2006

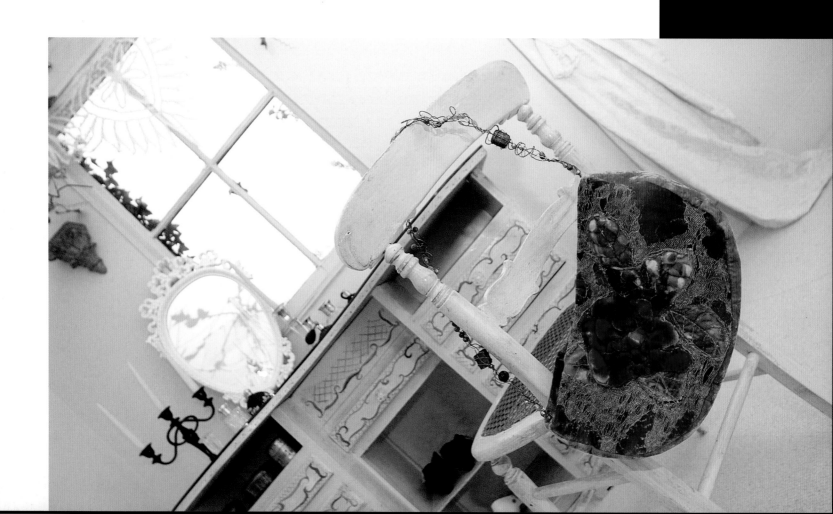

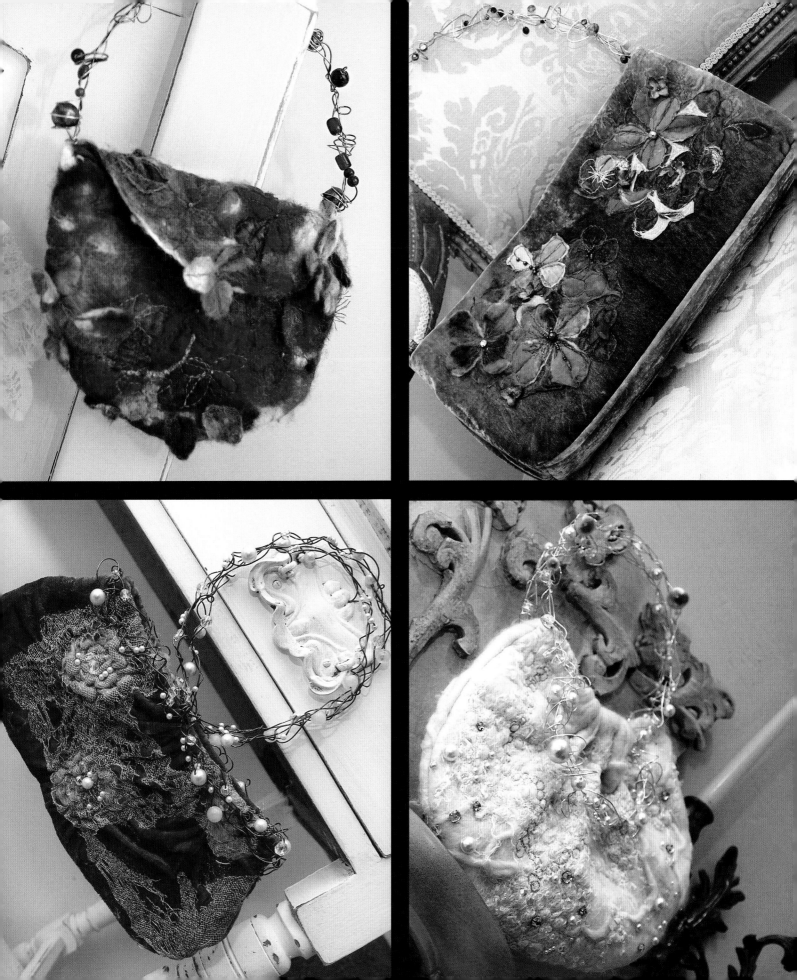

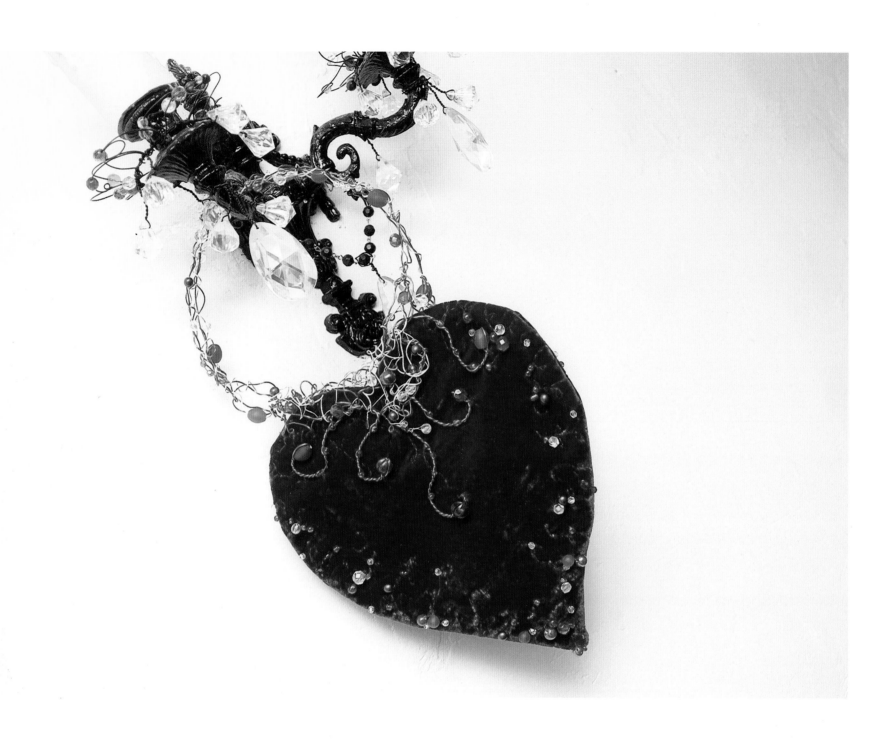

This decadent little sweetheart bag has a luscious, deep red velvet base
and is adorned with machine-stitch work and Swarovski crystal beads.

Photographer: David Paul Betts, 2006

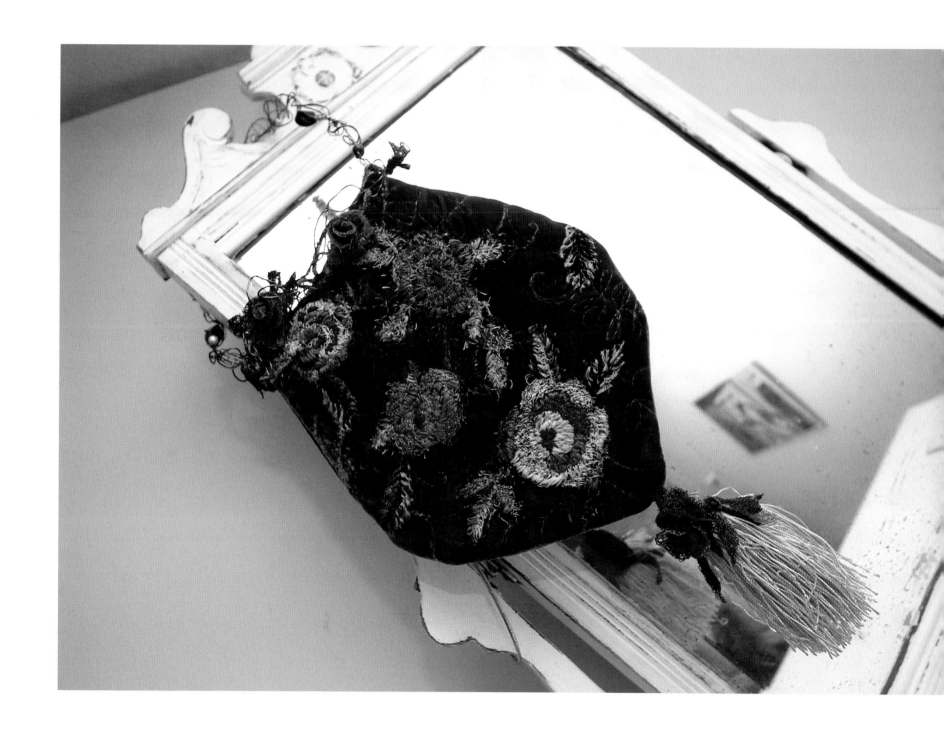

Deep purple silk velvet makes a perfect background to the hand- and machine-embroidered roses. Crafted three-dimensional roses and leaves sit quietly at the opening and on the gold tassel.

Photographer: David Paul Betts, 2006

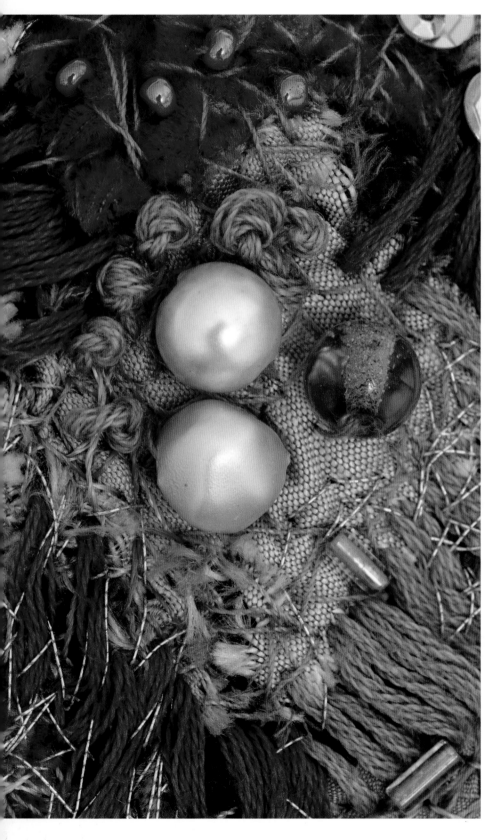

My journey into bags led me inevitably into scarves. The thought that I could make matching scarves and bags appealed. I had dabbled with scarves at college and I became enthused with the idea.

My scarves are works of art, like my handbags; luscious silks for the base with embroidery embedded on top. Embroidery can enrich the most basic, practical garment and turn it into something really special. Elaborate silk tassels adorned with beads hang from each end of the scarf and transform into something extraordinary.

Right: this felt scarf started life as a belt, designed to sit on a long flowing skirt, but for some reason it did not work. Its three-dimensional form looked too cumbersome over the hips. It was a beautiful piece and deserved to be displayed and, with a little playing around, I discovered it made a fabulous scarf. A multi-coloured felt base has silk fabrics appliquéd into it with hand and machine embroidery. Various beads and sequins finish off the piece. 83 x 15cm (32¾ x 6in).

Left: detail

Photographer: Julie Yeo, 2010

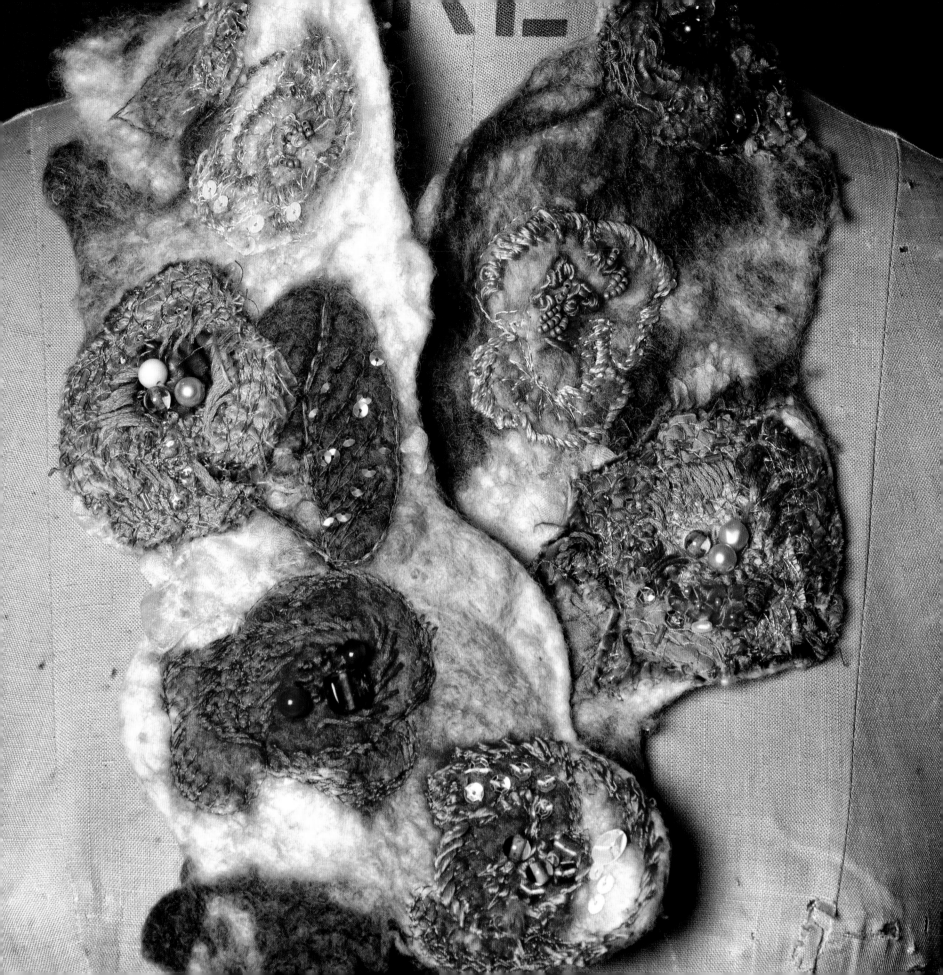

With my new three-dimensional techniques well and truly thought out, I decided to make my bags three-dimensional too. It was the spring, and inspiration was everywhere. Once I have a glimmer of an idea, it spawns a chain reaction from which new ideas grow and develop.

This bouquet bag was designed to be exhibited along with the bridal gown Sospiri (shown on page 63) in the shop window of Smythson to celebrate the royal wedding of HRH Prince William to Katherine Middleton.

Far right: this is one example where my initial idea did not work out. Rethinking the design, it re-emerged like a phoenix from the ashes as this creation. Shell-coloured, felt roses were added giving the bag a soft focus, while the green velvet flowers of the tropical *Celosia argentea*, a florist's favourite, add a splash of colour and texture. 51 x 20cm (20 x 7¾in).

Right: detail

Photographer: Julie Yeo, 2011

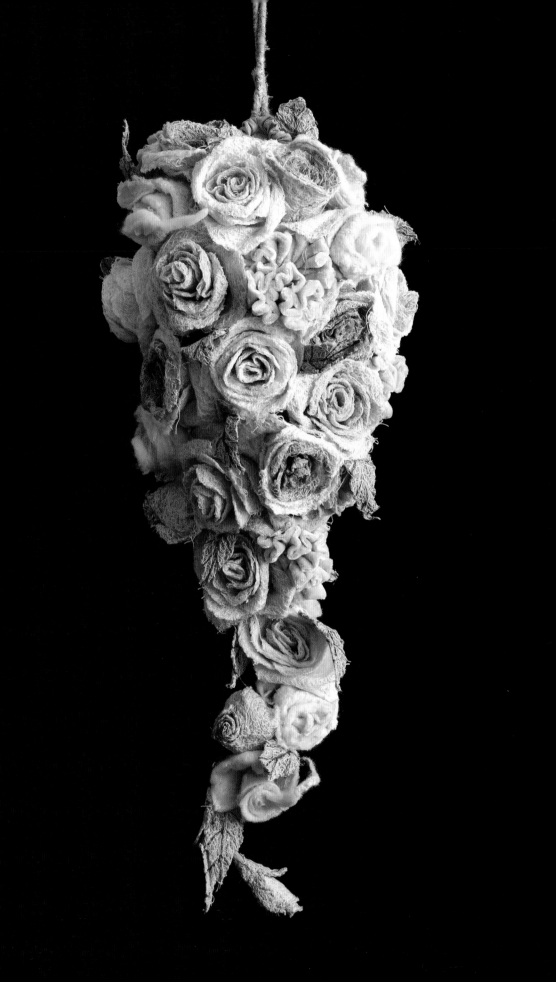

Right: in the spring, my garden is littered with bluebells, and it is from these that I took my inspiration for the bluebell bag. I have never planted bluebells – they appear as if by magic. My biggest challenge was in deciding which shade of blue thread to use for the bell-shaped flower heads – the flowers in my garden range from white, through lavender to blue. The white base fabric complements the blue and green of the flowers and gives the bag a fresh, bridal feel. 20 x 8cm (7¾ x 3¼in).

Above: detail

Photographer: Julie Yeo, 2010

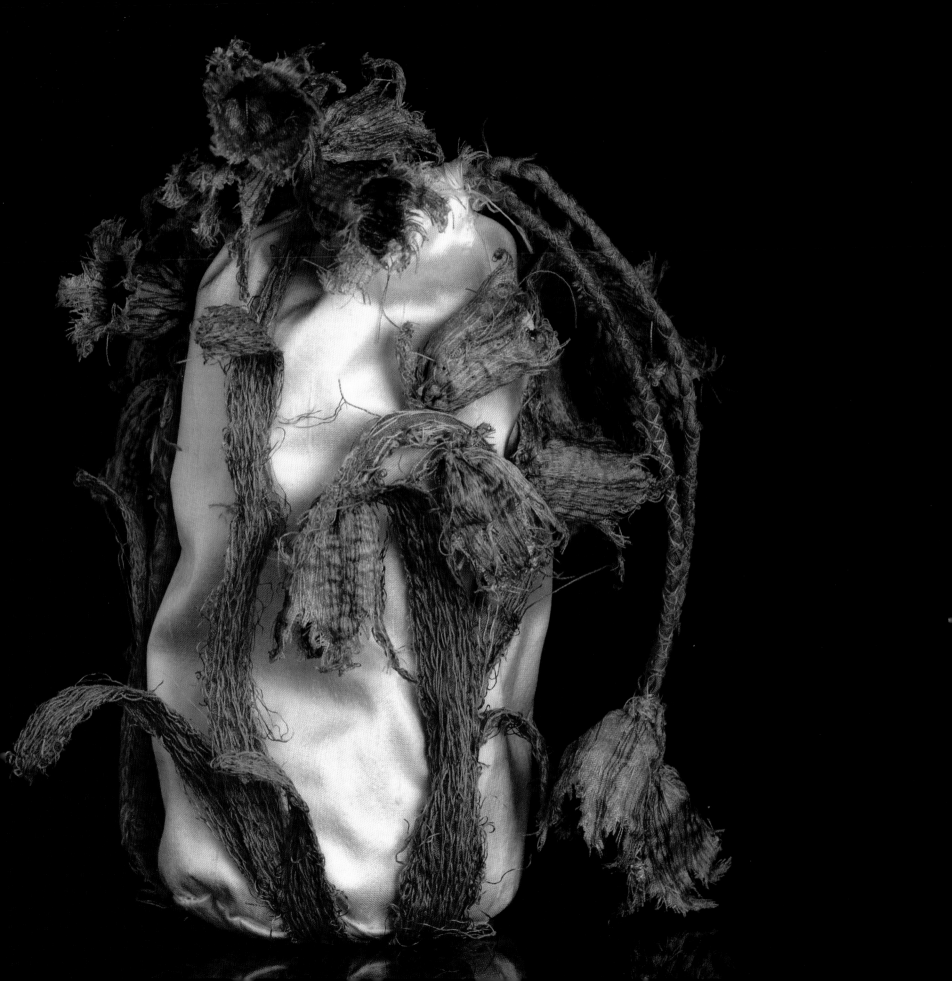

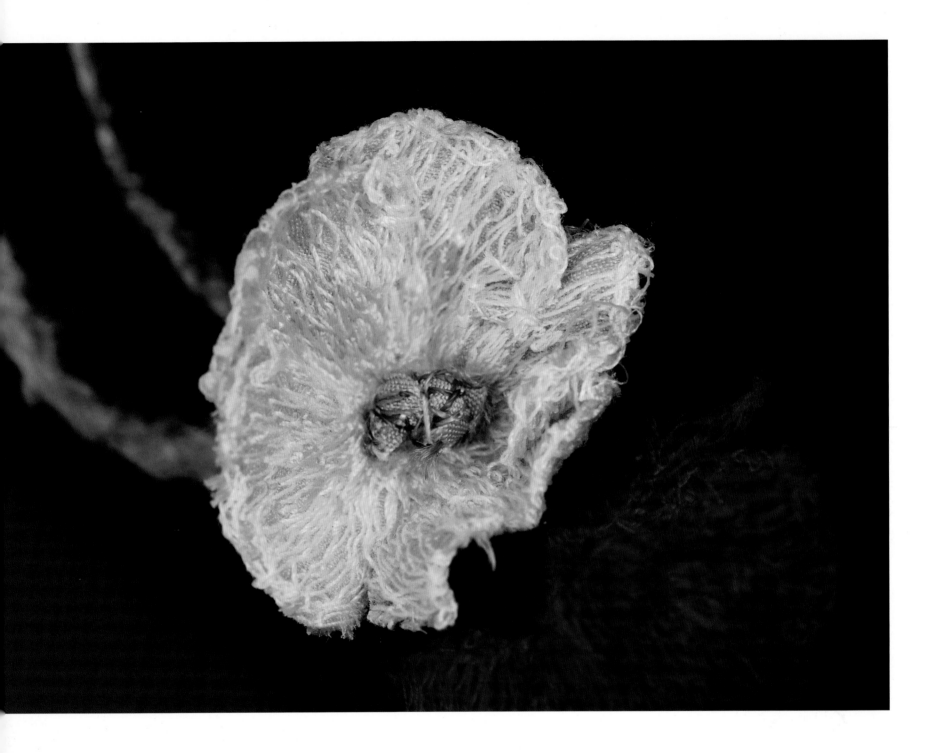

Right: the first of its kind, this was my first endeavour to produce a unique dolly bag. Like a wild primrose, the work grew up and around, from all angles, to form its pleasing rotund shape. 13 x 10cm (5 x 4in).

Above: detail

Photographer: Julie Yeo, 2010

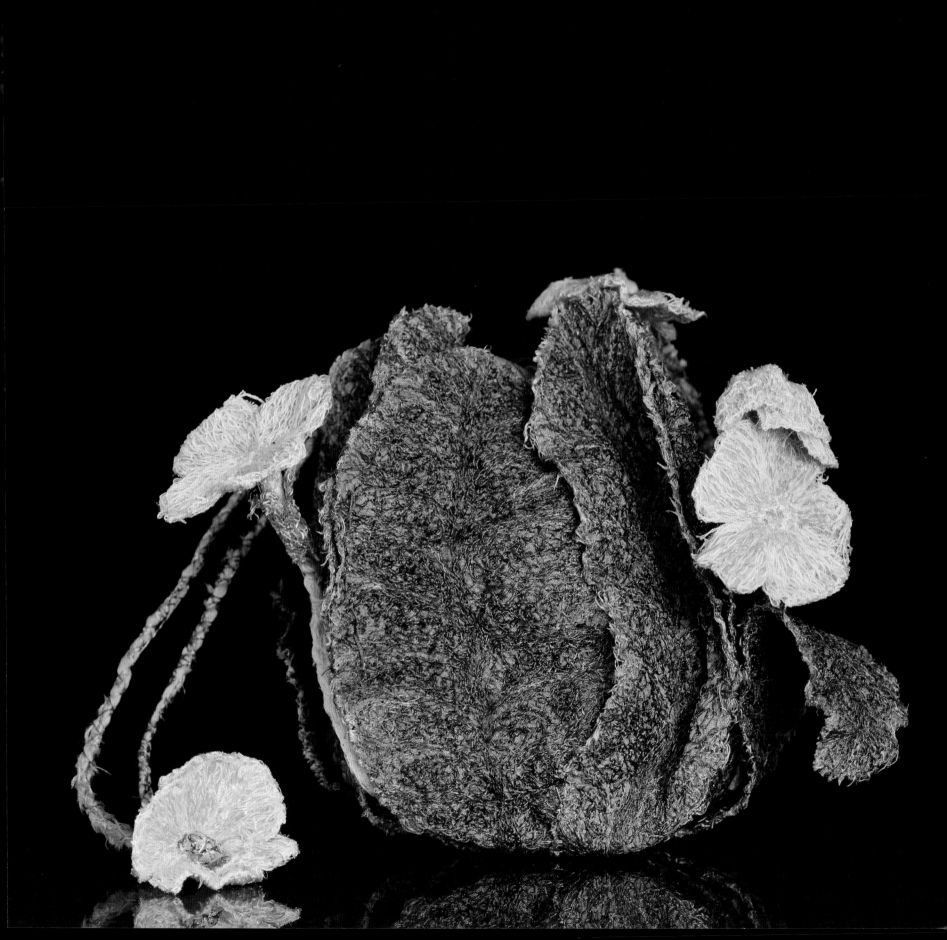

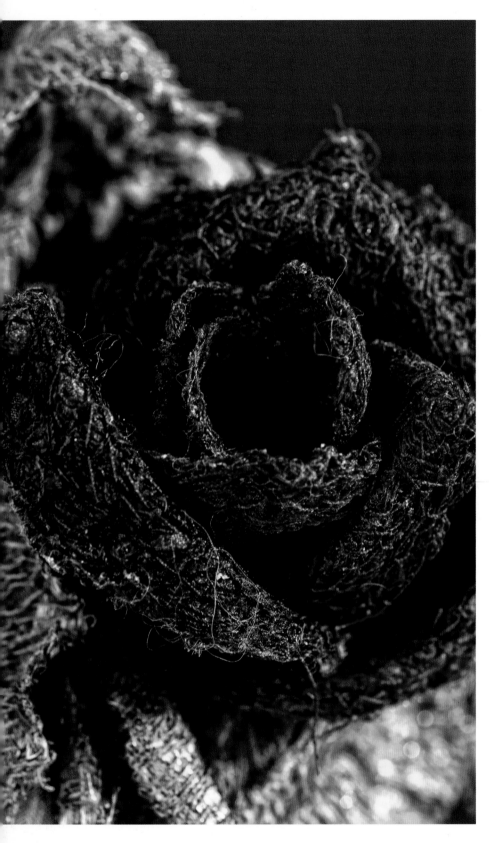

Right: *Old Rose* was made for Janice Blackburn to be exhibited at Sotheby's in her exhibition Old Friends, New Directions. It was winter, and Janice wanted the work to have an edgier feel. The piece was made, boxed up and ready to take to London, but what I was not expecting was snow – snow like we had not seen for many years. Eventually, having dragged it through thick snow for four miles, I was given a lift to the port and the rest of the journey to London was relatively uneventful.
15 x 14cm (6 x 5½in).

Left: detail

Photographer: Julie Yeo, 2010

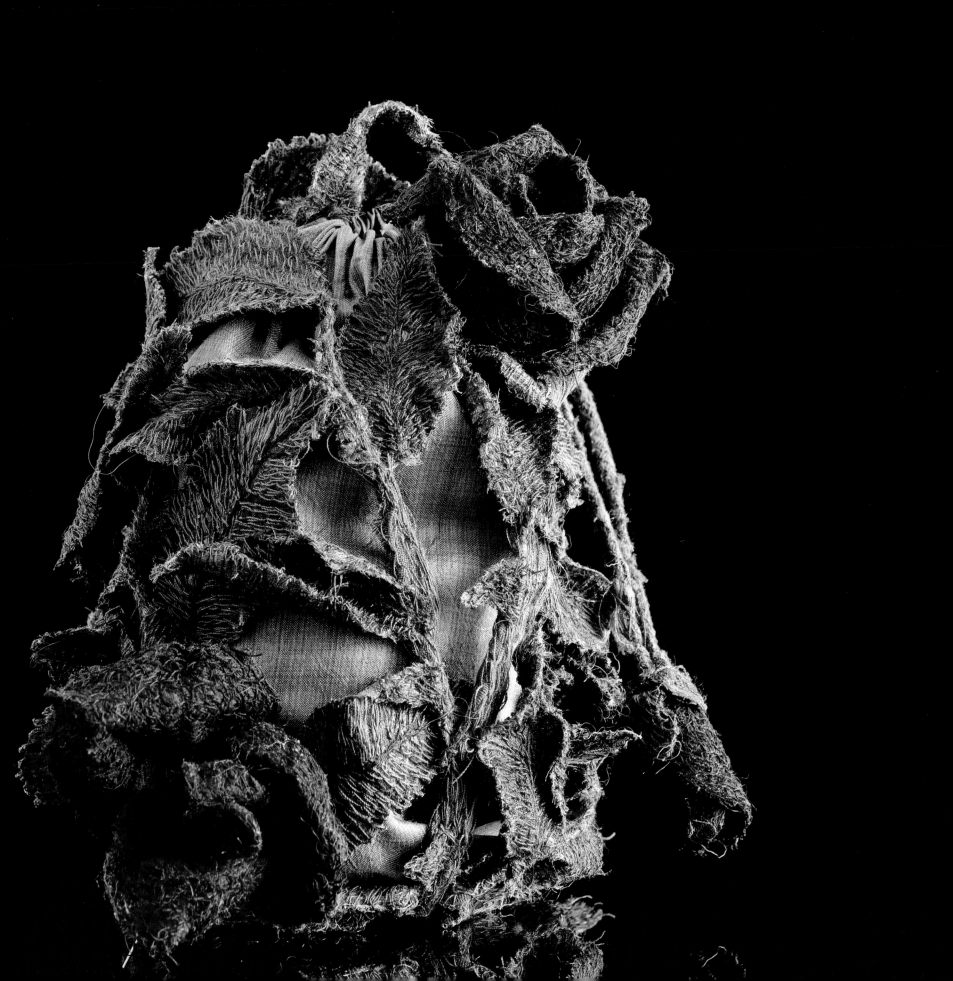

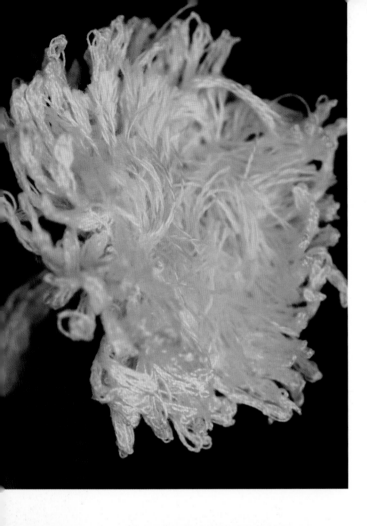

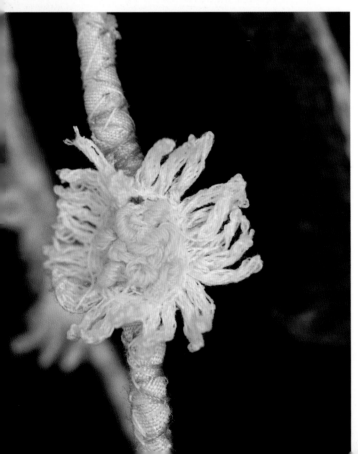

Right: dandelion using thread, fabric and wire. Silk fabric bases were used for the leaves of the dandelion. The flower heads were made using hundreds of tiny stitched petals, and French knots were stitched to the centre of each daisy as stamens; loose threads recreate the dandelion stamens. 17 x 9cm (6¾ x 3½in).

Left: details

Photographer: Julie Yeo, 2010

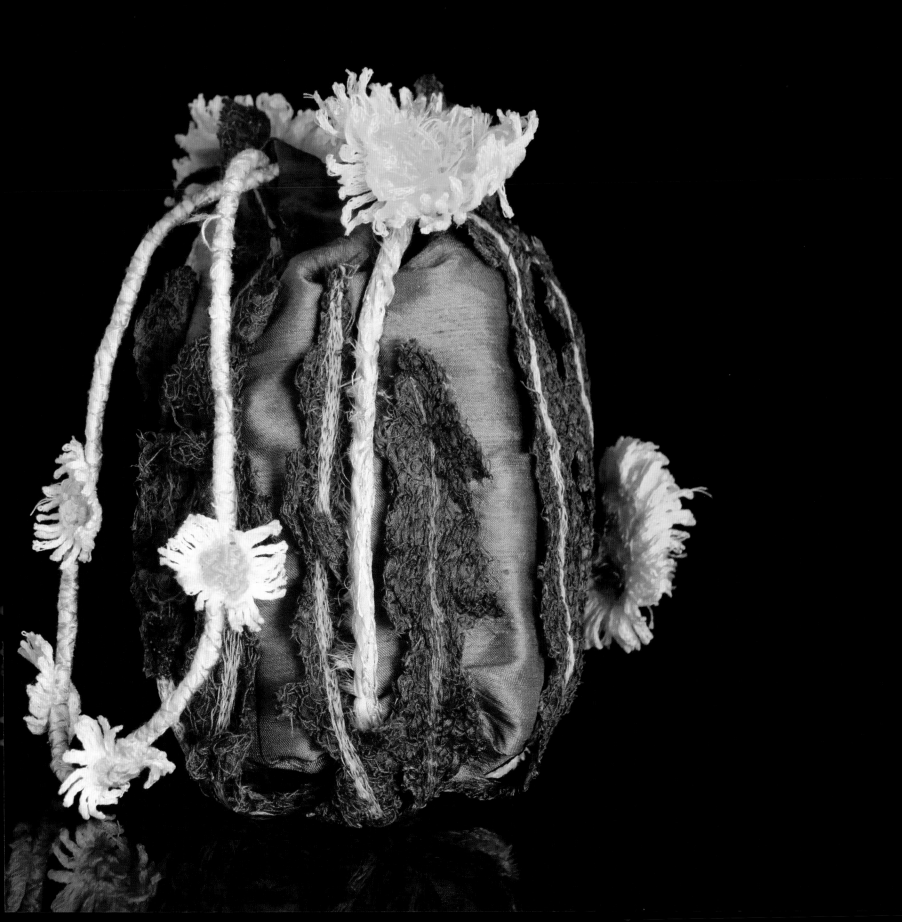

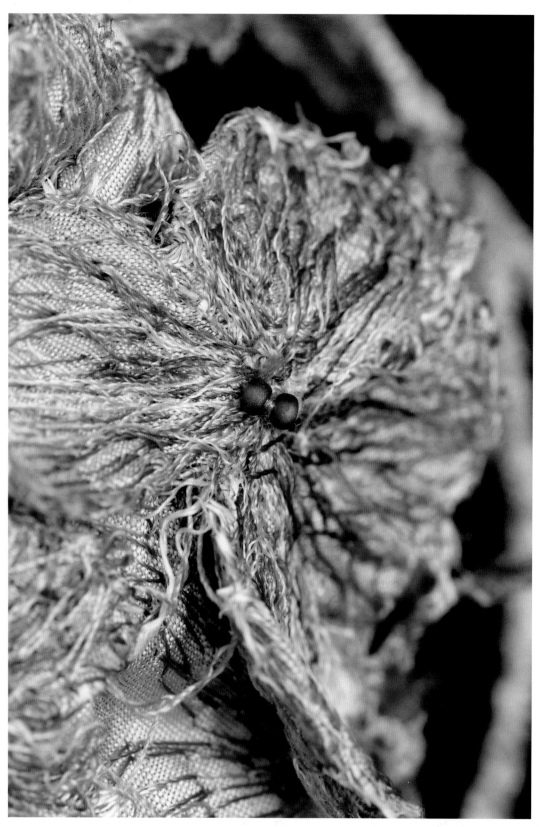

Right: hydrangea using fabric and thread. Inspired by the huge blooms of the mophead hydrangea, its multi-flowered head really does look like a mop and is the perfect shape for a bag. I love all the varying hues, especially the discolouration caused by the rain. Shades of blue, purple and green threads were used, and tiny, matt glass seed beads were perfect for the centre of each flower. 14 x 9cm (5½ x 3½in).

Left: detail

Photographer: Julie Yeo, 2010

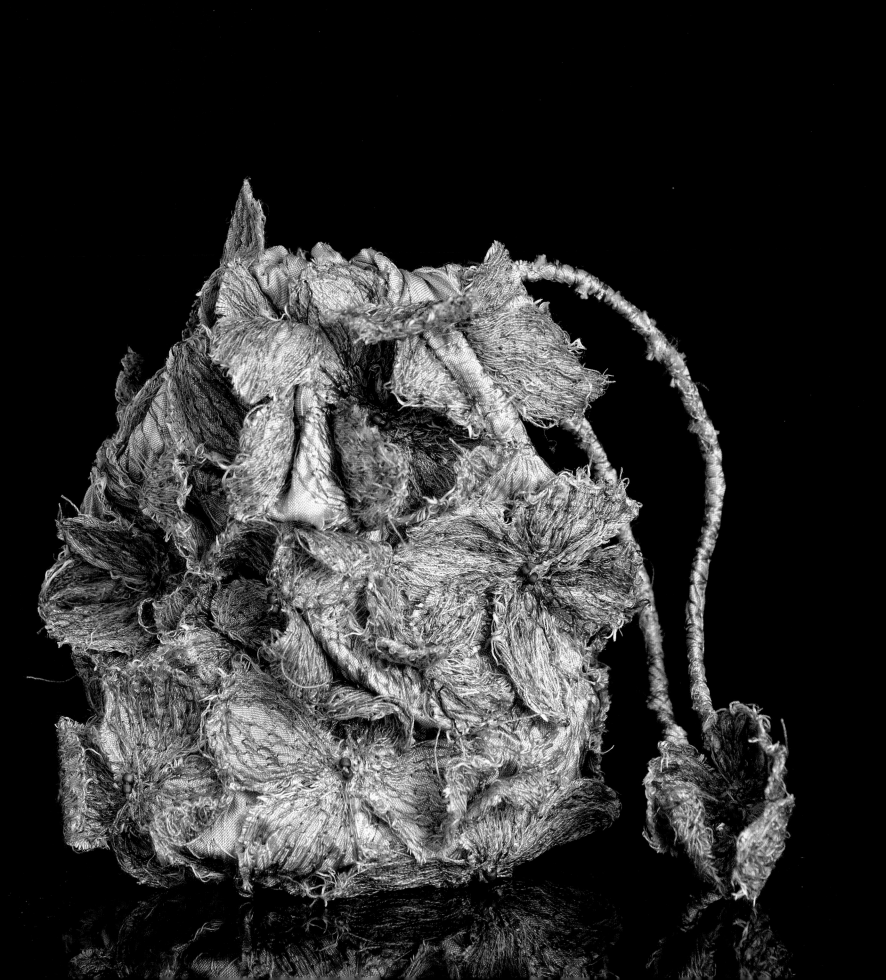

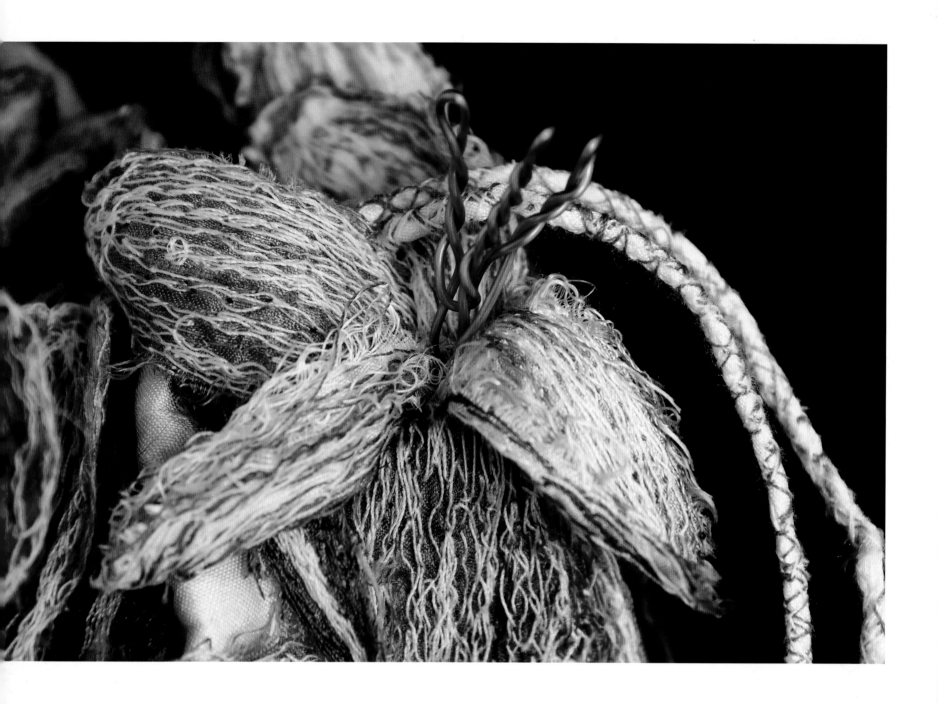

Right: crocus using fabric, thread, wire and beads. This was one of the first dolly bags I made. It was winter and nothing was flowering at the time, but I spotted a fabulous photograph of a crocus and the idea was born. I like to have a flower placed on the strap of my bags to give an added interest. Bronze wire was used for the stamens, while silk fabric was used as a base for the stitch work. 14 x 7cm (5½ x 2¾in).

Above: detail

Photographer: Julie Yeo, 2010

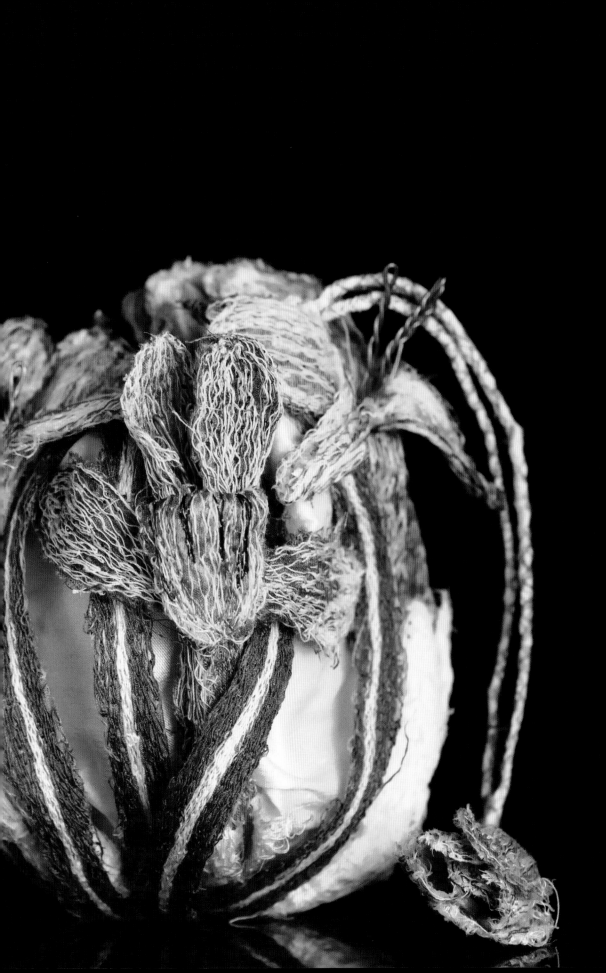

hats

My hats – definitely not the warm, practical variety – were designed as a range of statement pieces, to be displayed rather than simply worn. They sit on metal Alice bands and can be manipulated to fit the head while still remaining in place, even in a hurricane. Embroidered hats adorned with jewelled beads can't help but be noticed and, when not being worn, can be placed under a glass dome or vase as a work of art to be admired all year round.

Butterfly hat. Although I generally work with flora, fauna inspire me too and the most beautiful is the butterfly. Perhaps it is because butterflies remind me of fairy wings – the markings, colours, shape and dancing movement encourage us all to love them. A silk base fabric, vintage glass beads and sturdy wire were used to create this distinctive piece. 30 x 17cm (11¾ x 6¾in).
Photographer: David Shih, 2011
Model: Victoria Winterford
Make-up artist: Sarah Frasca
Stylist: Yanina Nikitina
Base Models

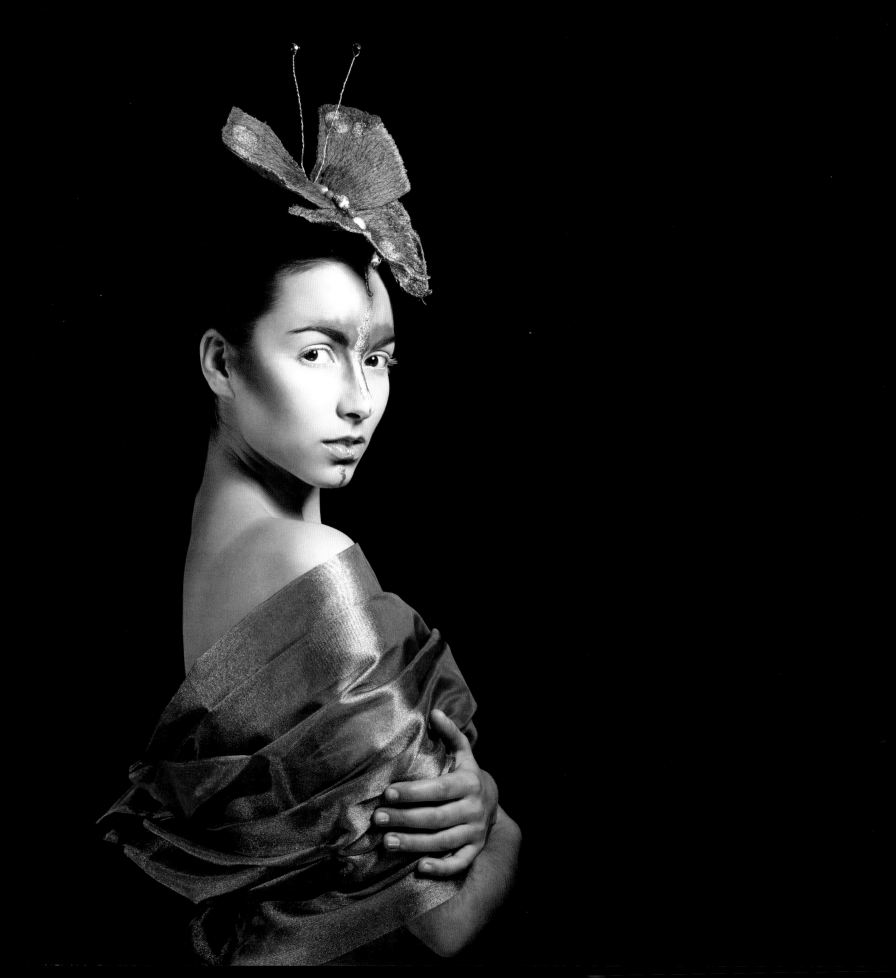

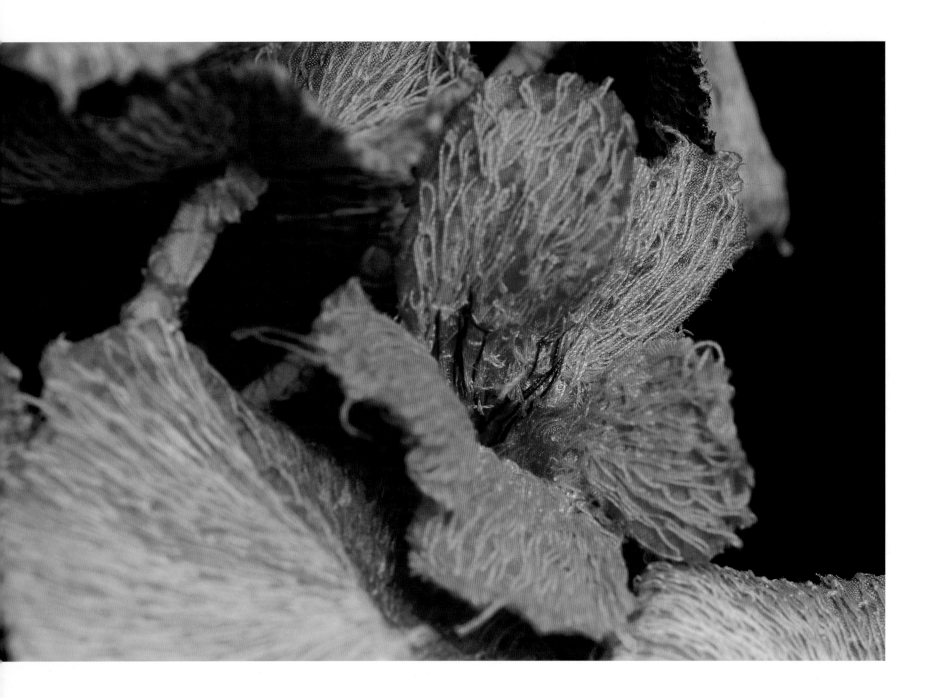

Right: nasturtium hat. By my back door in my herb garden sits an old battered butler sink, which I love to fill with nasturtiums. I use the young leaves, flowers and seeds in cooking, their peppery taste and bright colour spice up a boring mixed leaf salad. I used a silk base fabric with wired embroidery to create and sculpt this naturalistic piece. 34 x 16cm (13½ x 6¼in).

Above: detail

Photographer: Julie Yeo, 2010
Model: Bianca Baker

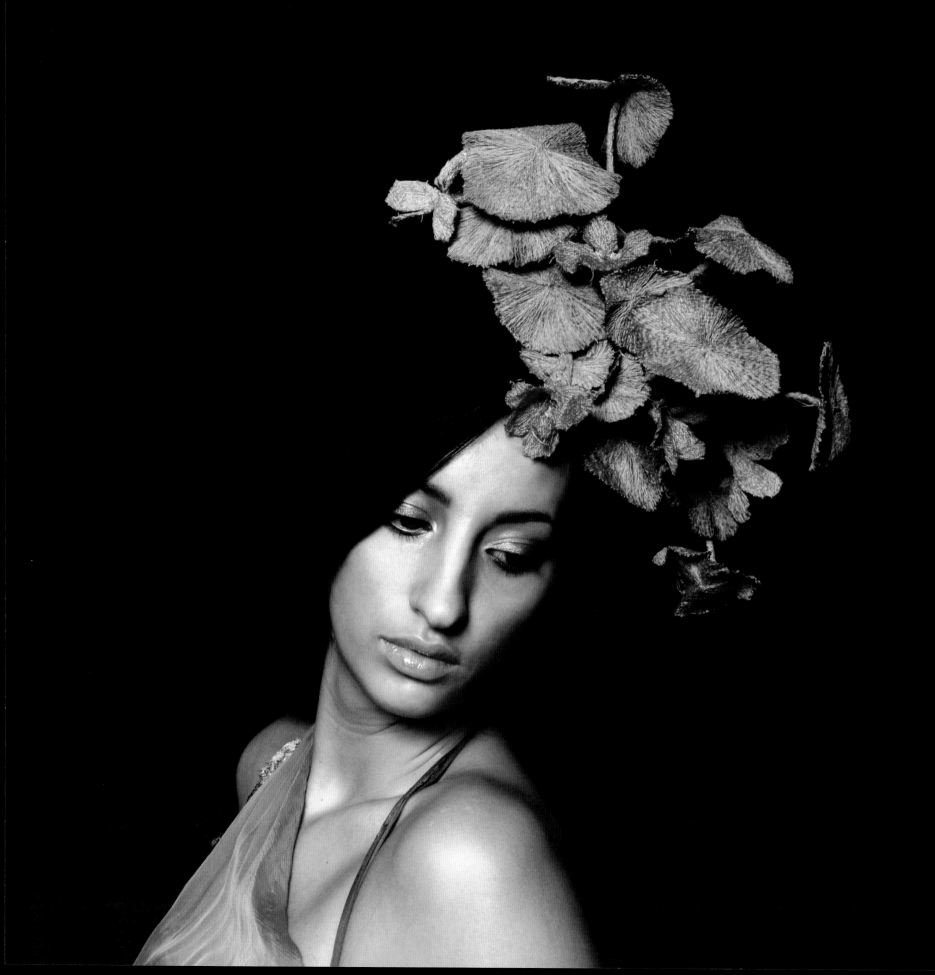

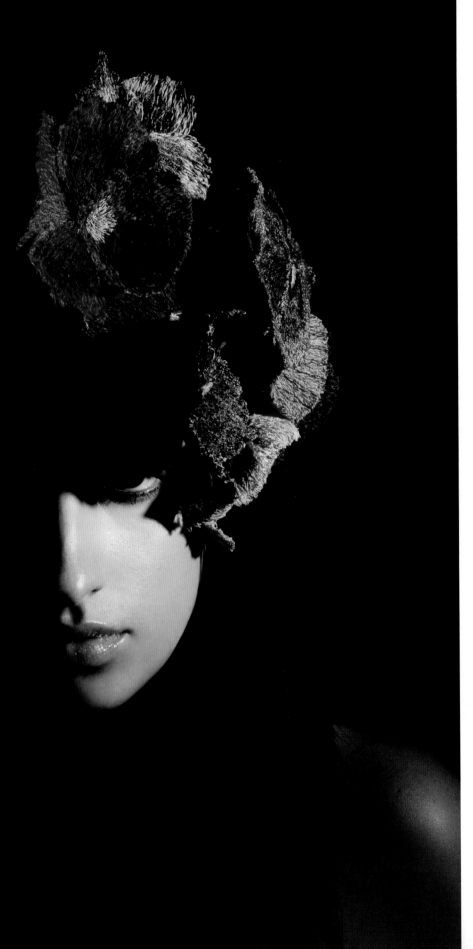

Right: tea roses inspired this hat. It was originally designed to look like a bunch of roses sitting on top of the head, while the leaves nestled amongst the wearer's hair, but it was too top heavy. After some adjustment I arrived at this creation. I used machine embroidery stitch worked on to silk fabric. 33 x 22cm (13 x 8¾in).

Photographer: David Shih, 2011
Model: Victoria Winterford
Make-up artist: Sarah Frasca
Stylist: Yanina Nikitina
Base Models

Left: the pansy, derived from the viola, has inspired artists and poets alike for centuries. Here, multi-coloured pansies worked in heavy machine embroidery on a silk base create a rich, jewel-like piece. 25 x 24cm (9¾ x 9½in).

Photographer: Julie Yeo, 2010
Model: Bianca Baker

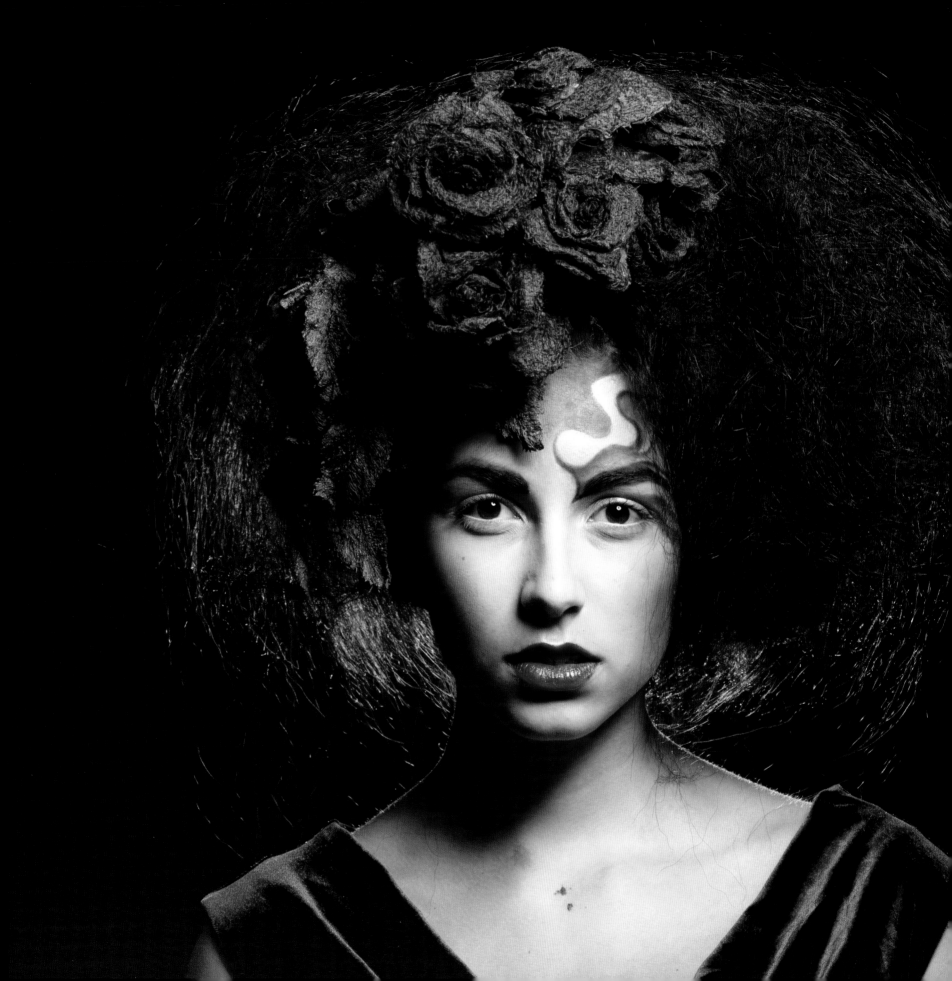

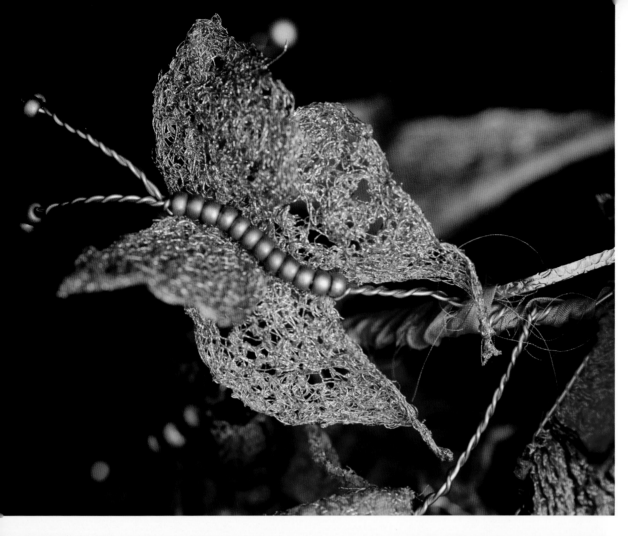

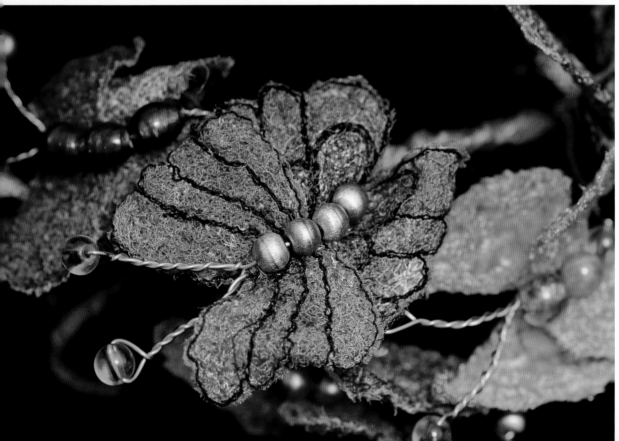

Right: amber butterflies hat. Some of the butterflies have silk fabric as a base while the more lace-like butterflies are created purely from stitching. Bronze-coloured wire was used to give the illusion of flight. I love mixing these two methods. Over the years I have amassed a large collection of beads and here all sizes of glass and metal beads have been used.
24 x 15cm (9½ x 6in).
Photographer: Paul Cotton, 2009
Model: Bianca Baker

Left: details
Photographer: Julie Yeo, 2010

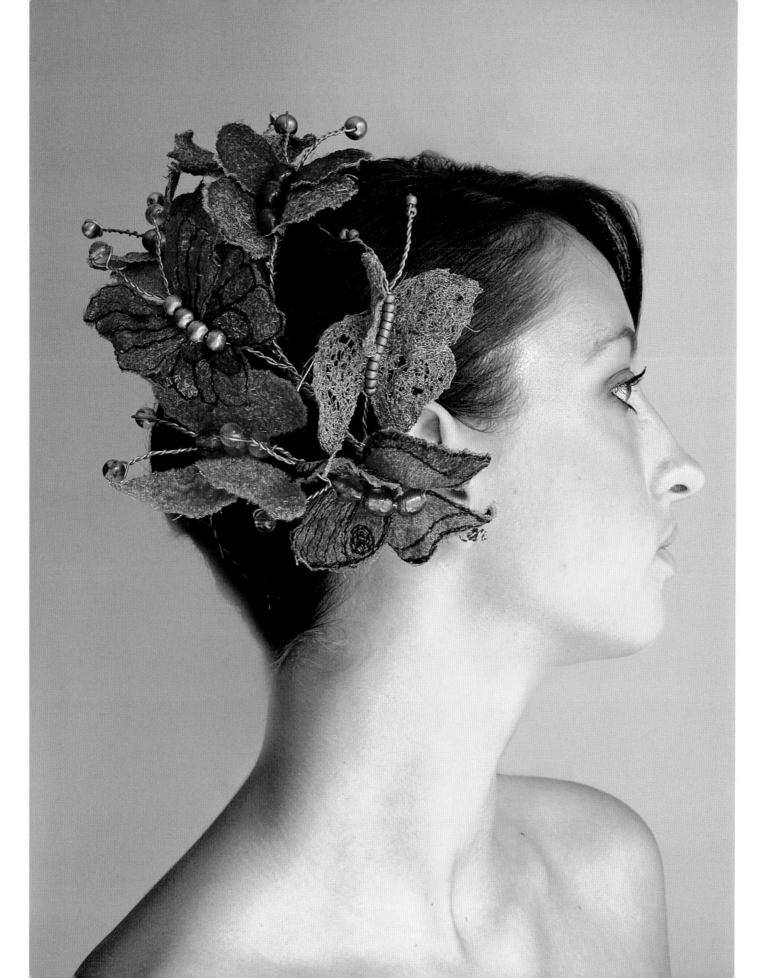

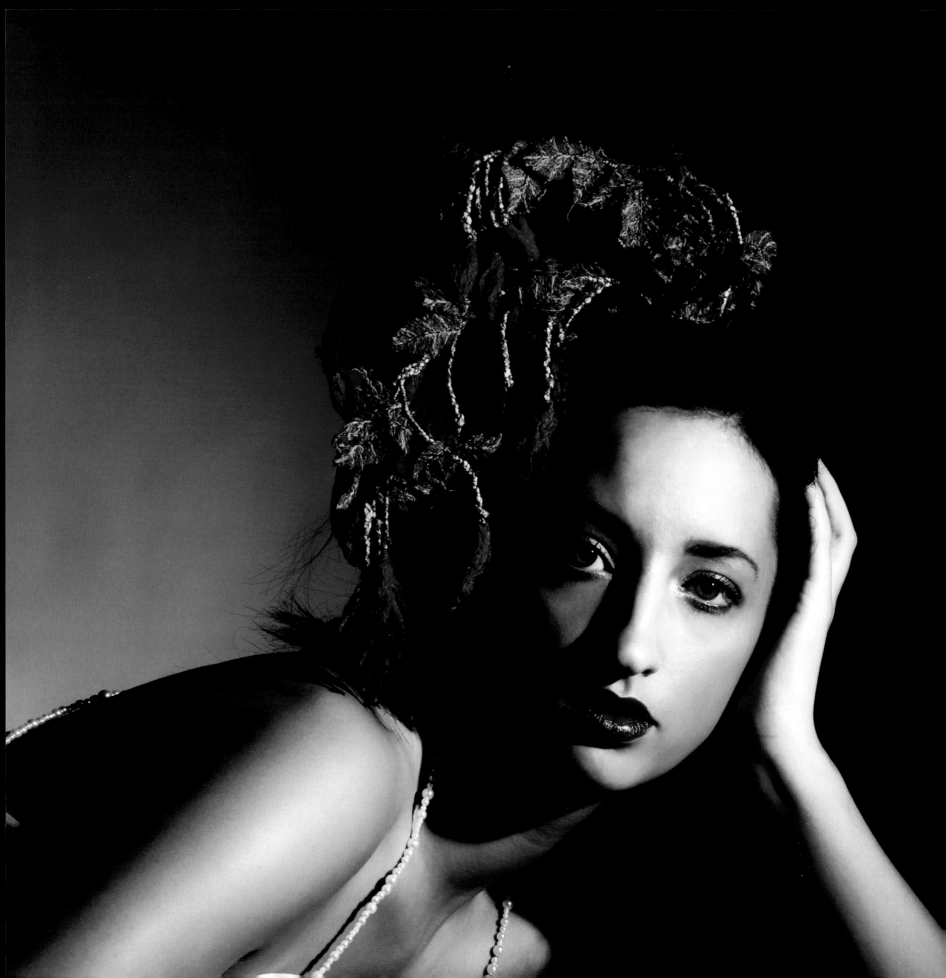

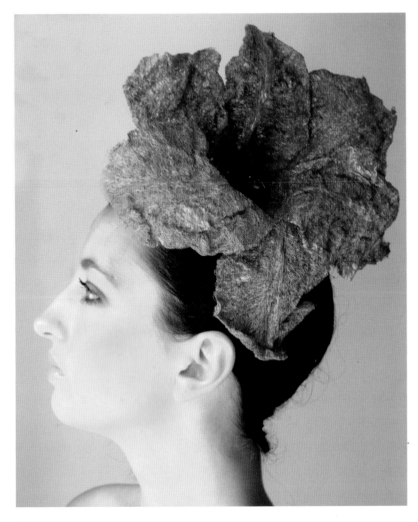

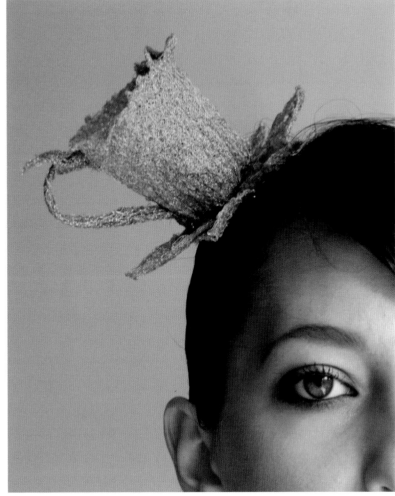

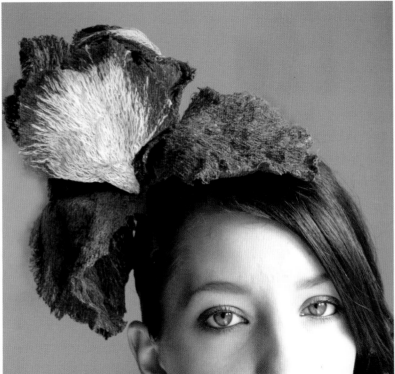

Far left: having already learned the techniques of working with the fuchsia flower, I thought it would make a really interesting hat – not a hat that sits on the head like my other creations, but one that cascades from a central crown. I found that by stripping ostrich feathers back to the centre shaft I was able to cover this in fabric and attach it to an Alice band, allowing movement not possible with wire.

Photographer: Julie Yeo, 2010
Model: Bianca Baker

This page, top left: a base of silk fabric was used with very heavy machine embroidery to create this parrot tulip hat. Wire helps to keep the shape and embroidered stamens sit in the centre of the flower. 21 x 23cm (8¼ x 9in). Top right: daffodil hat made from gold metallic thread. 10 x 8cm (4 x 3¼in). Bottom left: iris hat, machine stitched into silk fabric and wired for stability. 26 x 26cm (10¼ x 10¼in).

Photographer: Paul Cotton, 2009
Model: Bianca Baker

95

jewellery

Jewellery has been worn for thousands of years to adorn the body, often as a status symbol. Art jewellery is created for dramatic effect and bought by collectors and museums all over the world. At the end of the nineteenth century, French glass artist René Lalique revolutionised jewellery design through his experiments with plastic and glass. Lalique was revered for his Art Nouveau perfume bottles and his name is synonymous with beauty and quality.

Designers are forever looking to both new mediums and the reworking of old pieces. Embroidery as a medium for jewellery is a rather new idea but because of its light weight, it can work beautifully with large pieces.

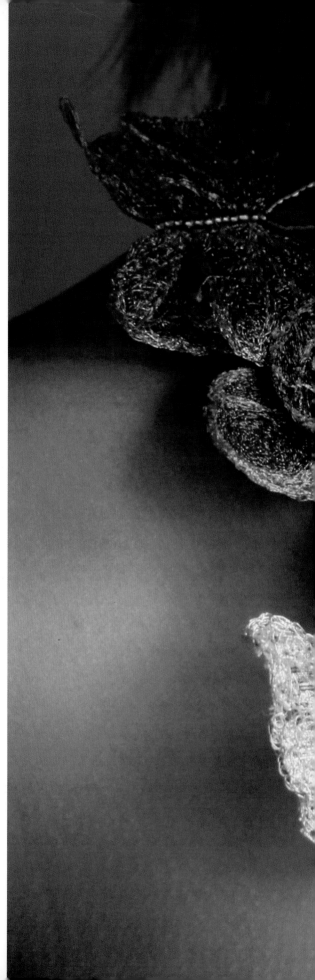

Butterflies have always been an inspiration to me and I am regularly drawn to representing them. Nature allows their intricate beauty to dazzle and dance for only a few days. Their wings remind me of fairies, and with so many varieties to choose from, butterflies make the perfect muse.

I wanted to design a jewellery range to complement my accessories, and butterflies' shapes and colours and their gentle, dancing movements provided the perfect inspiration for my first necklace. Lying somewhere between a typical necklace and a collar, it became the foundation for my later works in which I mix the bold and the delicate to create my unique pieces.
27 x 22cm (10¾ x 8¾in).

Photographer: Paul Cotton, 2008
Model: Bianca Baker

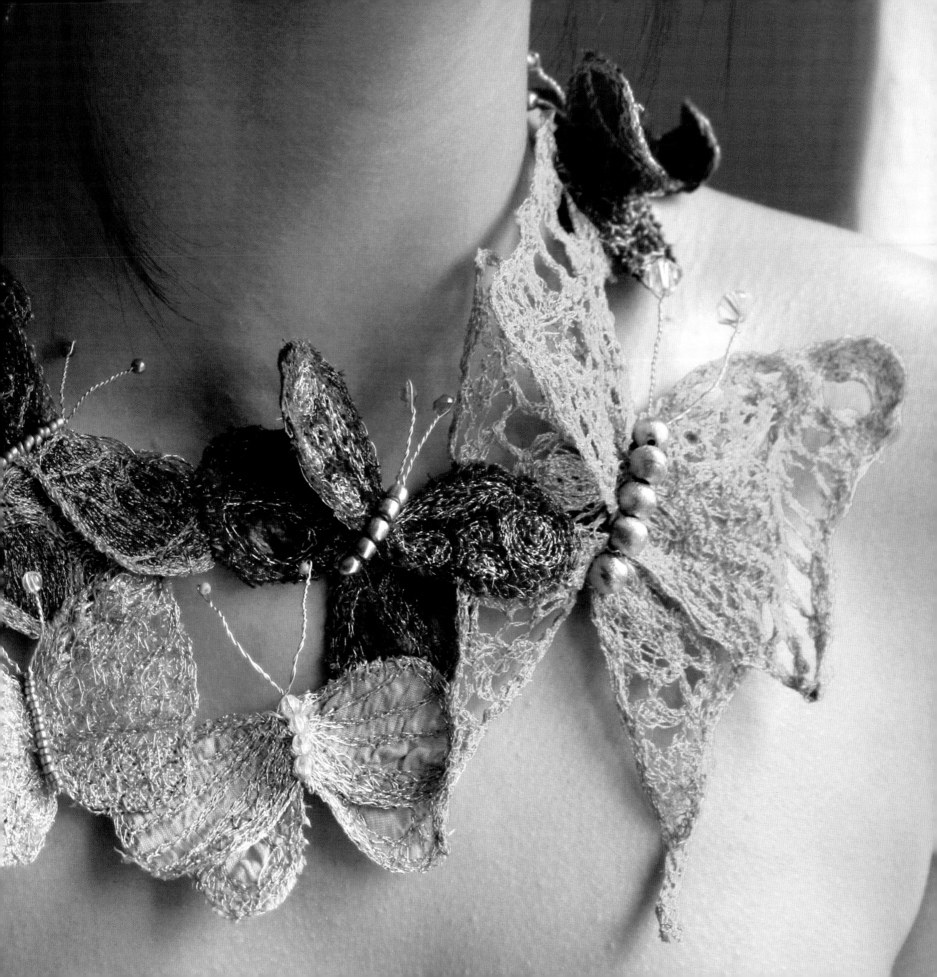

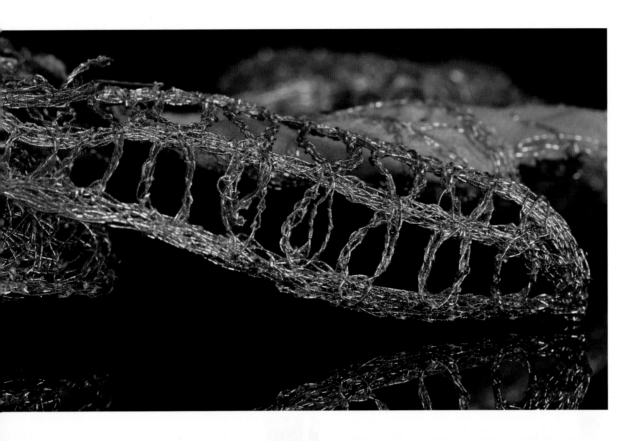

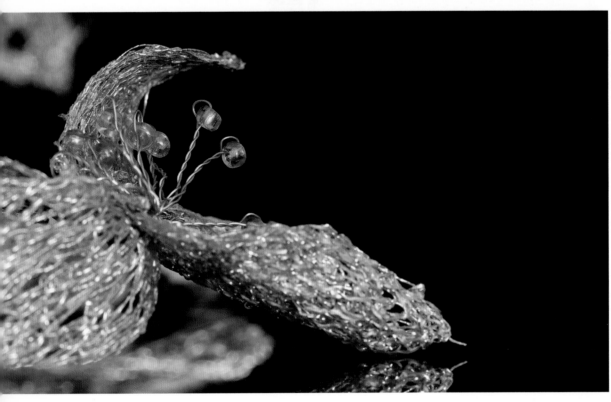

Right: many shades of gold metallic embroidery threads were required to make this piece. While the majority of the work consisted purely of threads, I also incorporated some gold silk fabric as a contrast to the metallic lace. 19 x 9cm (7½ x 3½in).
Photographer: Paul Cotton, 2008
Model: Bianca Baker

Left: details
Photographer: Julie Yeo, 2010

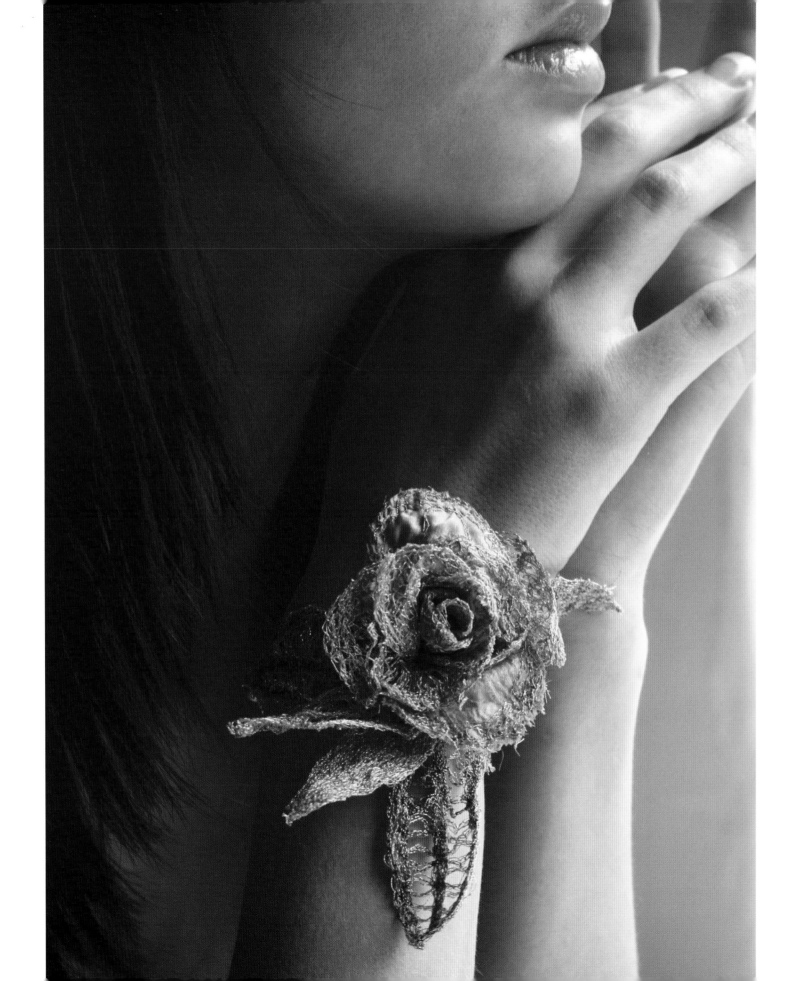

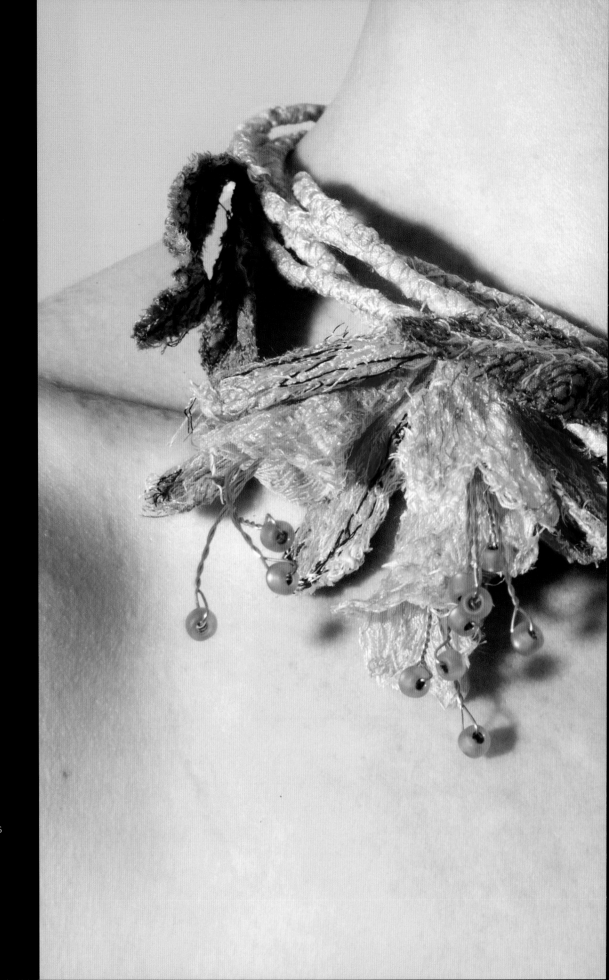

The twisted vine of the climbing honeysuckle –
characterised by a profusion of tubular flowers
during the summer months and its intense
fragrance. Silk fabric with machine stitch was
used to create the flowers and foliage; the
cords are zig-zag stitched silk and the stamens
constructed of silver wire and frosted beads.
47 x 11cm (18½ x 4¼in).

Photographer: Julie Yeo, 2013
Model: Bianca Baker

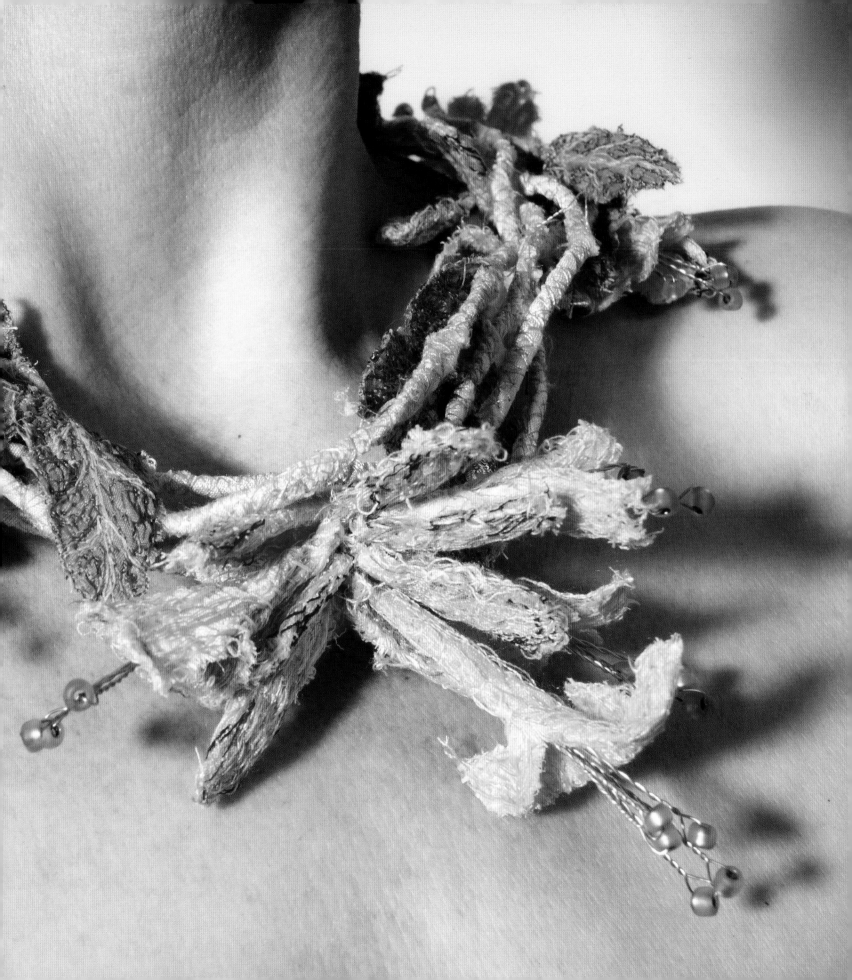

The wild briar rose climbs naturalistically around the neck of the wearer. With a silk fabric base for the heavy machine embroidery, cotton embroidery twist and bugle beads were used as stamens. 48 x 21cm (19 x 8¼in).

Photographer: Julie Yeo, 2010
Model: Bianca Baker

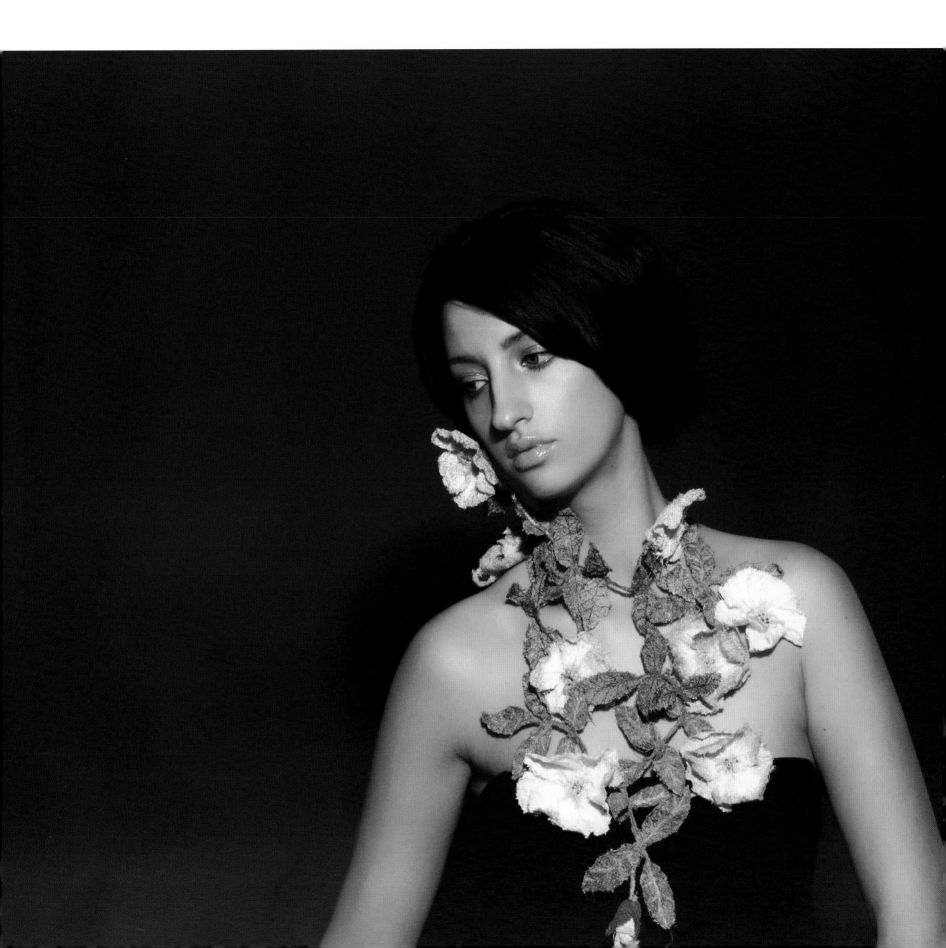

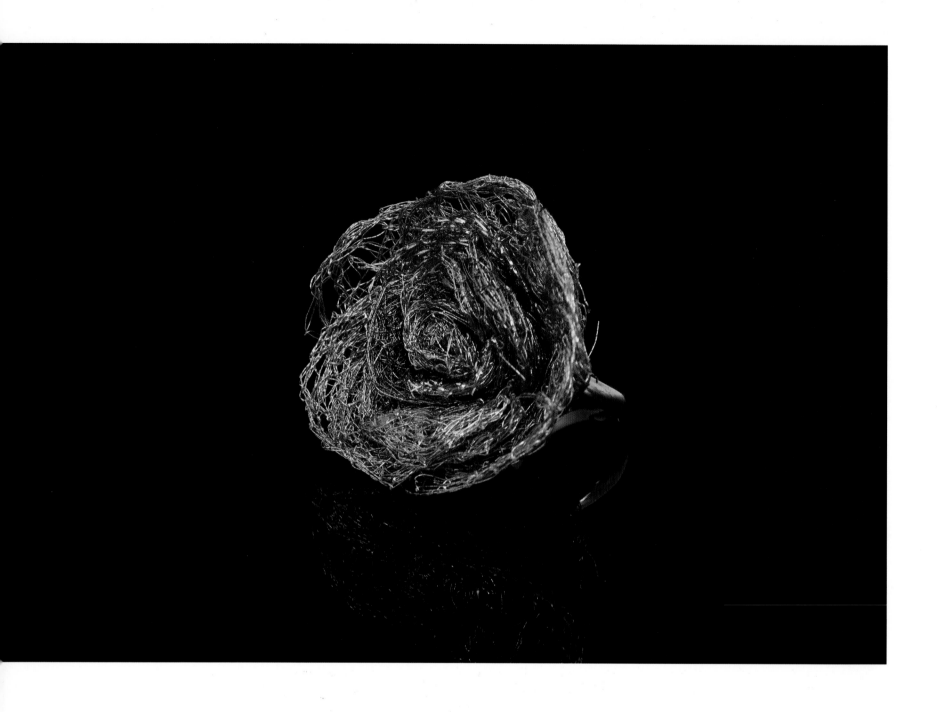

Above and right: I had the idea to grade this metallic thread necklace and ring in varying hues from pewter, silver through to gold and bronze. Metal threads sewn on to water-soluble fabric. 33 x 7cm (13 x 2¾in).

Photographer: Julie Yeo, 2012
Model: Bianca Baker

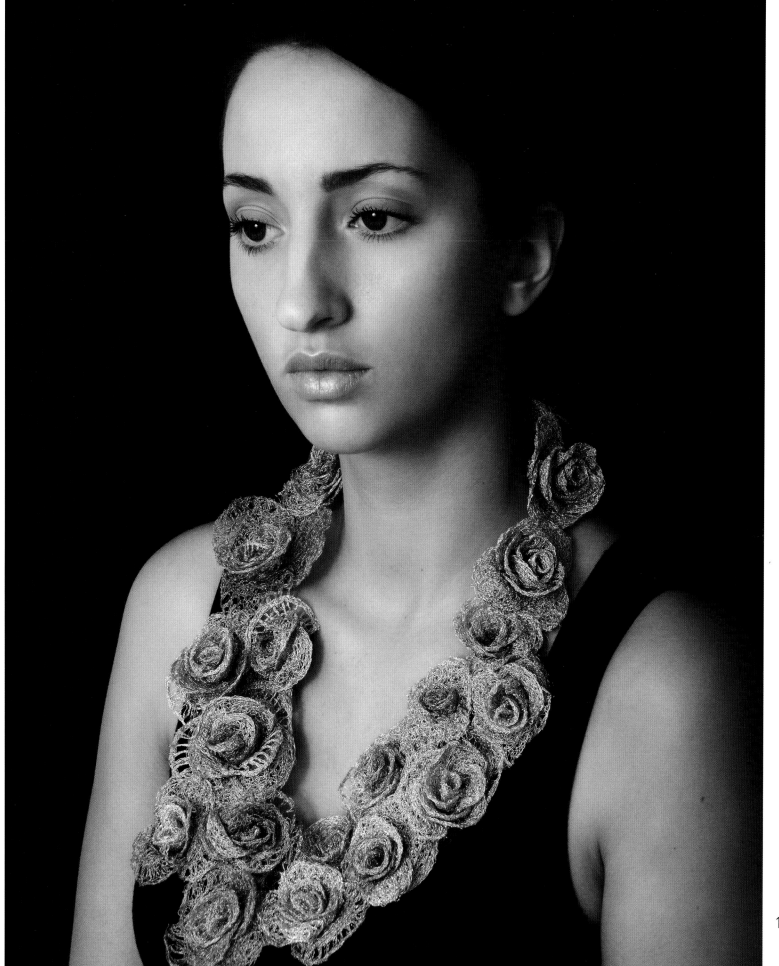

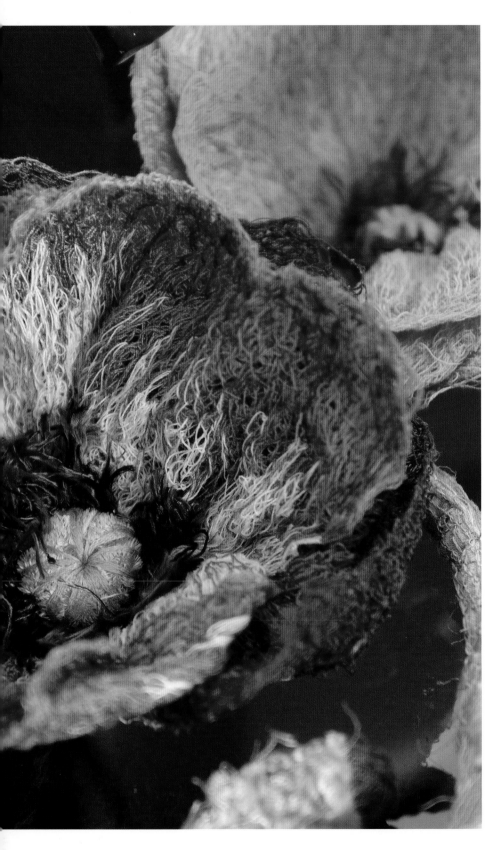

Right: the poppy necklace. Heavy machine embroidery was used to create the petals and silk velvet wrapped in embroidery twist for the seed pod. Loose embroidery threads were used to make the stamens, while the leaf and stem are stitched silk. This piece was inspired by the poppy teacups I made using the same techniques (shown left). 34 x 14cm (13½ x 5½in).

Photographer: Julie Yeo, 2011
Model: Bianca Baker

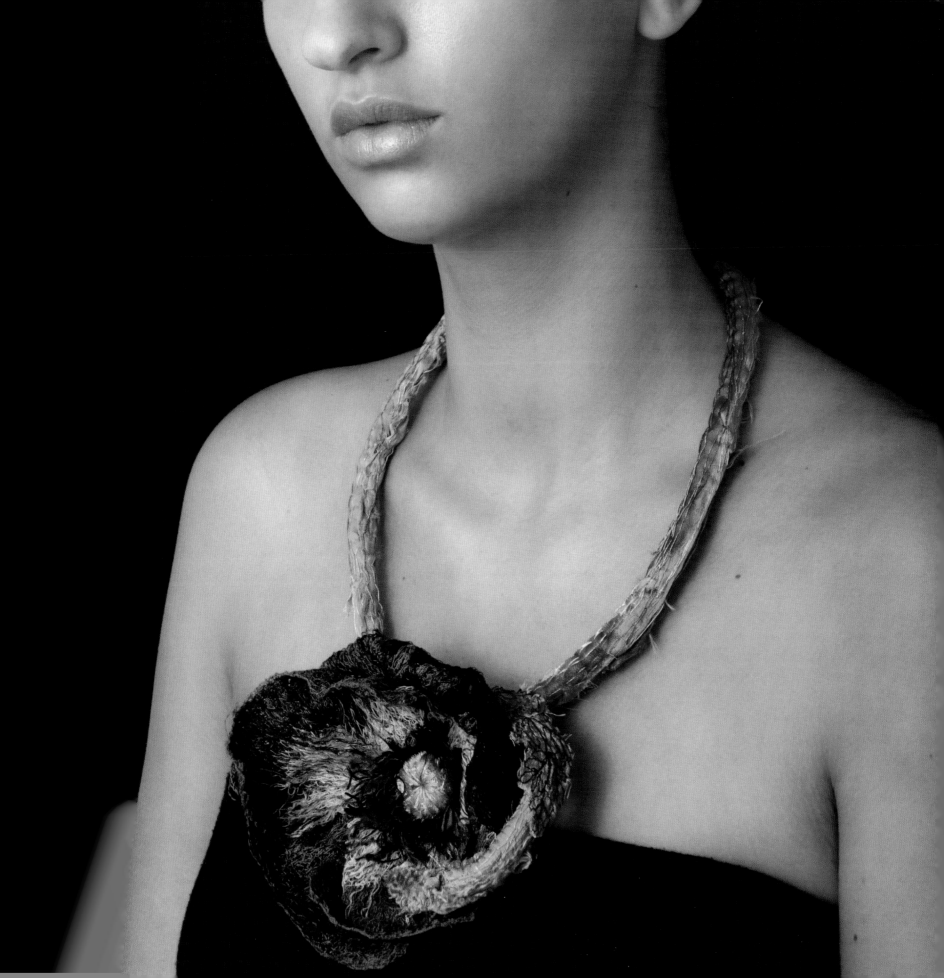

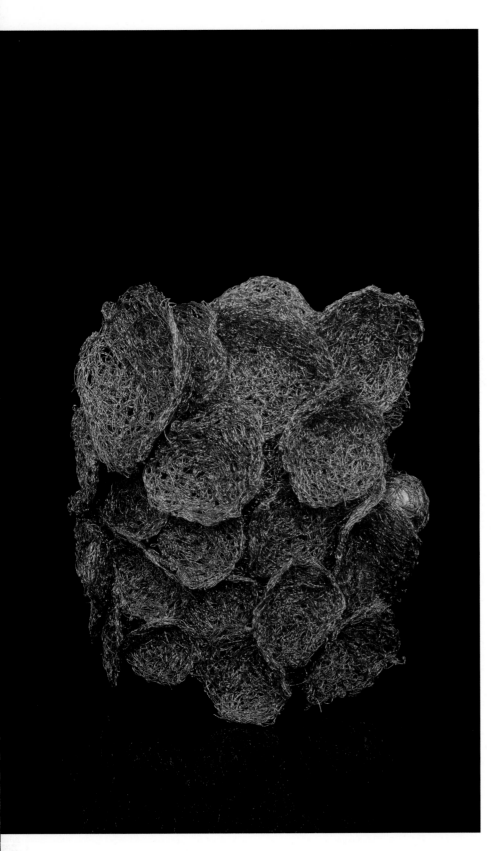

Right: ivy always reminds me of Christmas, and here I have recreated it as a jewellery piece. A base of oyster silk chiffon was distressed using an embellishing machine and the metallic gold leaves were enhanced with olive and gold wired beads. 38 x 8cm (15 x 3¼in).
Photographer: Julie Yeo, 2010
Model: Bianca Baker

Left: while holidaying in Cornwall, I spotted a low-growing succulent peeping between old stone walling. I later discovered it to be the pennywort and could see its potential within an embroidery. Gold metallic thread stitched into water-soluble fabric was used to create this gold cuff.
Photographer: Julie Yeo, 2010

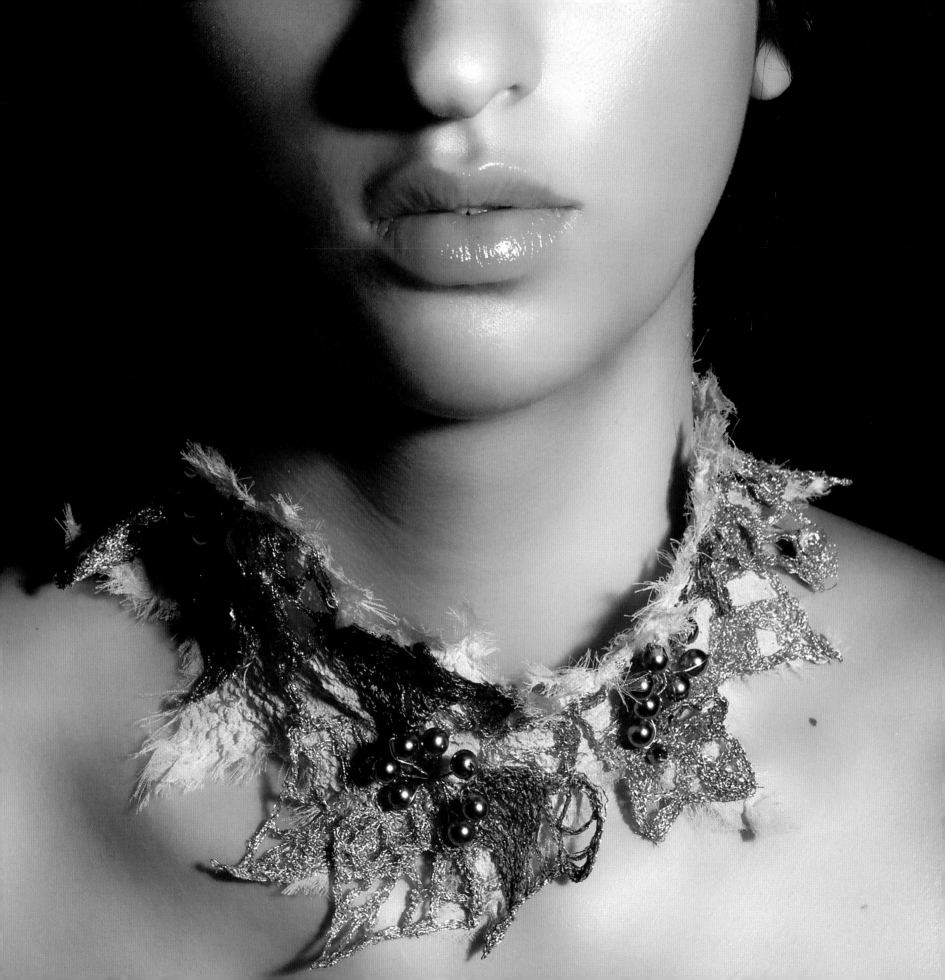

shoes

My journey into three-dimensional art led me towards shoes. I was inspired by a beautiful book entitled *The Botanical Footwear of Dennis Kyte*. Kyte captured my imagination with his wonderful illustrations of floral footwear; with my embroidered shoes, I took the essence of his illustrations into a three-dimensional reality. In the past, I had decorated bridal shoes to complement the gowns, but now my imagination could really run wild.

I took the techniques I had developed for my poppy teacups (shown on page 17) and applied them on a smaller, more delicate scale.

To make my shoes, I start with a base of pelmet Vilene covered in silk fabric, manipulate it into my desired shape and stitch it into place. The heels are made from all sorts of things, including wood, wire or plastic, depending on the look I want to achieve. The freehand machine embroidery is then pinned into place before stitching.

A climbing rose embroidery covers the inside sole of this shoe. Wire and wood were used to strengthen the heel, and for the rose petals and leaves I used freehand machine embroidery. 24 x 13cm (9½ x 5in).
Photographer: Paul Cotton, 2006

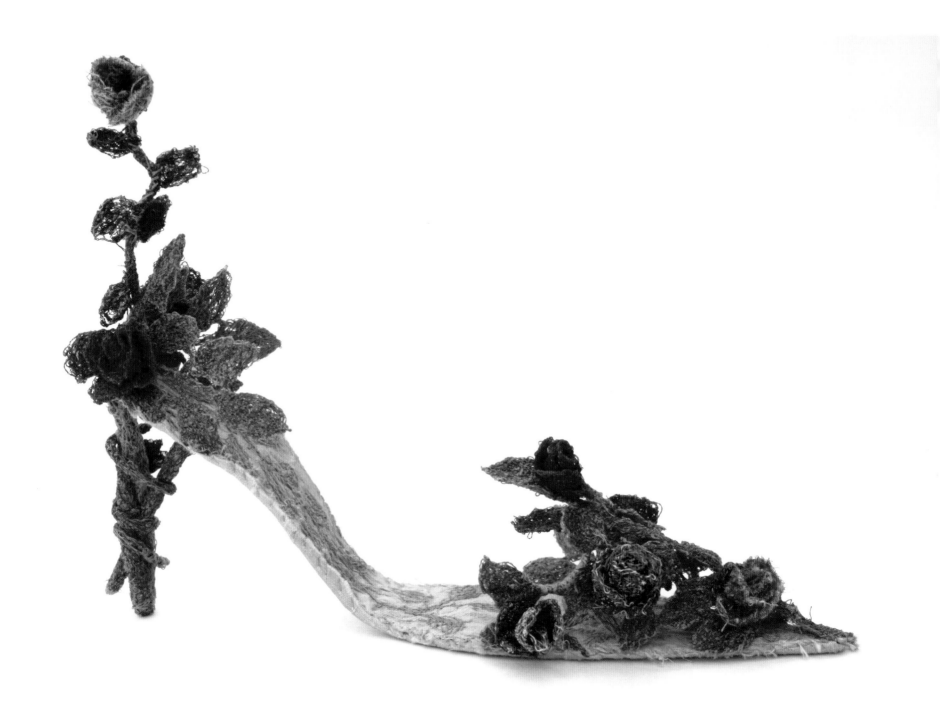

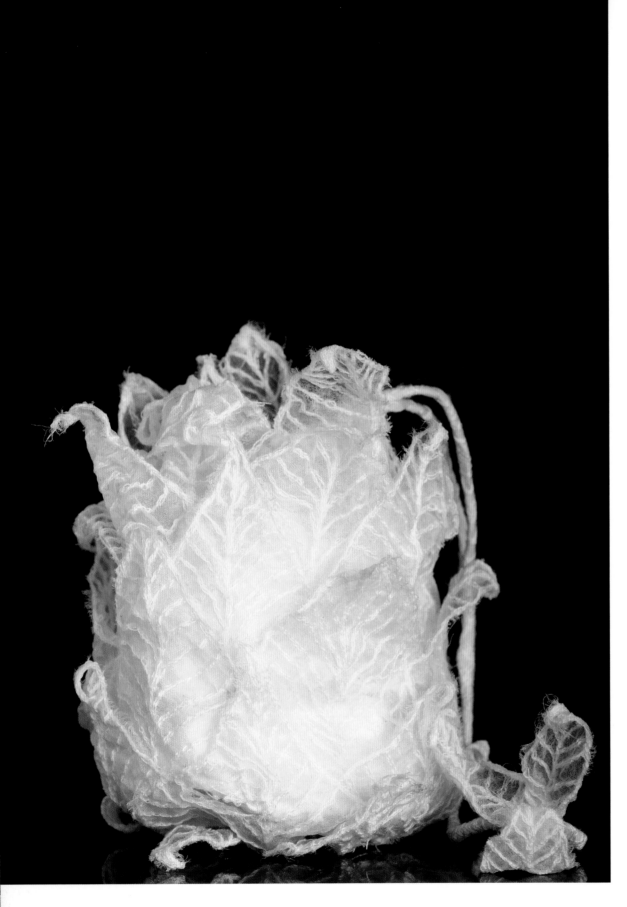

Right: I love the delicate beauty of skeletonised poppy seed heads and wanted to incorporate them into a shoe. Intrigued by their beautiful lace-like quality, I finally decided to use them as a heel. This shoe has a silk-wrapped wire heel, and incorporates silk organza and stitch with a pelmet Vilene base.
24 x 13cm (9½ x 5in).

Photographer: Julie Yeo, 2010

Left: made to complement the shoe, this skeletonised leaf bag was made in the same way using silk organza as a base for the embroidery. 11 x 13cm (4¼ x 5in).

Photographer: Julie Yeo, 2010

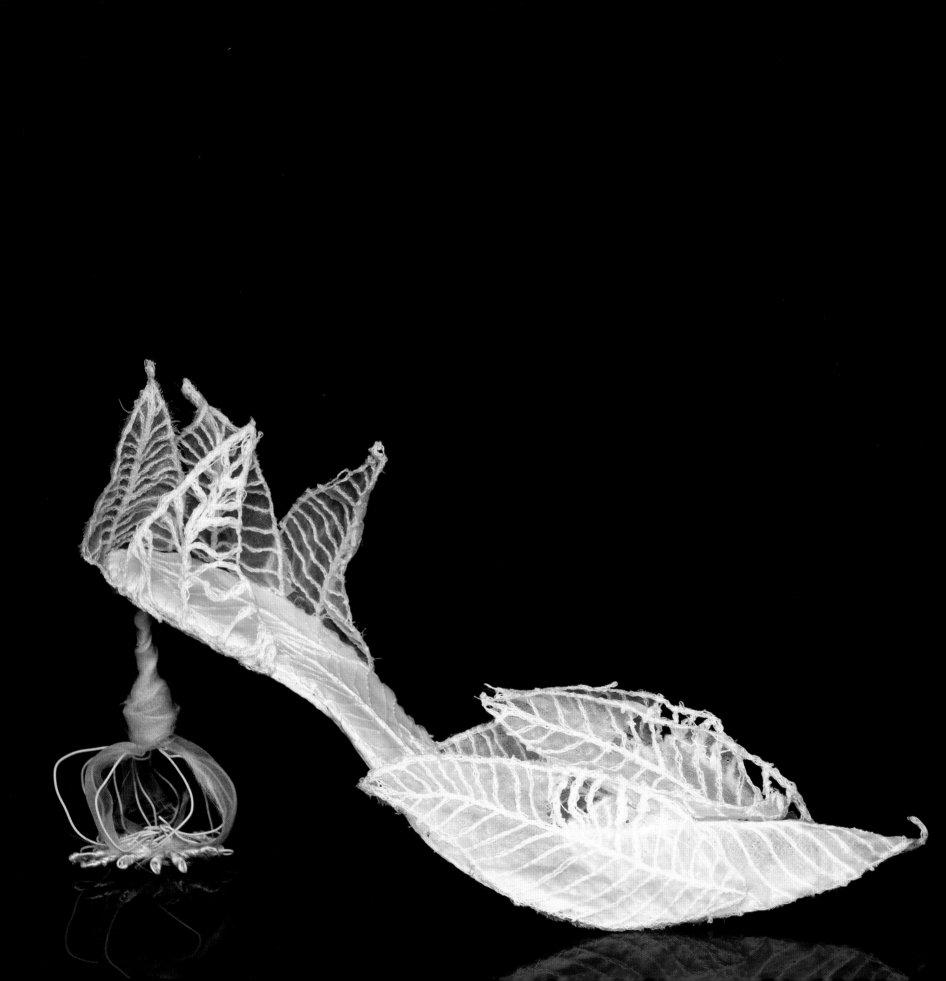

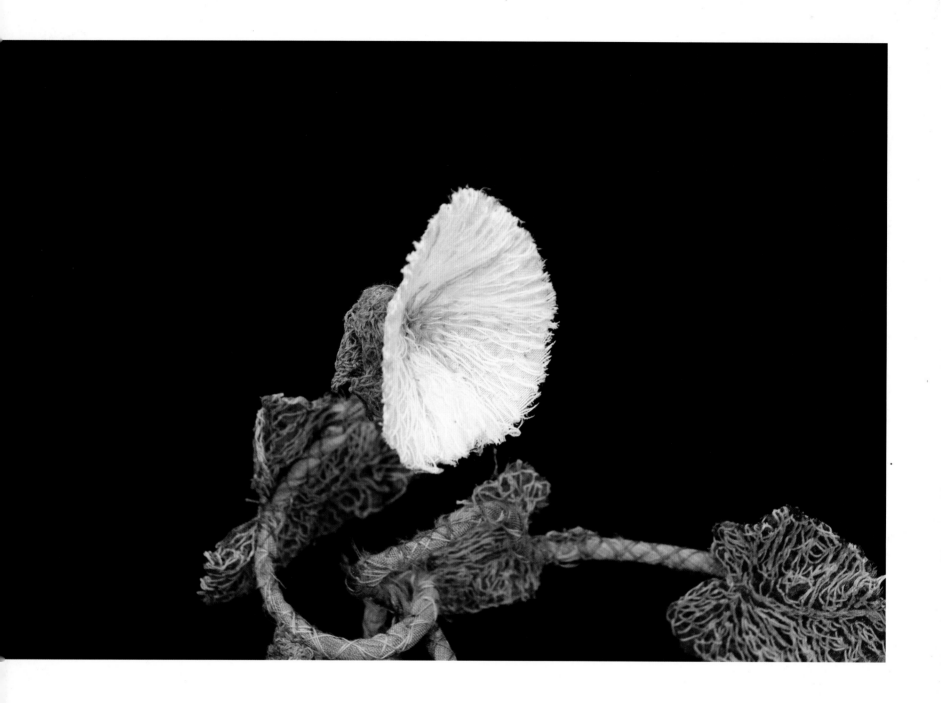

The leaves of the bindweed were embroidered on to the inner sole of this shoe, while the flowers and leaves were made by freehand machine embroidery on to a base of silk. Wire was used to strengthen the heel. 24 x 19cm (9½ x 7½in).

Above: detail

Photographer: Julie Yeo, 2010

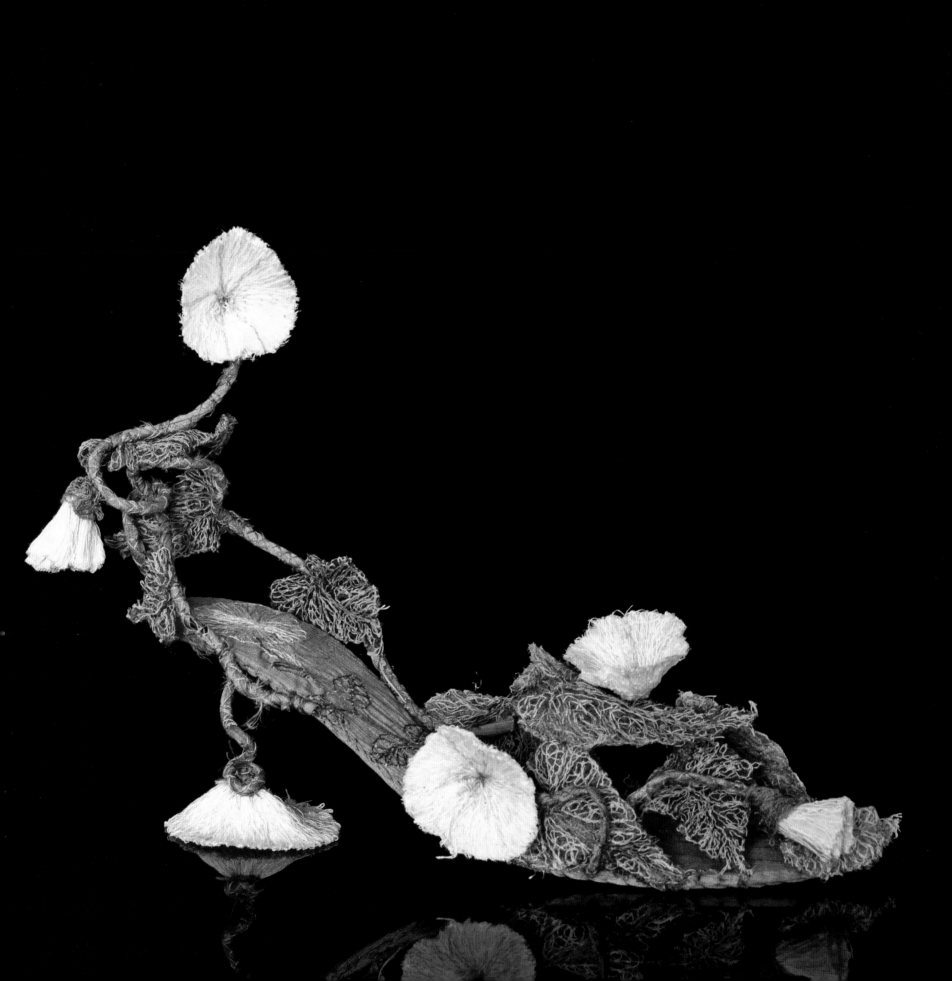

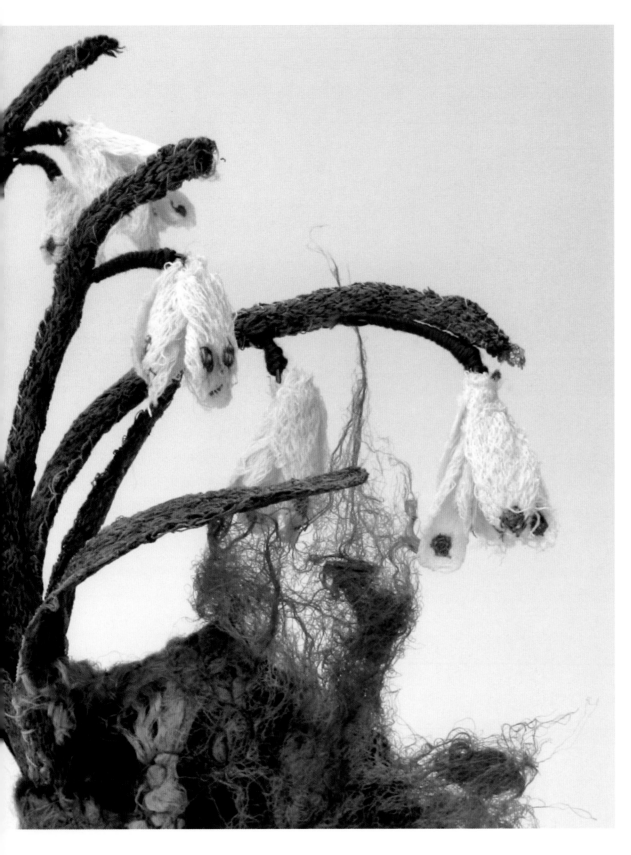

Arching snowdrops are the inspiration behind this dramatic shoe. This was my first attempt to produce realistic moss by stitching into merino wool tops and hand-dyed silk fibres. Cardboard was used to strengthen the heel, and the flower stem has been wired.
24 x 23cm (9½ x 9in).
Photographer: Paul Cotton, 2008

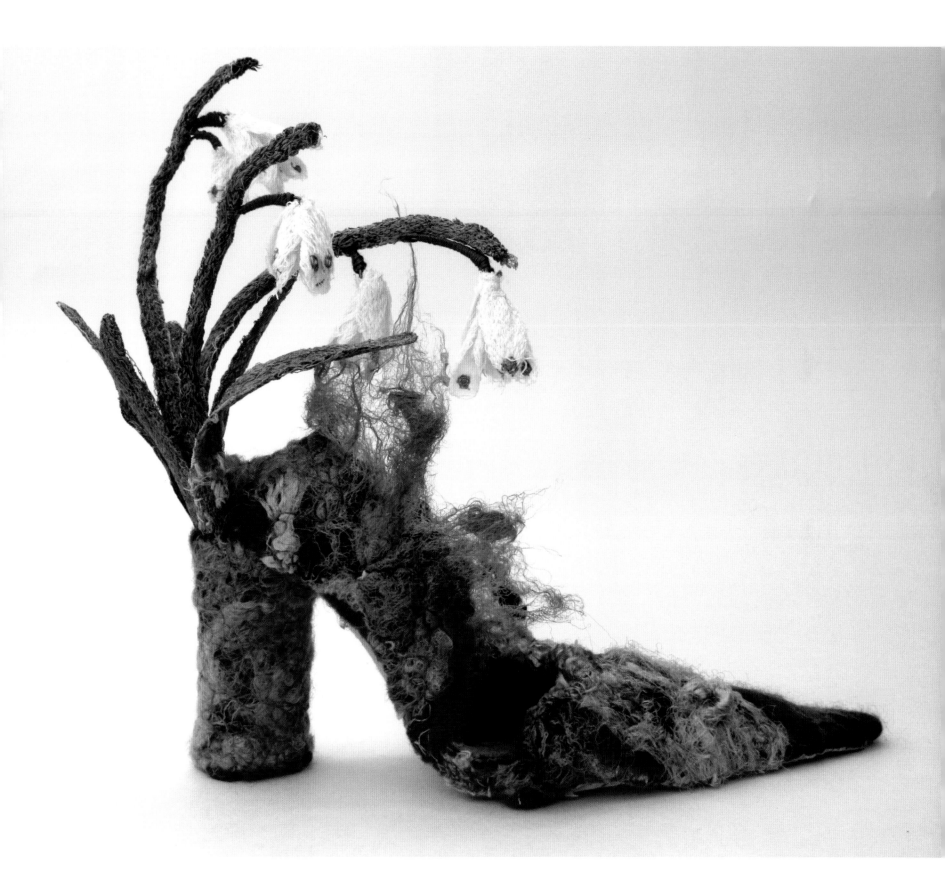

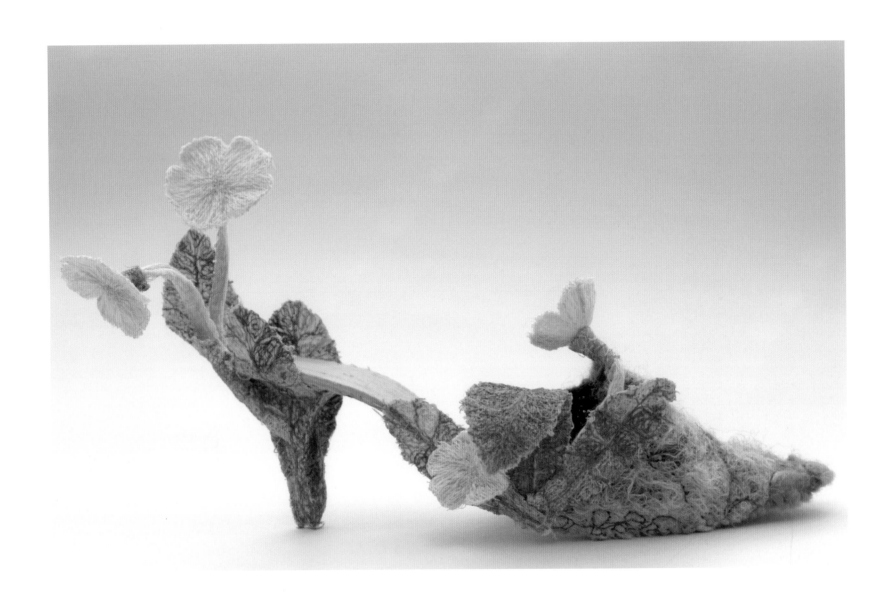

Silk fabric covering a Vilene base was used for the sole of this primrose shoe. It has a merino-felted upper, machine-embroidered silk leaves and flowers, and wire supporting the heel and stems. 21 x 11cm (8¼ x 4¼in).

Photographer: Paul Cotton, 2008

118

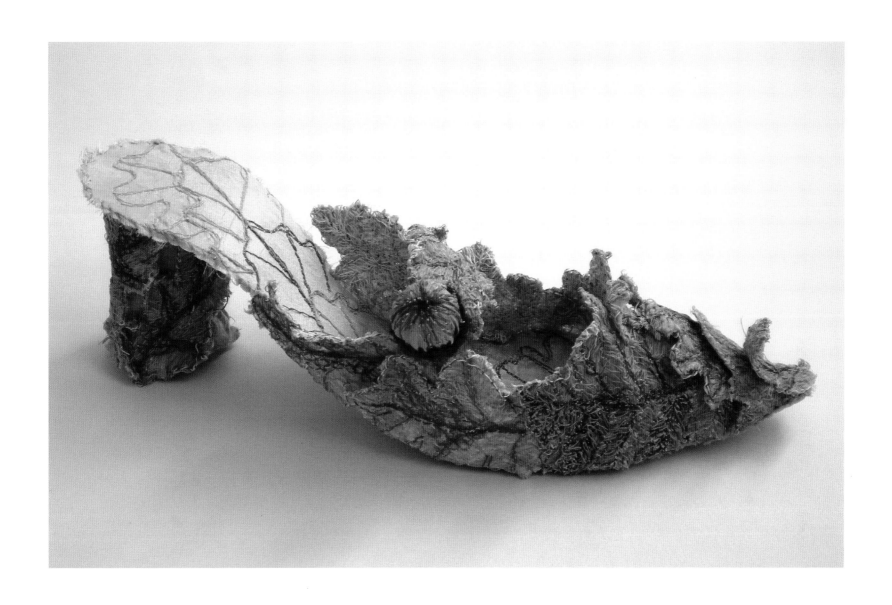

Walking through the forest in autumn, the carpet of bronzed leaves
covering the path became my inspiration for this shoe. Multi-coloured
threads with a silk fabric base were used to replicate the autumnal leaves,
and cardboard was used to support the heel. 24 x 10cm (9½ x 4in).

Photographer: Paul Cotton, 2008

I have had an interest in Victoriana since its revival in the 1980s. Even the most basic items were highly decorated, from the humblest teaspoon to the grandest of houses. It came as no surprise that the Victorians were huge collectors of exotic plants, and the terrarium – first invented by Nathaniel Bagshaw Ward – provided an airtight, temperate environment in which the specimens they collected could live.

It soon struck me that the terrarium would be ideal for housing and exhibiting my shoes. I wanted my terrariums to have a contemporary look, yet with a dark and sinister feel reminiscent of the Victorian Gothic style. I designed my terrariums and, with the help of my father, made them out of Perspex. I then gave them a distressed mirror backing and painted an algae effect on the inside. I wanted to convey the feeling that my shoes were living organisms, so I placed them in a 'living habitat' consisting of crafted leaf matter, soil and plant material.

Initially, my shoes were exhibited on purpose-made shelves, but these offered them no protection from the environment. With the help of my new take on the Victorian terrarium, however, my shoes now have a safe, miniature world in which they can be displayed and admired.

My pansy shoe sits on a bed of felted moss while ferns grow up from behind. The pansy flowers consist of heavy stitch work on to silk fabric, with wood inside the heel for support and wire in the stem of ivy.
Photographer: David Paul Betts, 2009

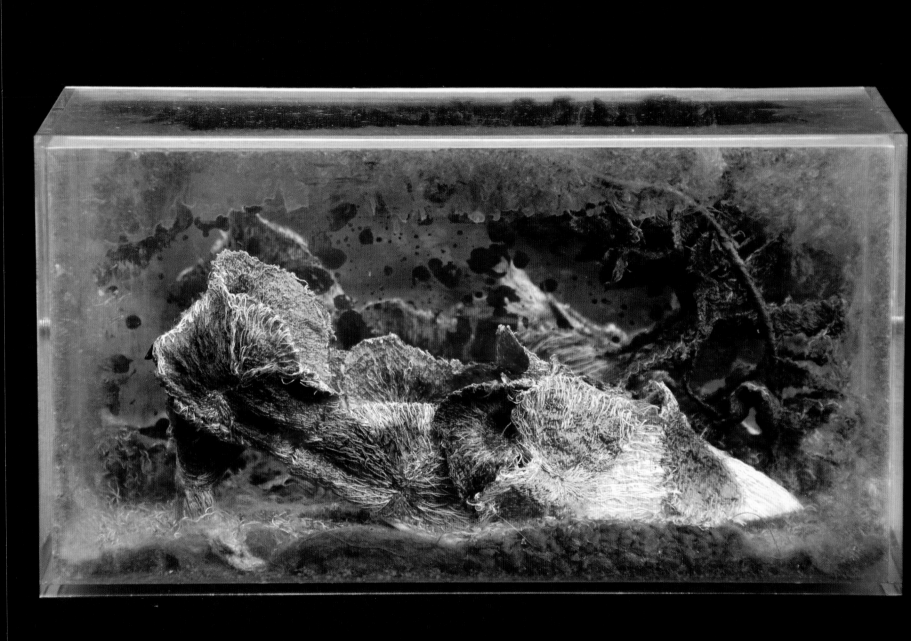

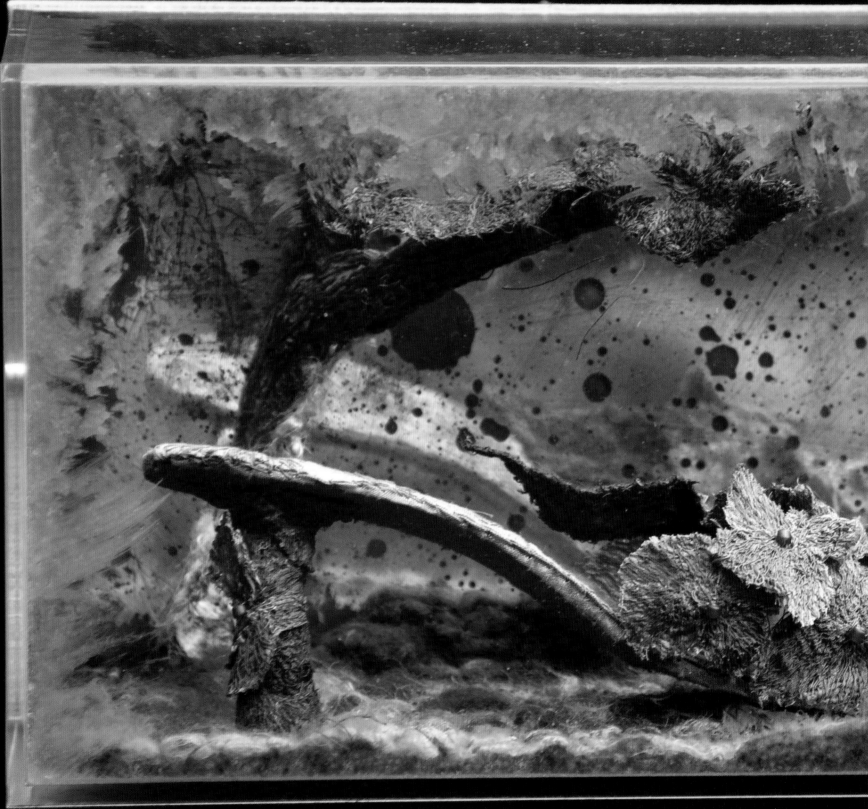

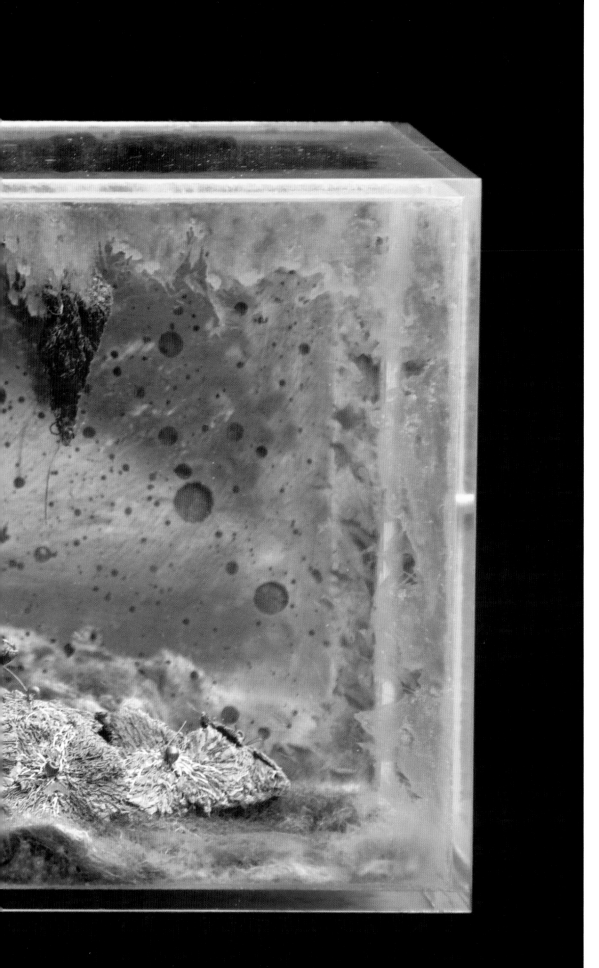

This dainty hydrangea sling-back shoe sits on a bed of moss, with vegetation apparently growing inside the terrarium.

Photographer: David Paul Betts, 2009

installations

This, my first book, is a glimpse into my ideas and thought processes, but for me my journey is unending. I always have new ground to cover, new challenges to be met, new techniques to discover.

My venture into three-dimensional art started with a tiny teacup, but why stop there? It is always exciting working on a new project, with all the new challenges that brings. It provides opportunities to try out new techniques, or revisit those from the library of my mind that I may have tried at college and not attempted since. In this last chapter, I have included my most ambitious pieces to date, each with its own story to tell, from the smallest – a pincushion – to the largest – a wing-back chair.

Inspired by my newly planted vegetable plot and having perfected the cabbage leaves on the shoe (see page 17), I tried having a go at a red-stemmed cabbage. The ivory cotton base fabric has heavy stitch work, and the handle is wired for support. 20 x 13cm (7¾ x 5in).

Photographer: Julie Yeo, 2010

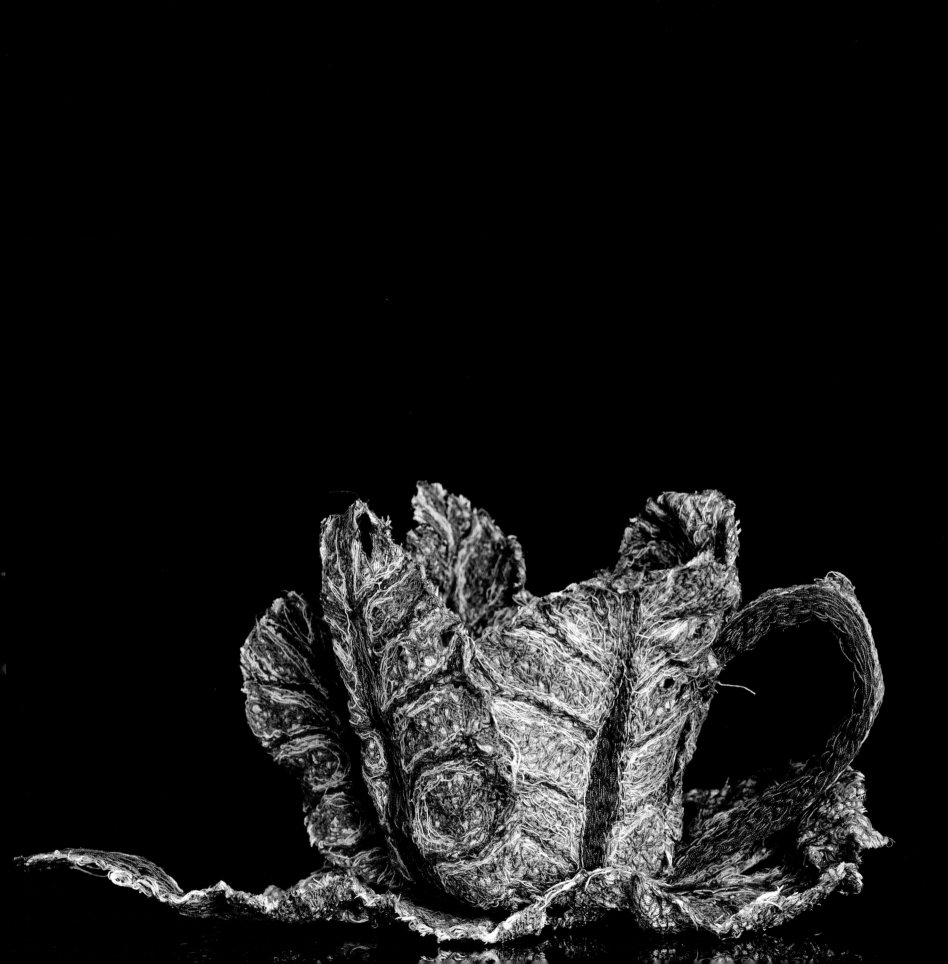

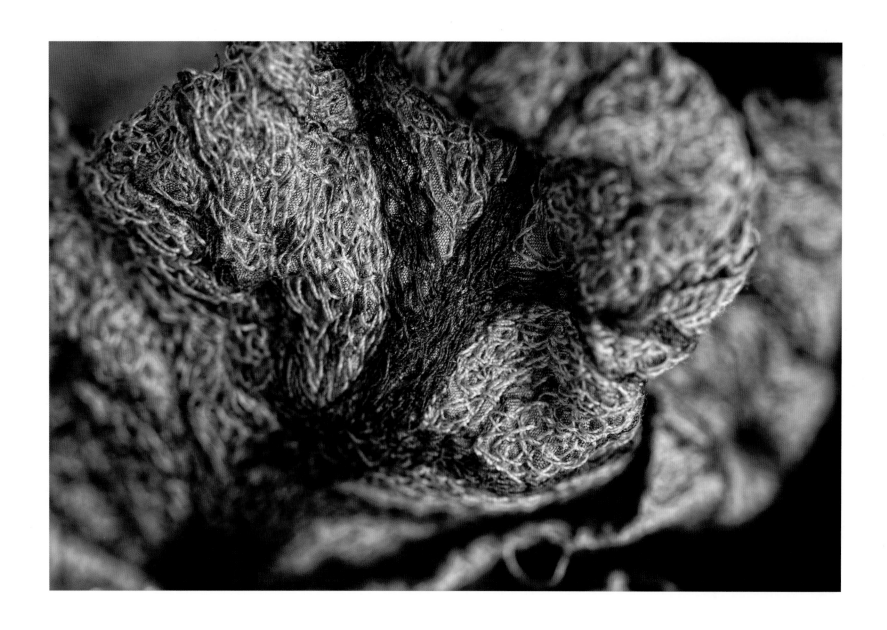

Having made the cabbage cup and saucer on the previous page, I produced a red one to create a tea set. I was thrilled with the end result. 14 x 9cm (5½ x 3½in).

Photographer: Julie Yeo, 2010

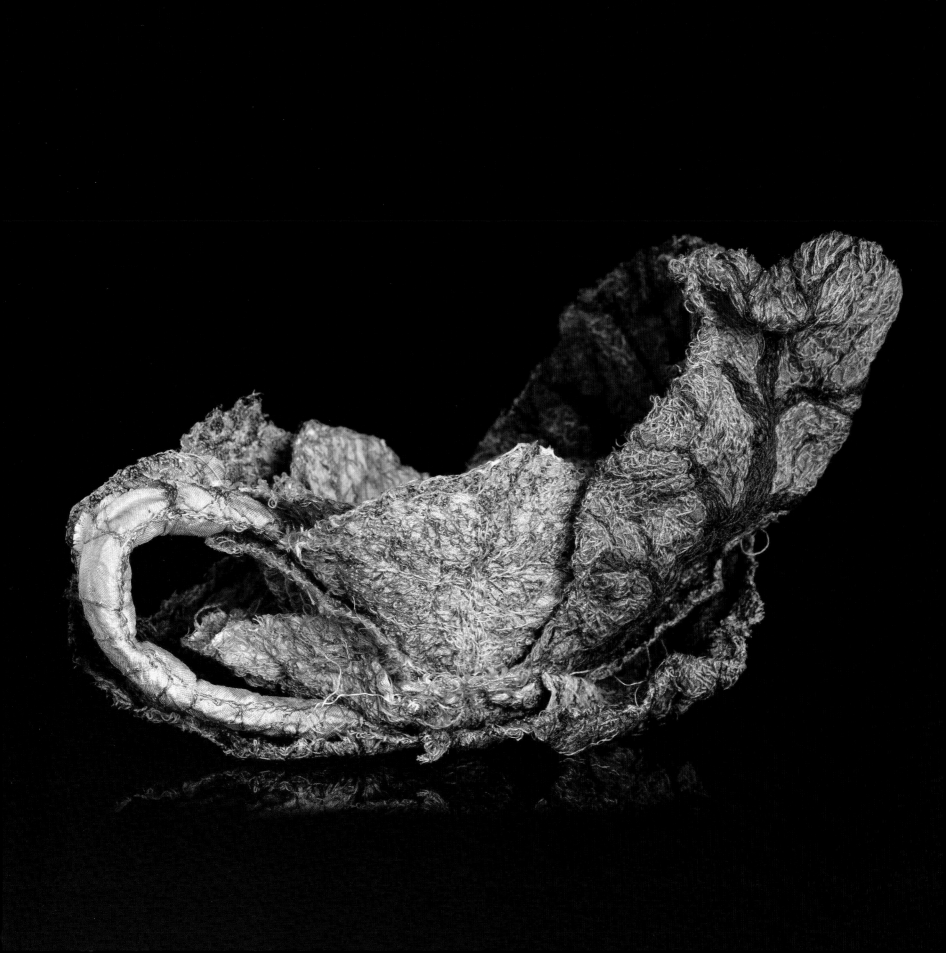

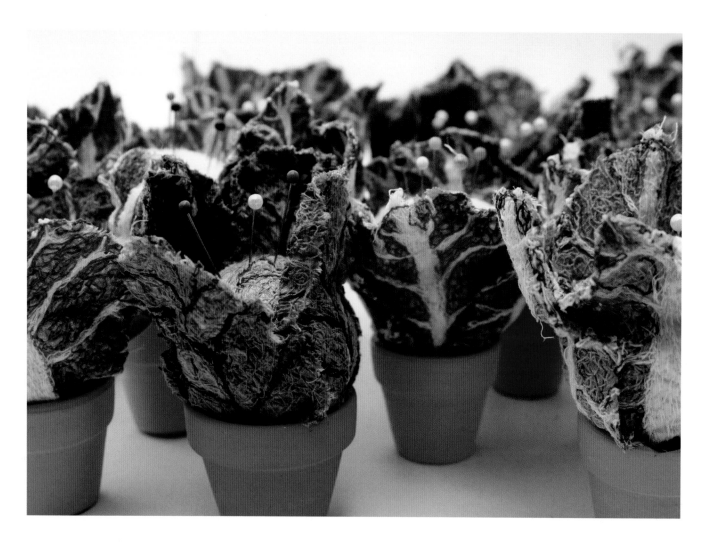

These little cabbage and cauliflower miniature works of art were designed with matching scissor- and needlecases for the keen needle woman. They were first exhibited at the Knitting and Stitching Show in 2010. 9 x 5cm (3½ x 2in).

Photographer: Paul Cotton, 2009

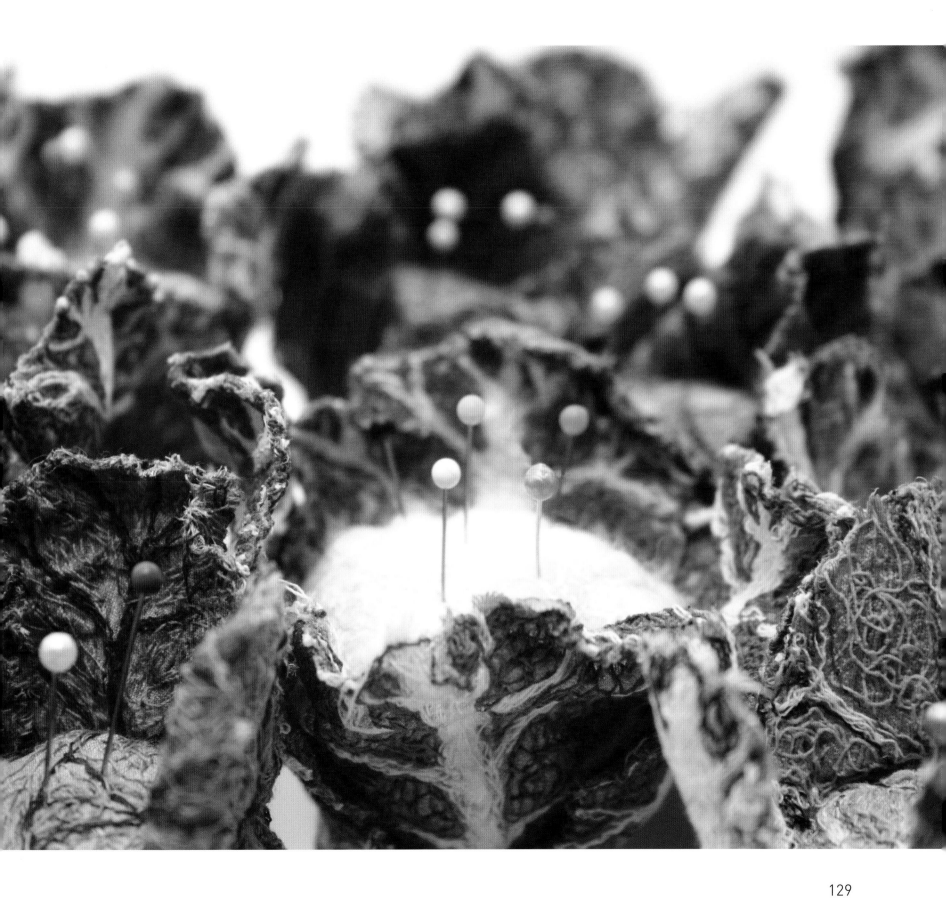

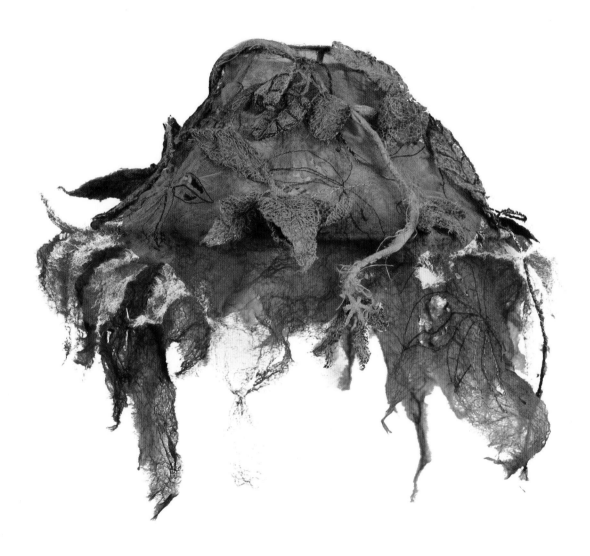

Right: this bramble teacup has a similar colour palette to the Virginia creeper lampshade shown opposite. I find the subtle colour changes that take place during autumn inspiring.

Above left: Virginia creeper assumes the most wonderful shades with the first frost; some leaves remain green while others turn from shades of pink to crimson, magenta and cerise. This lampshade, inspired by the transient autumn colours of this climbing plant, was commissioned to be exhibited at 100% Design, London. This was my first attempt at a light shade. I used a base fabric of silk organza for the shade, stitching on to silk fabric for the leaves, and silk-wrapped wire as stems. 36 x 32cm (14¼ x 12½in).

Photographer: Paul Cotton, 2008

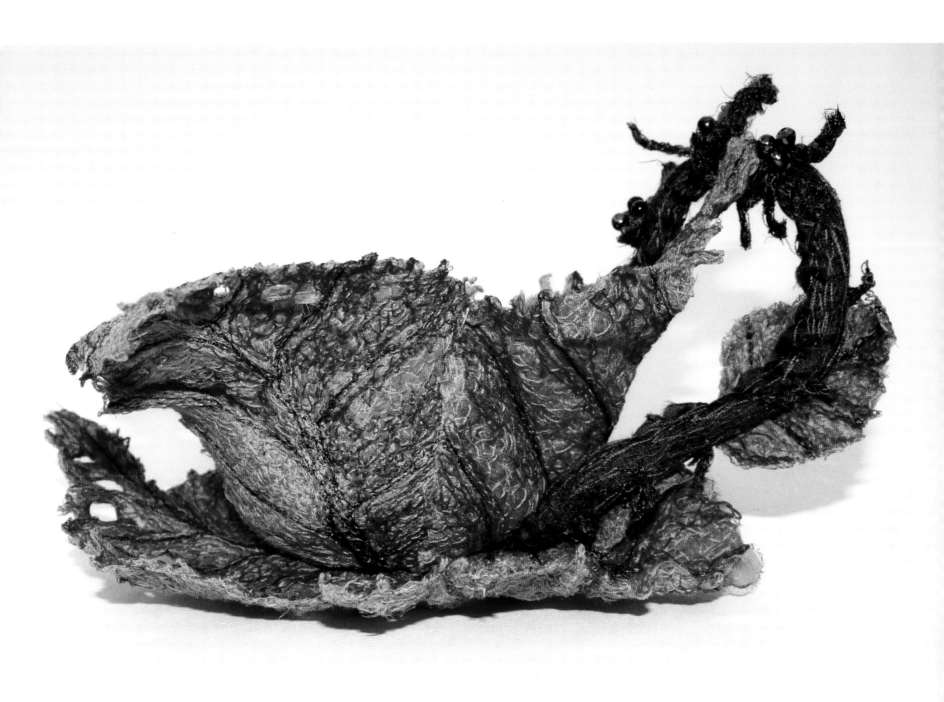

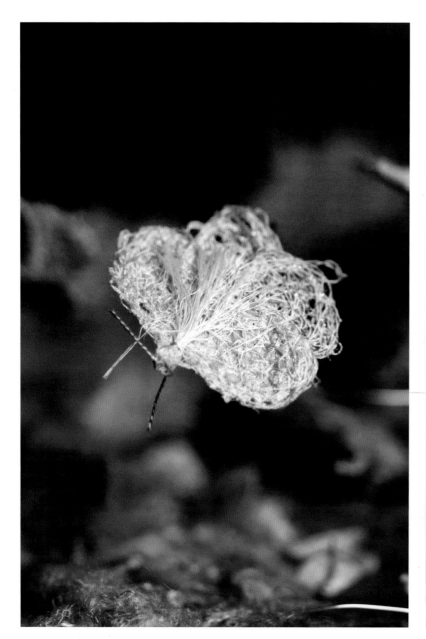

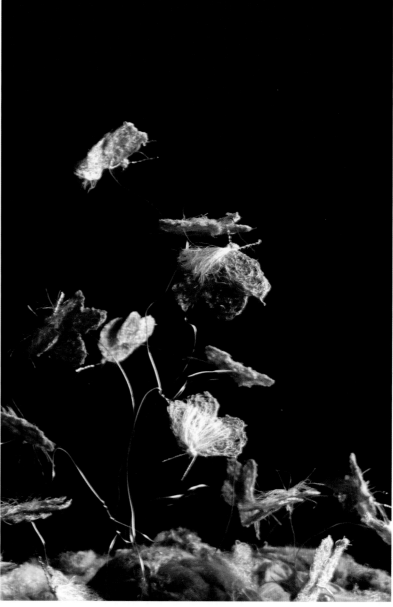

Right: this piece was the start of a collaboration with a colleague of mine, Margaret Moore. Margaret was dabbling with silver metal clay and produced a small work of art that became the inspiration for the piece shown here. Margaret's work suggested to me a pair of moth wings, so for impact I decided to make several moths, reproducing their wings using metal threads. For the bodies I used single strands of embroidery twist and for the antennae I used wire. I suspended the moths on wires to give the illusion of them fluttering up into the moonlight. I already had the glass dome so I fashioned a felt moss base within it and secured the moths inside. 35 x 43cm (13¾ x 17in).

Above: details

Photographer: Julie Yeo, 2011

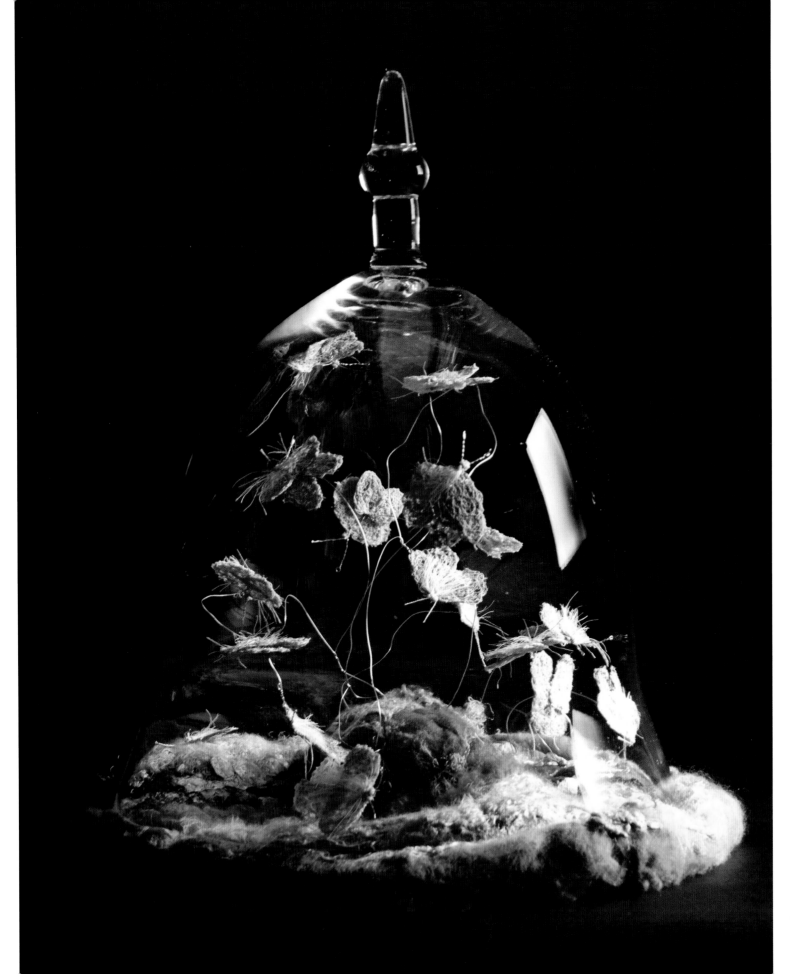

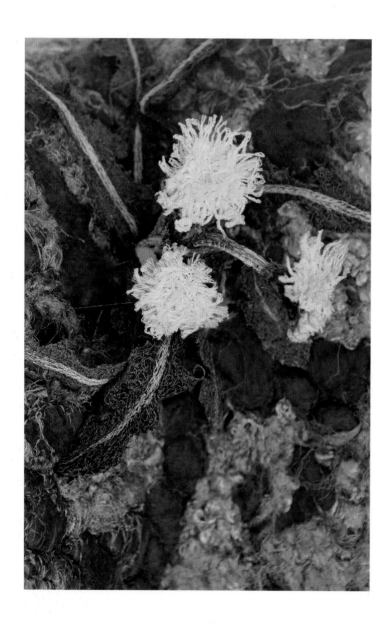

Right: forgotten armchair, 114 x 78 x 65cm (44¾ x 30¾ x 25½in); lamp, 180 x 65cm (71 x 25½in) and table, 55 x 35cm (21¾ x 13¾in). Photographed at Appuldurcombe House, a ruin on the Isle of Wight, I originally made the pieces for an exhibition, at which I had kindly been offered a fabulous area in the artists' gallery and needed something magnificent to display there. Along came the idea of the chair, then the lamp and finally the table. Each piece was entirely covered in stitched felt to represent moss. The chair was adorned with arching brambles and dandelions, the table with ivy and the lamp with bindweed. The idea was born out of my love of disregarded furniture, left to the elements, allowing Mother Nature to creep up, envelope it and claim it as her own.
Photographer: Paul Cotton, 2010

Above: detail
Photographer: Julie Yeo, 2010

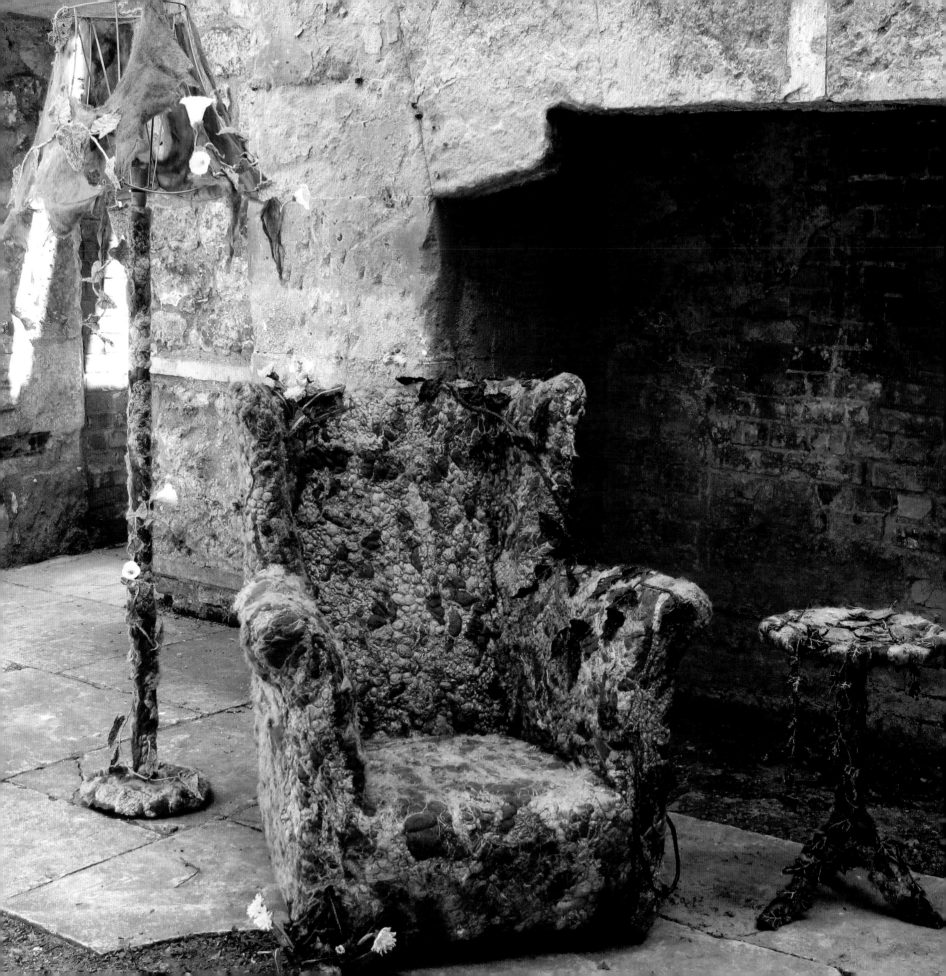

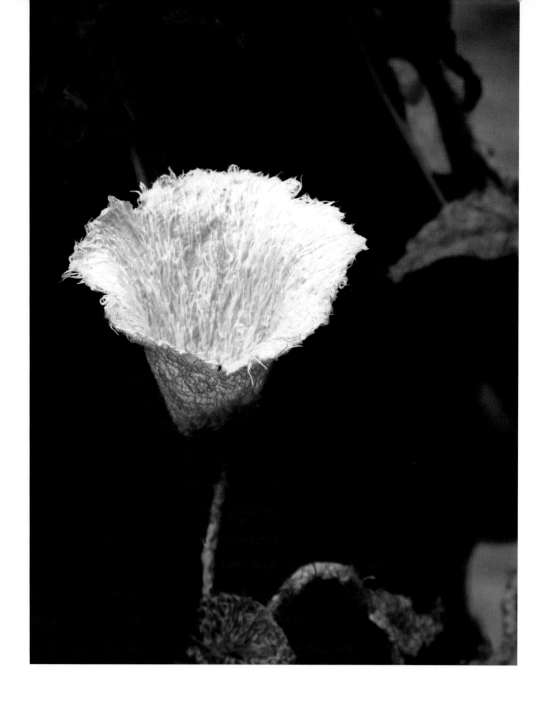

Lamp details. I have a love–hate relationship with bindweed. It takes over my garden in the late summer, climbing through my beloved rose plants, yet it is a great plant to imitate in fabric and thread. The stage I love most is when the leaves turn yellow in late summer and are nibbled all over by tiny insects, producing a lacy effect. The flowers don't last long, disappearing as if by magic with the first frost. Here, bindweed covers the lamp in much the same way as it entwines my garden plants. The flowers and leaves consist of a fabric base with heavy stitch work and wired stems. For the fine moss-like fabric on the lampshade, silk organza fabric was embellished with merino wool tops using an embellishing machine.

Photographer: Paul Cotton, 2010

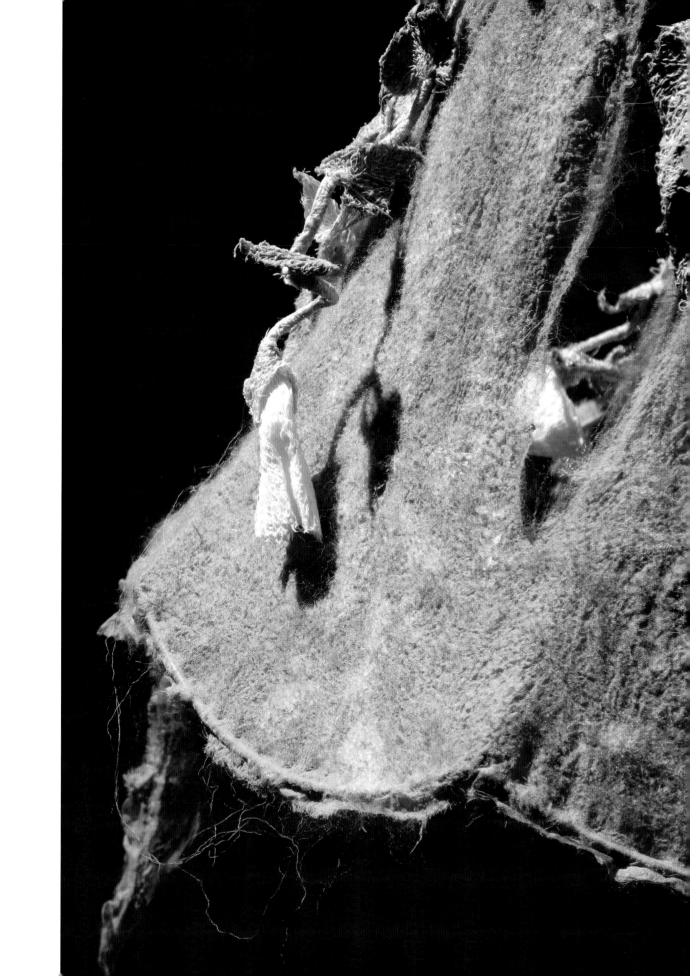

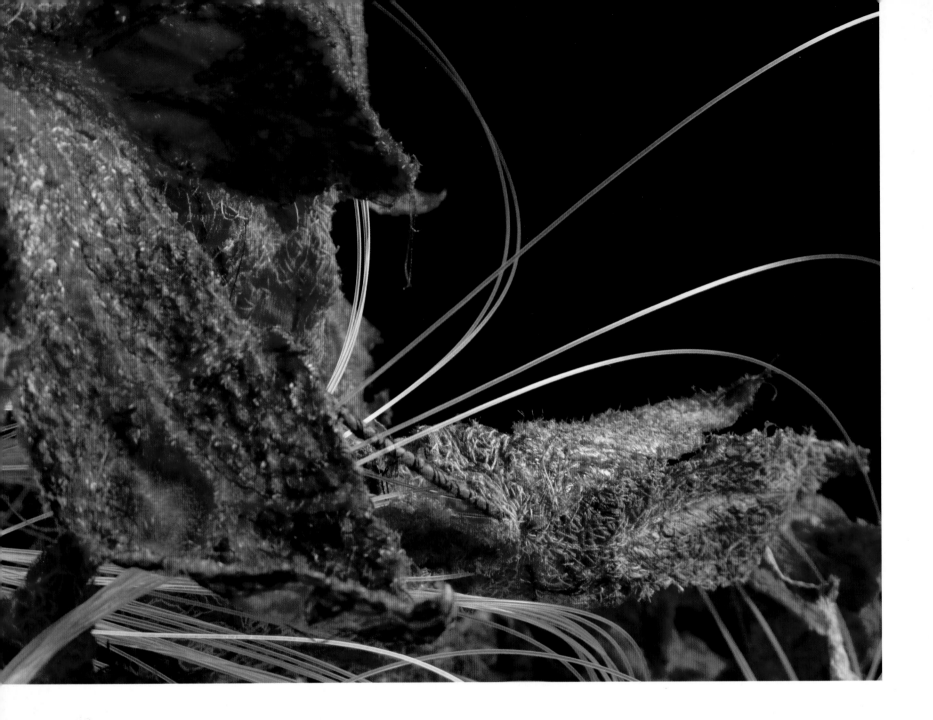

Right: Virginia creeper chandelier, made with thread, fabric, wire and fibre optics. This plant grows in my hedges at a rapid speed, almost completely covering the foliage beneath. It comes into its own in early autumn when the first frost hits. Each leaf consists of five leaflets, and I made each one individually before sewing them together. There is a huge variety of sizes, the smallest being about 5cm (2in) long and the largest, at the top, about 58cm (23in) in length. I used coloured wire to imitate the twisting suckers, and fibre optics encased inside the foliage turns this chandelier into a real show stopper. 170 x 51cm (67 x 20in).

Above: detail

Photographer: Paul Cotton, 2010

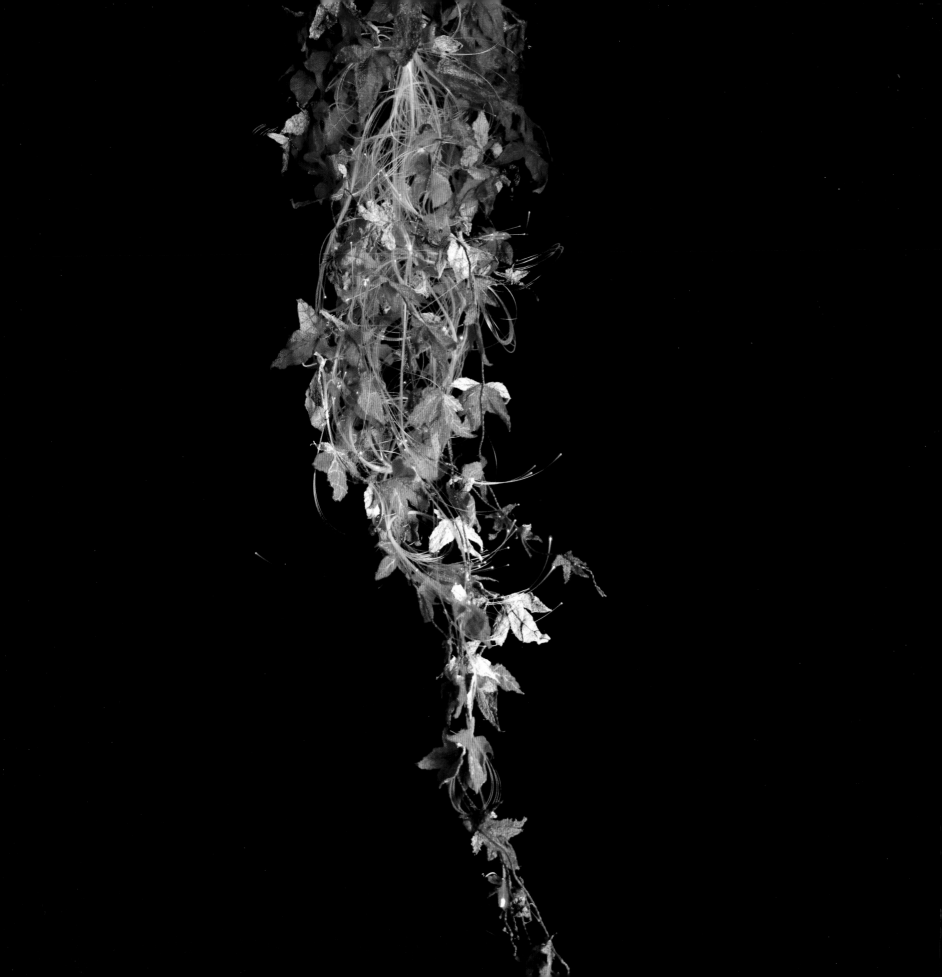

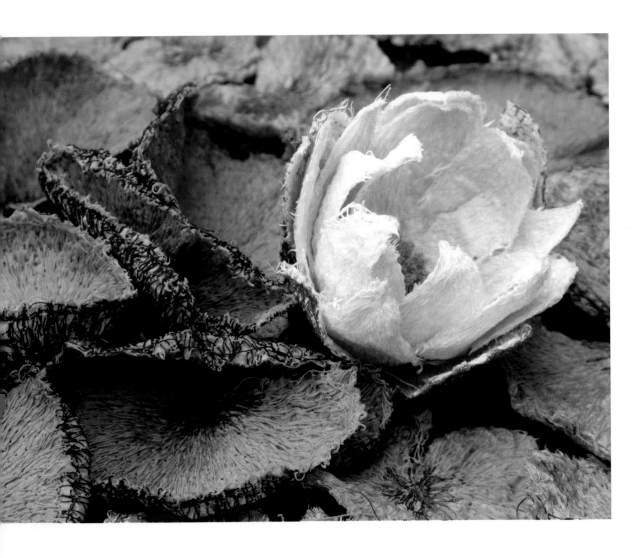

Right: the idea of making an embroidered pond came to me while I was sitting at my little garden table next to my pond. I knew it would make a great subject for an embroidery, and the idea of a pond coffee table took it a step further still. I like my pieces to have a use, so I effectively married the idea of my little table and my pond together to make this piece. 74 x 60cm (29¼ x 23½in).

Photographer: Julie Yeo, 2010

Above: detail

Photographer: Paul Cotton, 2010

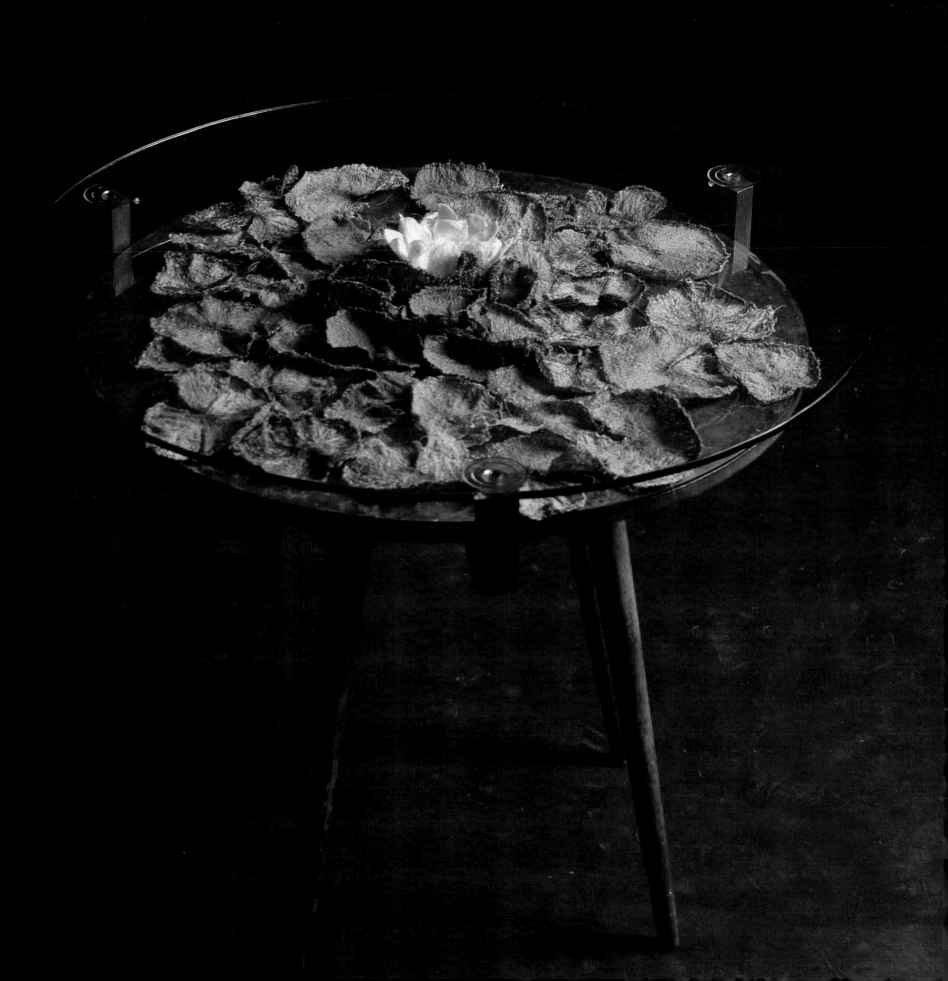

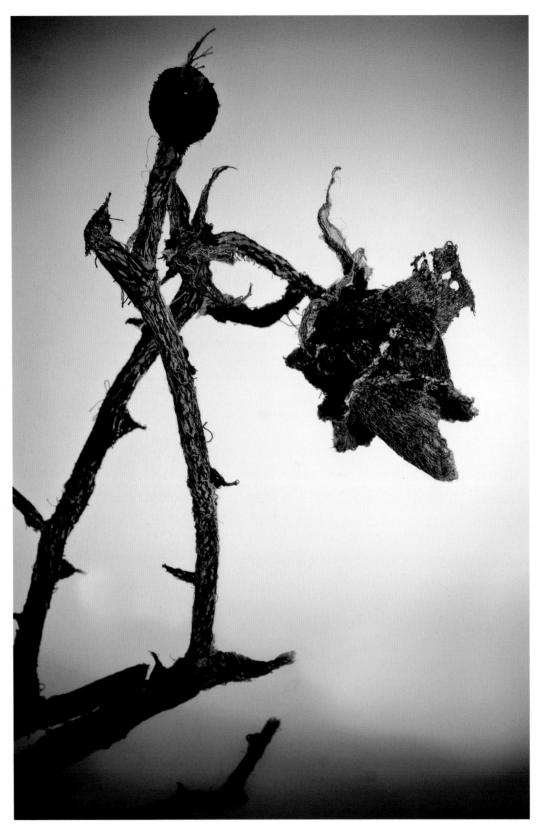

Disturbed beauty. Inspired by one of my rose bushes I had managed to kill, I noticed a strange and Gothic elegance to this once resplendent plant. Silk-wrapped wood was used for the branches and roots, while felted 'moss' grows around the base of the rose. The rosehips and heads were achieved with a silk base and heavy machine stitching. 118 x 62cm (46½ x 24½in).

Above: detail

Photographer: David Paul Betts, 2010

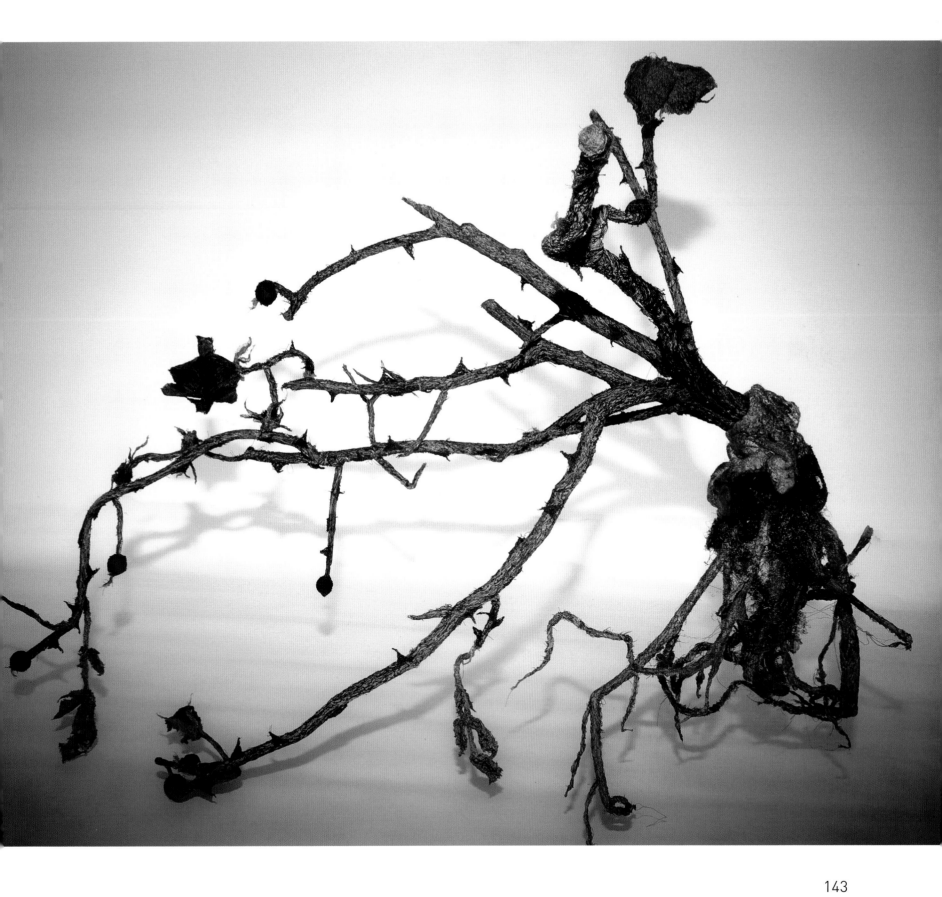

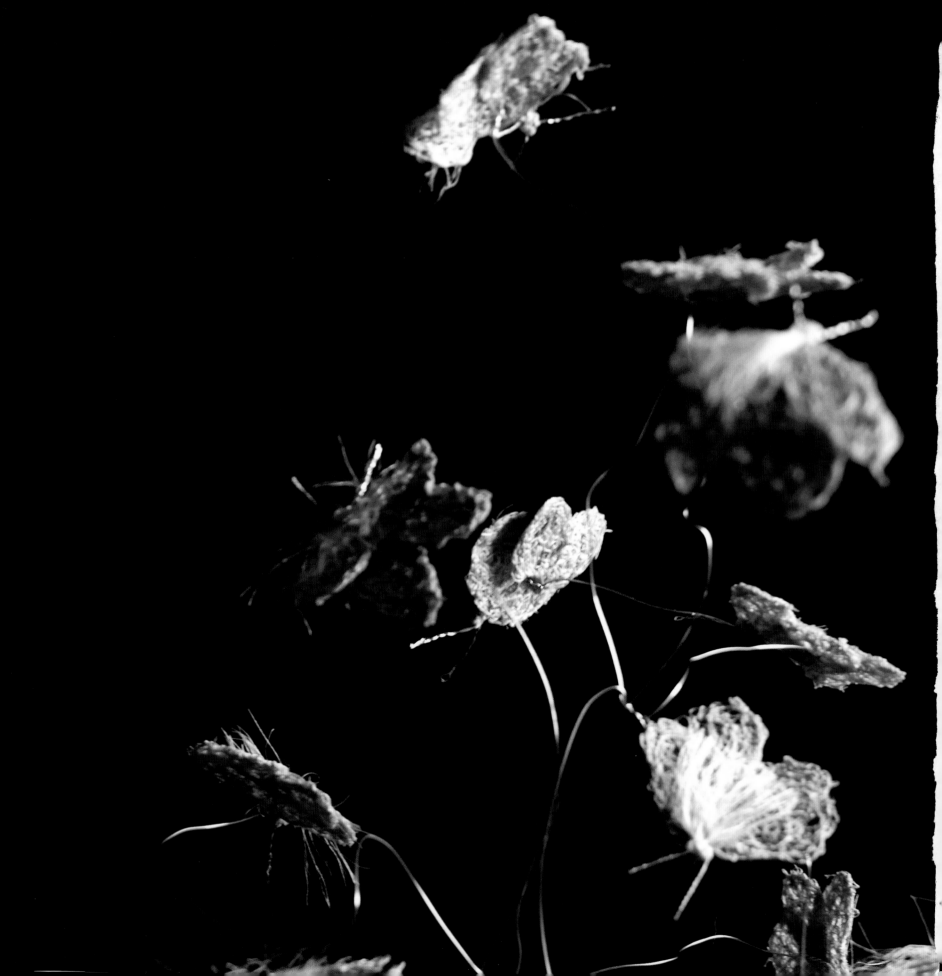

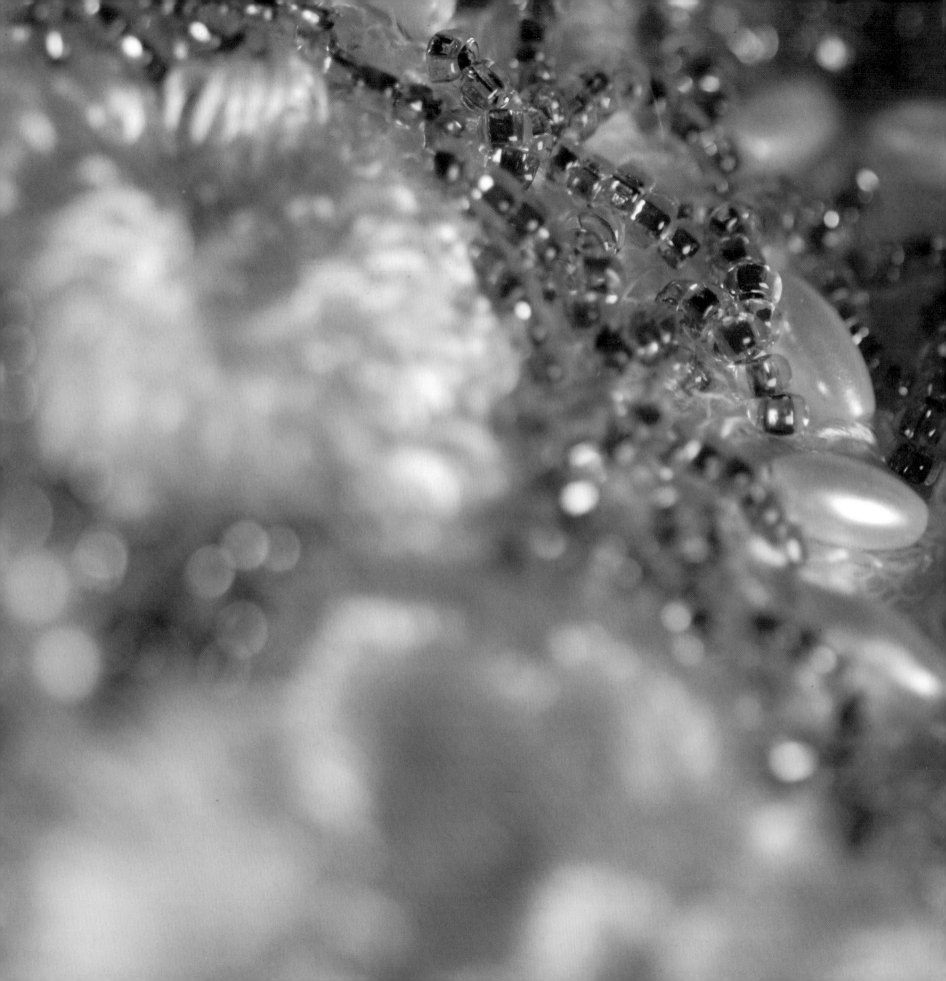